Suzi Gablik

Magritte

with 21 colour plates
155 in monochrome
and 49 line drawings

Thames and Hudson · London

© Suzi Gablik 1970
Sixth Printing 1977

Text filmset in Great Britain by BAS Printers Limited, Wallop, England
Monochrome illustrations processed in Western Germany by Klischeewerkstätten Der Industriedienst GmbH & Co., Wiesbaden
Colour illustrations processed in Great Britain by Colour Workshop, Hertford

Printed and bound in Singapore by FEP International Ltd

Magritte

CONTENTS

I paid my first visit to René Magritte and his wife in 1959. The visit lasted for eight months, during which time I lived in their house, gathering material for the monograph which has only now been fully realized. My gratitude for the support and trust accorded me over so many years by Magritte and by his widow cannot be expressed in words. That the book will now finally have a life of its own in the world is a great pleasure to me: I am at last able to say thank you properly.

I was also fortunate in making the acquaintance of certain members of the artist's circle during the time I lived in Brussels. Notable among these is Louis Scutenaire, whose constant help and encouragement have been invaluable to me. His generosity in putting the documents from his personal dossier at my disposal, and in allowing me to draw freely on his own excellent writings about Magritte, made my work possible.

I am further indebted to all those persons who have lent their support in various ways over the years. In particular, I should like to thank André Blavier, André Bosmans, Charles Byron, William S. Copley, Charlotte Gilbertson, Barnet Hodes, Brooks Jackson, Alexandre Iolas, M. and Mme Francis de Knop, George Melly, Mr and Mrs Jean de Menil, Duane Michals, Dorothy Miller, Jean-Yves Mock, Bénédicte Pesle, Howard Rose, Irène Hamoir Scutenaire, Simone Swan, David Sylvester and Harry Torczyner. I should also like to acknowledge the kindness of all those persons, galleries and institutions who generously supplied me with photographs.

Lastly, I should like to extend my thanks to Mrs Eva Neurath, Chairman of Thames and Hudson, for the special attention she has given this project. I am particularly grateful for the editorial efforts of Constance Kaine and David Britt in finalizing the book. And to John Russell, whose ungrudging patience saw me through every boring detail, I offer my most affectionate thanks.

1 Philosophy and Interpretation

René Magritte, the Belgian Surrealist painter, died on 15 August 1967 in Brussels, in his own bed, at approximately two o'clock in the afternoon. His life had been a solitary posture of immense effort: to overthrow our sense of the familiar, to sabotage our habits, to put the real world on trial. He had always tried to live within the subjunctive mood, treating what *might* happen as a construction of his own highly inventive will. And, like Baudelaire, in the end he exhausted his own lucidity.

He suffered the 'bizarre affliction' which was at once the source of all his ills and all his melancholic progress: *ennui*. He lived it as a metaphysical condition – not only in his conscious intellectual intentions, but in his attitude as a whole, in all he was in his life and work. When it came to painting, he manifested an almost constitutional dislike, feigning something between boredom, fatigue and disgust – 'the savoured infirmities of a retired acrobat'. He particularly liked to refuse the name of artist, saying that he was a man who *thought*, and who communicated his thought by means of painting, as others communicated it by writing music or words. Painting represented for him a valid means of expressing, in a constantly changing light, the two or three fundamental problems with which our mind is always struggling. More particularly, it represented a permanent revolt against the commonplaces of existence.

He kept a slight distance, during his lifetime, from the main road of success. The success or hatred that his work aroused would interest him for a short time; then he would sink into his usual mood of finding every enterprise absurd and steeping himself in this sense of absurdity. Magritte was that true Baudelairean hero who amused himself all alone – who knew how to people his solitude or to be alone in a crowd. But his ideas were never idle phantasmagoria. They represent nothing else than unborn realities, for Magritte was a conscious utopian. He gave new possibilities their meaning, manipulating objects until he became the man who discovered their destiny.

To those who tried to interpret his pictures, he liked to answer (as did Stéphane Mallarmé to those who supposed they had found the meaning of his poems): 'You are more fortunate than I am.' Magritte's paintings are intended as an attack upon society's preconceived ideas and predetermined good sense. He considered his work successful when *no* explanation of causality or meaning can satisfy our curiosity. In Magritte's paintings, we perceive events without the inner connection that usually links cause and effect. Problems are solved, in the manner of philosophy, not by giving new information, but by rearranging what we have always known.

'The fear of being mystified', according to Magritte, 'applies equally to painted images which have the power to provoke such fear. Sometimes an image can place its spectator under serious accusation.'

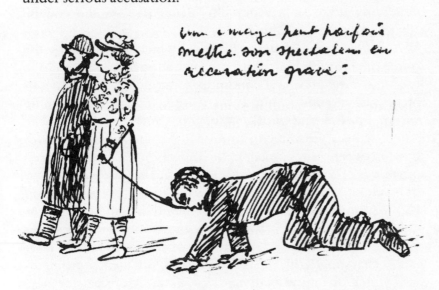

A person who only looks for what he wants in painting will never find that which transcends his preferences. But, if one has been trapped by the mystery of an image which refuses all explanation, a moment of panic will sometimes occur. These moments of panic are what count for Magritte. For him they are privileged moments, because they transcend mediocrity. (But for that, there doesn't have to be art – it can happen at any moment.)

The mark of the philosopher is to doubt what is usually taken for granted, and to think how everything could 'just as easily' be otherwise, attaching no more importance to what is than to what is not. It is a way of questioning the stereotyped habits of the mind, since only a wilful disruption of the usual certainties will liberate thought and open the way

to authentic revelation. But for this, attention must be shifted from the trivialities of experience to its real nature. Magritte used painting for this purpose alone: 'I think as though no one had ever thought before me,' he has said.

A study of his work is therefore likely to disclose the intellectual integrity and searching mind of a philosopher rather than the aesthetic and painterly concerns of an artist. Magritte was at peace only when his mind was tormented by problems. The matter-of-fact literalness of his style, so often described as unpainterly and academic, is merely the most effective means of achieving clarity of thought. Magritte's paintings attempt to make thought visible – but thought which is identified with images and not with ideas. The meaning of these paintings does not reside in any literary explanation or interpretation which can be offered. They are the evidence, however, of a philosophical temperament which was continually investigating and analysing the structure of our common-sense beliefs and struggling to reconcile the paradoxes of existence.

People have always looked for symbolic meanings in Magritte's pictures, and in some cases managed to find them. Nothing caused him greater displeasure.

To equate my painting with symbolism, conscious or unconscious, is to ignore its true nature.... People are quite willing to use objects without looking for any symbolic intention in them, but when they look at paintings, they can't find any use for them. So they hunt around for a meaning to get themselves out of the quandary, and because they don't understand what they are supposed to think when they confront the painting.... They want something to lean on, so they can be comfortable. They want something secure to hang on to, so they can save themselves from the void. People who look for symbolic meanings fail to grasp the inherent poetry and mystery of the image. No doubt they sense this mystery, but they wish to get rid of it. They are afraid. By asking 'what does this mean?' they express a wish that everything be understandable. But if one does not reject the mystery, one has quite a different response. One asks other things.[1]

If we look at a thing with the intention of discovering what it means, we end up no longer seeing the thing itself, but thinking of the question that has been raised. The mind sees in two different senses, according to Magritte: it sees, as with the eyes, and it sees a question (no eyes). But the eye itself sees in the way that the hand grasps – passing over many things which, through a lack of interest, nothing induces it

to seize. Magritte's painting challenges this normal discontinuity of our vision, which tends to see only what it wants to see. Seeing is an act, according to Magritte, in the course of which it can happen that a subject escapes our attention. 'A thing which is present can be invisible, hidden by what it shows.' For example, 'it is possible to see someone take off his hat in salute without thinking of politeness':

| Exterior view | Interior view | View from above and below |

The eye [wrote Paul Nougé], which sees that which is no longer, the star; on the screen, the image which has disappeared; which does not see that which is too fast, the bullet, that smile; which does not see that which is too slow, grass which is growing, old age; which recognizes a woman and it's another, a cat and it's a shoe, his love and it's emptiness – the freedom of the eye should have put us on our guard long ago.[2]

For Magritte, paintings worth being painted or looked at have no reducible meaning: they *are* a meaning. To be able to define the meaning of his images would correspond to putting the impossible into a possible thought. There is no way to define the meaning of an image in which one sees *precisely* what is represented, when no symbolic meaning has been presupposed. Magritte has written:

The images must be seen *such as they are*. Moreover, my painting implies no supremacy of the invisible over the visible. (The letter hidden in the envelope is not invisible; neither is the sun when it is hidden by a curtain of trees.) The mind loves the unknown. It loves images whose meaning is unknown, since the meaning of the mind itself is unknown. The mind doesn't understand its own *raison d'être*, and without understanding *that* (or why it knows what it knows), the problems it poses have no *raison d'être* either.

For Magritte, painting was a means of evoking a meta-reality which would transcend our knowledge of the pheno-

menal world. He referred to it continually as 'the mystery' – about which it is impossible to speak, since one can only be seized by it. Mystery, in Magritte's sense, may be explained in many ways, but it never explains itself. *That* is the real mystery, according to Magritte. However, in order that this mystery be invoked, means for doing so must be found. 'Realism', he has said, 'is something vulgar, ordinary; but for me, reality is not easily attained.' Magritte's mystery is not one of the possibilities of the real; it is that which is necessary in order for the real to exist. Only then can everyday reality pass from the realm of the contingent to that of the absolute. For Magritte, painting was never an end in itself; it was only a 'lamentable expedient' by means of which such a passage could be negotiated. This conception of the nature and purpose of art is something Magritte has in common with many of the other Surrealists. However, in other matters he was a Surrealist who slid down the rails when the others weren't looking.

Attempts to link Magritte's work either to Flemish art, or to the tradition of fantastic art, or to both, cannot be pursued to advantage either. He was familiar with, and even admired, the strangeness of certain Belgian artists like Antoine Wiertz, Félicien Rops, Xavier Mellery and Fernand Khnopff. Moreover, there is in some of Magritte's pictures that sense of eternality, of time suspended, which recalls the hermetic quietism associated with Memling, Van Eyck and Rogier van der Weyden. Present also is an analogous interest in ordinary objects and domestic interiors. But these tracks do not lead very far. 'Grouping artists', according to Magritte, 'because they are "Walloons" or because they might be, for example, "vegetarians", doesn't interest me at all (although "vegetarian" artists would have a slight superiority over "Walloon" artists: a good joke).' As for the tendency to link a certain branch of Surrealism with fantastic or 'fabulous' art, Magritte has also written his own comments on that subject:

The parallel of Hieronymus Bosch and Surrealism would seem to be taken as such a matter of course that it is appropriate to resist it for being both facile and false at the same time. Bosch painted ideas which his contemporaries held about monsters – ideas which could have been communicated without his pictures, notably by the medieval 'mysteries'. Bosch was a 'religious realist', in the way that today there are 'social realists' who 'express' the most 'up-to-date' or traditional ideas and feelings, like justice, nuclear power, industry, and so on. . . . *I don't paint ideas. I describe,* insofar as I can, by means of painted images, objects and the coming together of

objects, in such a light as to prevent any of our ideas or feelings from adhering to them. It is essential not to confuse or compare these objects, these connections or encounters between objects, with any 'expressions' or 'illustrations' or 'compositions'. The latter would seem to dissipate all mystery, whereas the description that I paint does not reveal to the mind *what it is* that might cause objects to appear, or what might connect them or make them fall in with each other.

In the paintings of Bosch, or James Ensor, the element of the fantastic is usually applied to some nameable idea. Hell and Paradise are imagined, for example, and, although they are constituted from elements of the visible world, the intention is that they represent "another world" – one inhabited by angels and demons. The bodies of men fuse with those of animals – a technique which was adopted also by Magritte and some of the other Surrealists for blending once distinct species into hybrids. In Bosch, however, this hybridization is used to create fantastic monsters, dragons or chimeras, whereas for Magritte it is never a question of bizarre objects or even of fabulous creatures. Magritte never amused himself with the creation of 'hideous absurdities', as did Lord Byron, who, according to Swinburne, indulged himself with ideas of lava kisses, baby earthquakes and walls that have scalps. Magritte used only familiar objects, brought together or combined in such a way as to evoke something else, something *unfamiliar*. That something makes its presence felt while the familiar things continue to maintain, within the painting, their aspect of resemblance to the world. There is no visible symbol for what is invisible, but the mind moves in response to the outside world, and when it is touched it knows. Like a block of wood which suddenly starts up and makes a noise, the mind sees what the eye doesn't. Given an object produced with meticulous attention to reality, how is it possible for such an object to operate contrary to physical laws? For Magritte,

... the commonplace knowledge we have of the world and its objects does not sufficiently justify their representation in painting; the naked mystery of things may pass as unnoticed in painting as it does in reality. . . . If the spectator finds that my paintings are a kind of defiance of 'common sense', he realizes something obvious. I want nevertheless to add that for me the world is a defiance of common sense.

In short, it is the unexpected in Magritte's work which provides information, since what is fully expected tells us nothing.

That is to say, a statement that something will occur only conveys information if that something is unlikely to occur. For example, if somebody tells me that the sun will also rise tomorrow, he tells me very little. For Magritte, reality denies the impossible to which, *within the bounds of the possible*, his paintings aspire. The important thing is to know *what* to paint, and it is inspiration which makes this known. 'Inspiration', according to Magritte, 'is the moment when one knows what is happening. In general, we do not know what is happening.'

Magritte tended to work back and forth through a small range of variants at different times, elaborating on certain key ideas, most of which are present in a germinal state in paintings from 1926 onward. (That he also frequently duplicated pictures – mostly to satisfy a demand for certain popular images – makes the chronology of his work both complicated and confusing.) The morphology of early and late work can often be understood as early and late versions of an inter-related theme; any stylistic alterations which do exist are marginal and secondary developments. In this book I have tended to order the works taxonomically rather than chrono-logically, that is, by classifying the images into groups which progressively chart the 'scripts' of the major themes as they reveal themselves through frequent repetition and variation. Such sequences form quite naturally, and create a network of gradually altered repetitions that are recognizably similar, yet different. In this way, each separate work has a positional value in relation to a sequence, in addition to the value that it has on its own. The range of discourse for a given picture is thus enlarged when it is seen as part of a connected effort toward the solution of a particular problem, rather than as an isolated entity. As a result, the key themes achieve a heightened clarity, since they are presented as the sum of numerous variations, derivatives, cross-references, combinations, trans-formations and syntheses.

2 Curriculum Vitae 1898-1925

'I detest my past,' Magritte has written, 'and anyone else's. I
detest resignation, patience, professional heroism and obli-
gatory beautiful feelings. I also detest the decorative arts,
folklore, advertising, voices making announcements, aero-
dynamism, boy scouts, the smell of mothballs, events of the
moment, and drunken people.'

The Belgian poet Louis Scutenaire has pointed out, in an
excellent monograph on the painter, how Magritte had the
ideas of everyone else on matters where we might expect
singularity, and extraordinary ideas in realms where we would
be unlikely to expect them.[3] (For example, he preferred a
beautiful woman to a beautiful statue, and a beautiful statue
to a beautiful woman.) Magritte applied his irony, which was
complex and unpredictable, to his life as much as to his art.
Once he told me: 'This morning at the butcher's a woman
asked for two nice kidneys. When it was my turn, I was
tempted to ask for two horrible kidneys.' Passing for a moment
in front of the American consulate, he thought of going in
and politely asking the Ambassador to do 'what was neces-
sary' so that he could be named king of America on the
following day. And, if some informed person were to con-
verse with him about his painting, recounts Scutenaire, he
was likely to complain: 'He had me cornered for an hour
telling me sublime and incomprehensible things about my
painting. What a pain in the neck!' Should the same informed
person have happened not to mention his work, he was as
likely to remark: 'What a pain in the neck! He cornered me
for an hour and didn't breathe a word about my painting.'

Magritte was born, the eldest of three brothers, in 1898. 5
The date of his birth, 21 November, situates him under the
astrological sign of Scorpio – the illustrious sign of Napoleon,
Picasso, Dostoyevsky, Louis XIV and Edgar Allan Poe, a
writer whom Magritte specially admired. Persons born under
the sign of Scorpio are neither talkative nor demonstrative,
which is one way of recognizing them. They tend to be

1 Magritte's studio, 1965

Photo Duane Michals

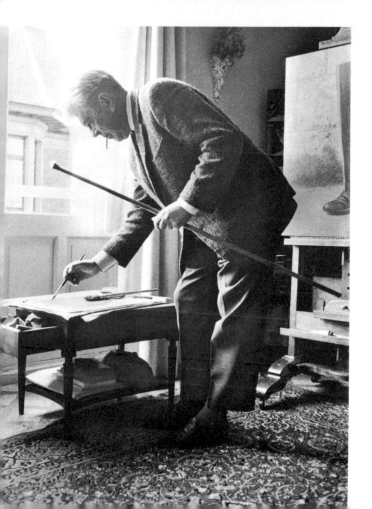

2, 3 Magritte at work, 1963

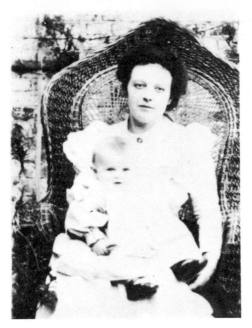

4 Magritte and his mother, *c.* 1899

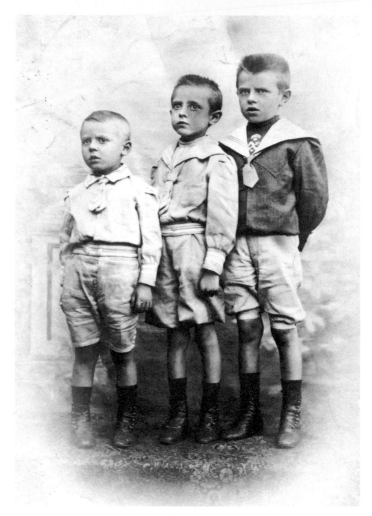

5 Magritte (right) with his brothers Paul and Raymond

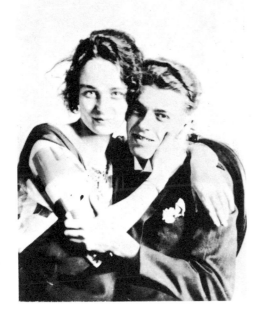

6 Magritte and his wife, 1922

7 Magritte with tuba, photographed by the author, 1960

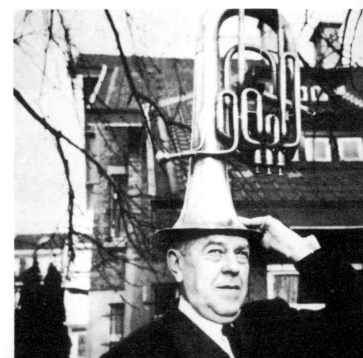

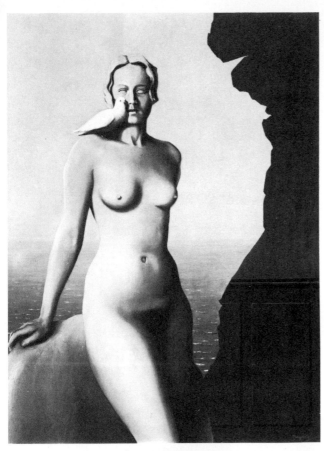

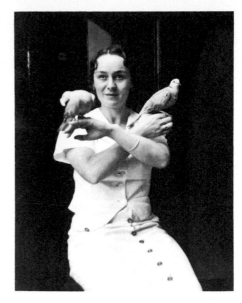

8 Black Magic · *La magie noire* 1934

9 Mme Magritte with pigeons, 1937

10 Photographic study:
Universal Gravitation (with Scutenaire) 1943

11 Universal Gravitation
La gravitation universelle 1943

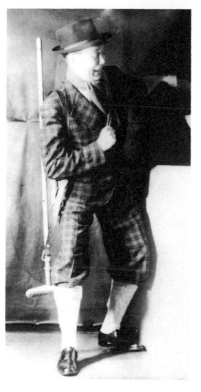

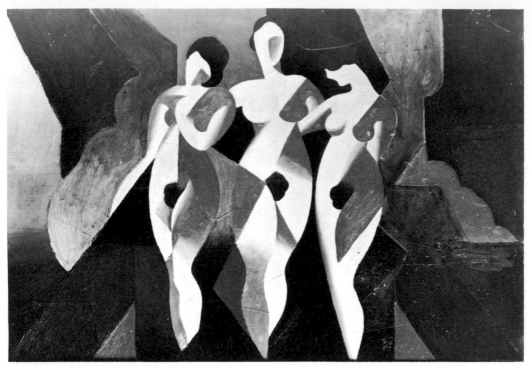

12 Three Women · *Trois femmes* 1922

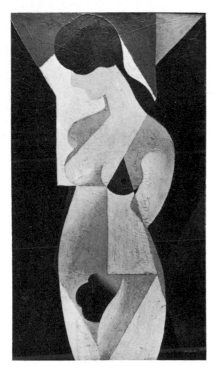

13 Girl · *Jeune fille* 1922

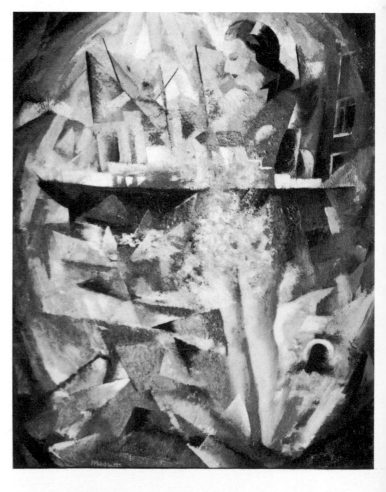

14 Youth · *Jeunesse* 1922

secret, strange and disquieting, full of unusual premonitions and intuitions. They often have a special taste for the bizarre, the subversive, the mysterious and the scabrous, and show a special affinity for the grotesque. Secretly, they are haunted, and have easy commerce with phantoms; their passion for investigation and analysis and their insatiable curiosity make them excellent secret agents or detectives. (A number of writers have already described the way in which Magritte concealed his subversive nature by living a bourgeois life disguised as an ordinary man.) He was baptized under the names René-François-Ghislain, and for this reason he signed his first productions 'Renghis, Detective'. They were adventure stories which were never published and have, moreover, disappeared.

The one-storey white house in Lessines, Belgium, in which Magritte was born, has since disappeared and been replaced by a large freight building of red brick. Lessines, situated in the province of Hainaut, is, together with Liège, the most 'French' and the most cosmopolitan part of Belgium.

Magritte's recollections of early childhood were few, but they were all bizarre. What he remembered especially, as in a kind of vision, was a large wooden chest which had stood enigmatically near his cradle. He also remembered how, when he was a year old and his family had moved from Lessines to Gilly, two balloonists arrived suddenly one day, dressed in leather and wearing helmets, and dragging down the stairs the deflated envelope of their balloon, which had somehow become entangled on the roof of the house where he lived.

The family moved again shortly afterward to Châtelet, where he first began to draw and paint at the age of twelve, while still in short pants. On Sunday mornings he studied pyrogravure and the decoration of umbrella stands in an improvised classroom on the first floor of a candy store. (All the other pupils were girls.) He spent his vacations at Soignies with his grandmother and his Aunt Flora. There, he used to play with a little girl in an old abandoned cemetery, lifting up the iron trap-doors and descending into the underground vaults. He has himself described how one day, among the broken stone columns and heaps of dead leaves in the cemetery, he saw an artist who had come from the city painting there. And from that day onward, he claimed, painting seemed to him a magical activity (see Appendix II).

Another childhood game consisted of dressing up as a priest. In front of a small altar he had made himself, he would

hold a mock mass in dignified seriousness. Religious décor fascinated him: the darkened atmosphere heavy with the smell of incense, the organ music, the relics and the mysteries of the confessional.

In 1912, Magritte's mother, Régina Bertinchamp, was found drowned. Scutenaire has described the event, as Magritte told it to him:

She shared the room of her youngest son who, waking to find himself alone in the middle of the night, roused the rest of the family. They searched the house in vain; then, noticing footprints outside the front door and on the sidewalk, they followed them as far as the bridge over the Sambre, the river which ran through the town. The mother of the painter had thrown herself into the water and, when they recovered the body, they found her nightgown wrapped around her face. It was never known whether she had covered her eyes with it so as not to see the death she had chosen, or whether she had been veiled in that way by the swirling currents.

Of his mother's death Magritte's only remembrance was, he imagined, a certain pride at being the centre of attention in a drama. It gave him a sense of his own importance and a new identity: he was the son of the 'dead woman'. But the cause of her death always remained a mystery.

After the death of his mother, his father Léopold took René and his two brothers, Paul and Raymond, to live in Charleroi. René no longer said mass, but would mumble his prayers in an excited voice, crossing himself ostentatiously at lightning speed a dozen times to upset the servants and anyone else who was present. Following his studies at primary school, he enrolled at the Athénée, the high school at Charleroi, to study humanities. He was fifteen when, on a carousel at the annual town fair, he met his future wife Georgette Berger for the first time.

Bored with his classical studies at Charleroi, Magritte obtained his father's permission in 1916 to study at the Académie des Beaux-Arts in Brussels. However, his attendance at classes was as intermittent here as at Charleroi. Toward 1918, the whole family moved to Brussels. From this period date the beginnings of Magritte's 'public' career and certain of his lifelong friendships. In 1919, he made the acquaintance of the poet Pierre Bourgeois, and together with another fellow-student, Pierre Flouquet, they published an ephemeral review called *Au Volant!* He also exhibited his first canvas at the Galerie Giroux, a work entitled *Three* 12 *Women*, reminiscent of the early Cubist paintings of Picasso.

In 1920, Magritte met E. L. T. Mesens, a Belgian poet, musician and collagist who remained his friend for many years (although they were divided by political differences after World War II). At that time, Mesens gave piano lessons to Magritte's brother Paul. A while later, Paul took up composing, but with something of the same disdain for music that his brother showed for painting. All three of them wrote Surrealist prose poems.

René and Paul were the eldest and the youngest, respectively, of the three Magritte brothers, and both were born under the same astrological sign. They shared many similarities of character, and were quite unlike their third brother Raymond, who later became a successful businessman. Paul Magritte still lives in Brussels, in relative isolation with his wife and dog, occasionally writing music or strange pseudo-dissertations whose ironic punning is suggestive of Magritte's pictures.

If the rain often succeeds in wetting man, the latter has not succeeded in wetting the rain or in causing it the least moral or material discomfort. This establishes, in irrefutable manner, the superiority of the rain.

By inventing a glue which would be able to stick water together, perhaps we shall succeed in annoying the rain or making it laugh? Huh! I doubt it, because, unfortunate worms that we are, we must submit, and how the hammer drives in the nail! Rain reigns and rusts the king's crown.

In the same year (1920), while walking in the Brussels botanical gardens with Mesens, Magritte re-encountered Georgette. With his ever-present perverse humour, he promptly fabricated a story to shock her: that he was on the way to see his mistress. He married Georgette two years later, in 1922. During this same period, he spent several unpleasant months doing military service in a camp outside Antwerp. Later, he had to support the household by painting cabbage roses in a wallpaper factory. He also designed posters and did publicity work, using his free time for painting.

During these years, Magritte was searching both for a style and for the meaning of painting. The Cubists and the
12 Futurists attracted him, and his early work was made under their influence. However, his Futurism was never orthodox, in that it was always combined with a certain eroticism, as in
14 the picture *Youth*, where the diffused figure of a nude girl hovers over the image of a boat. Magritte had his first exhibition of quasi-Cubist works in 1920, with Pierre Flouquet,

in a gallery called Le Centre d'Art. The images were of
locomotives, railroad stations and landscapes composed of
flat, linear planes. They showed the diverse and contradictory
influences of Henri Matisse, Albert Gleizes, André Lhote and
the Italian Futurists.

Magritte had providentially been given a catalogue of
Futurist paintings in 1919. Seeing those paintings for the first
time was a genuine discovery, about which he has written:

A singular accident willed that someone, probably intending to
play a joke, should send me a catalogue with illustrations from an
exhibition of Futurist paintings. Thanks to that joke, I became
familiar with a new way of painting, and, in a real intoxication, I set
about creating animated scenes of stations, festivals or cities in which
the little girl from the cemetery, whom I associated with my
discovery of painting, lived out an exceptional adventure. Un-
doubtedly, one pure and powerful sentiment, eroticism, kept me
from falling at that time into a more traditional search for formal
perfection. What I really wanted was to provoke emotional shock.

(No doubt a parallel can be drawn here with the work of
Marcel Duchamp, for whom the element of eroticism also
played a primary role.) One of the few paintings which
survive from this period is *Girl*. Already present in embryonic *13*
form is the suggestion of an idea which transcends purely
formal concerns: the sexual organ of the girl has been painted
to resemble a flower. In another picture (not illustrated) a
nude woman has been given a rose for a heart. These pictures
represent two rather unsuccessful attempts to paint in a manner
other than purely Cubist.

In 1925 Magritte founded a review called *Œsophage* with
Mesens. It appeared only once, but was followed by three
issues of *Marie*, 'a bi-monthly paper for beautiful young
people'. These two soon joined with Marcel Lecomte,
Camille Goemans (later the director of the first gallery devoted
to Surrealist painting in Paris), André Souris and Paul Nougé,
who were publishing at that time a monthly tract entitled
Correspondance. From this period dates the beginning of
Belgian Surrealism.

3 The Lost Jockey

In 1925 Magritte painted what he considered his first 'realized' picture, in that it introduced a poetic idea. This was the presence of something more than what can actually be seen – something mysterious and unknown. The painting was entitled *The Lost Jockey*, and, although the original version is not shown here, this version, which was painted in 1940, is almost identical. *The Lost Jockey* initiated the direction his future work would take. It marks a definitive abandonment of all formal investigations in favour of a specifically poetic research, unrelated to painting, to which Magritte remained committed for the rest of his life. His only really sustained effort at making collages (although he produced them sporadically throughout his lifetime) also dates from this period (1925–27), when he made about a dozen. A fine example, related to the theme of *The Lost Jockey*, still survives.

A year or two before, Magritte had seen a reproduction of *The Song of Love* by Giorgio de Chirico, which appeared in a catalogue published by the periodical *Valori Plastici*. It was another chance episode, like his discovery of the Futurists, but it had a revolutionary effect on his career. He has noted that it showed him 'the ascendancy of poetry over painting', a discovery that moved him to tears. The unexpected combination of a surgeon's rubber glove with the head of an antique statue represented for Magritte a new vision of painting, which was suddenly free of the stereotyped mental habits he considered as belonging to those artists who were 'trapped by their own talent, virtuosity, and little aesthetic specialities'. Magritte's discovery in the works of De Chirico that painting could be made to speak about something *other than painting* committed him to a pictorial experience that would put the real world on trial – not the mere picking of objects out of a mist (a phrase invented by Bernard Berenson to describe the paintings of Seurat). 'I used light blue where sky had to be represented,' Magritte wrote, 'but never represented the sky, as artists do, to have an excuse for showing one of my favourite blues next to one of my favourite greys.'

The Lost Jockey is one of the first pictures made under the *Magritte*
15–17
impact of this new discovery. In it, the jockey is situated in a
forest of trees whose trunks resemble giant balusters, similar to
those used to support a stair rail or a parapet coping. Or,
equally, they could be said to resemble turned wooden table
legs or magnified chess pieces (Magritte shared Duchamp's
passion for chess, although he never achieved the same
expertise). In his collages, he often used a similar structure, *16*
cutting the balusters out of printed music. These small pillars
are one of several virtually inexplicable but recurrent motifs
which appear consistently throughout Magritte's work;
others include enlarged jingle bells and filigree cut papers.
(All these three elements appear together in *The Annunciation*, *31*
which is highly suggestive of a Sienese religious painting.)
Max Ernst once invented a word, in the form of a verbal
collage, which might perfectly describe these objects: 'phal-
lustrade'. According to Ernst, the word phallustrade means
'an alchemical product, composed of . . . the autostrada, the
balustrade and a certain quantity of phallus'.

Obviously the baluster (or *bilboquet*, as Magritte called it)
represents, on however unconscious a level, a complex set of
thoughts interconnected by affective links, none of which can
be explained simply. Magritte's construction would appear to
have taken shape in an obscure area of consciousness, occupy-
ing an intermediary position between conscious and uncon-
scious – an element which common sense denounces as
unreal but which is psychologically true. Since it corresponds
to a state of mind, its polyvalent meanings cannot easily
be translated into words.

These uneasy presences dominate the early post-Cubist
paintings, sometimes being identified with the immobility of
a tree in contrast with the violent motion of a runaway horse
and rider (a favourite theme in Romantic painting), as in
The Lost Jockey or in *The Secret Player* – a variant in which the *19*
jockey has been replaced by two men playing a mysterious
game in a similar setting. At other times a *bilboquet* will appear
as a kind of anthropomorphic sentinel or spectator of events,
as in the various versions of *The Difficult Crossing*. In the 1926 *26*
version, the *bilboquet* has an unobtrusive eye. In the 1963 *27*
version, the eye has become much more ominous. It has
become the entire head, reminiscent of the 'all-seeing eye' in
Odilon Redon's *Vision* (1879), or even of certain lithographs
by Grandville in which the men have eyes for heads. Magritte
alluded to the shifting identities of these *bilboquets* in a passage
he wrote about a tree:

The Lost Jockey

Growing from the earth towards the sun, a tree is an image of certain happiness. To perceive this image we must be immobile like the tree. When we are moving, it is the tree which becomes the spectator. It is witness, equally, in the shape of chairs, tables and doors, to the more or less agitated spectacle of our life. The tree, having become a coffin, disappears into the earth. And when it is transformed into fire, it vanishes into the air.

As the object of a problem, the tree itself was transformed into a huge leaf whose stem was a trunk which planted its roots *30* directly into the ground, like those in *The Art of Conversation*. *28* In *Elementary Cosmogony*, a more humanized *bilboquet* holding a leaf in its hand reclines in a rocky landscape like an Ingres odalisque, while flames spout from the orifice in its head. A *33* related picture, *The Rights of Man* (which also contains a burning tuba), once again suggests the idea of a sentinel or witness. These anthropomorphic *bilboquets* are probably a throwback to De Chirico, who had depicted similar objects in various pencil drawings of 1917. They may possibly also have a spiritual affinity with De Chirico's articulated mannequins – the stuffed cloth figures with sewn seams who sometimes had accessory dramatic roles in his paintings. It has been said that De Chirico's mannequins were inspired by dressmaker's dummies; also, his brother Alberto Savinio had written a drama whose protagonist was a 'man without voice, without eyes or face', which may have been another source. Their special quality of seeming to exist somewhere between statue and flesh had certainly left its mark on Magritte, as evidenced *36, 32* in such paintings as *The Man of the Open Sea* and *The Flying* *35* *Statue*. *The Midnight Marriage* is highly suggestive of De *34* Chirico's *The Two Sisters*, in which a dummy skull is adorned with a wig. These equivocal figures were later transformed by Magritte into bowler-hatted men (see Chapter 10) whose metaphysical loneliness situates them in a silent and timeless world suggestive of certain paintings by Seurat or Piero della Francesca.

26 In the first version of *The Difficult Crossing* (1926), Magritte's whole universe is already present in embryonic form. The storm in the background is equivocal; it could be raging outside the window seen at the back, or it could be a painting on the wall. Auxiliary windows like cardboard panels lean against the wall. These diffuse and ambiguous juxtapositions of 'inside' and 'outside', and the picture-within-a-picture theme all bear the imprint of De Chirico's *Metaphysical Interiors*, but they are ideas which were continually being

The Flying Statue
La Statue volante *1958*

refined and crystallized by Magritte. Similarly, the bird and the plaster hand, the flapping curtain, the anatomical table-leg, and the *bilboquet* standing watch are all evocative elements in Magritte's future repertory; but the various objects tend rather to separate than to merge into the irrevocable affiliations he achieved later on. The turbulent sea and the suggestion of a shipwreck, like the jockey, embody a violent motion which is in some way menacing. This evokes a kind of unaccountable anxiety that is also present in the depopulated, haunting images of De Chirico. At this time, when Magritte's painting was still partly under the sway of De Chirico, he often used the same disorientating and emotive perspectives (which he later abandoned), combined with enigmatically juxtaposed objects, in order to achieve the co-existence of incomprehensible and banal reality.

In a much later variant of *The Lost Jockey*, called *The Wrath of the Gods*, an automobile is surmounted by the Lost Jockey and his horse. In another, called *The Childhood of Icarus*, the original elements of the jockey and the *bilboquet* are still present, and the diffusion of 'inside' and 'outside' – which can be traced back to the cruder cut-out windows leaning against the walls in *The Difficult Crossing* – has been added. The jockey is now inside a huge room, where images of the sky and a house are stacked against the wall.

Magritte had also applied himself more directly to the problem of the horse, about which he has written:

The first idea glimpsed was that of the ultimate solution, however vaguely perceived. It was the idea of a horse carrying three shapeless masses, whose significance I did not understand until after a series of multiple steps and experiments. First I painted an object consisting of a jar and a label bearing the image of a horse with the printed inscription: HORSE PRESERVE. Then I thought of a horse whose head was replaced by a hand; the index finger pointed the direction 'Forward'. But I realized that this was merely the equivalent of a unicorn.

I hesitated for a long time over an intriguing effect: in a dark room I placed a horsewoman seated near a table, leaning her head on her hand and looking dreamily at a landscape which was defined by the silhouette of a horse. The lower part of the animal's body and its four paws were the colour of earth, while, from a horizontal line situated at the level of the horsewoman's eyes, the horse's coat was the colour of the sky. Finally, what put me on the right track was a horseman in the position he assumes while riding a galloping horse; from the sleeve of his arm which was thrust forward emerged the head of a racing charger, and the other arm, behind, held a riding whip.

24

20
18

26

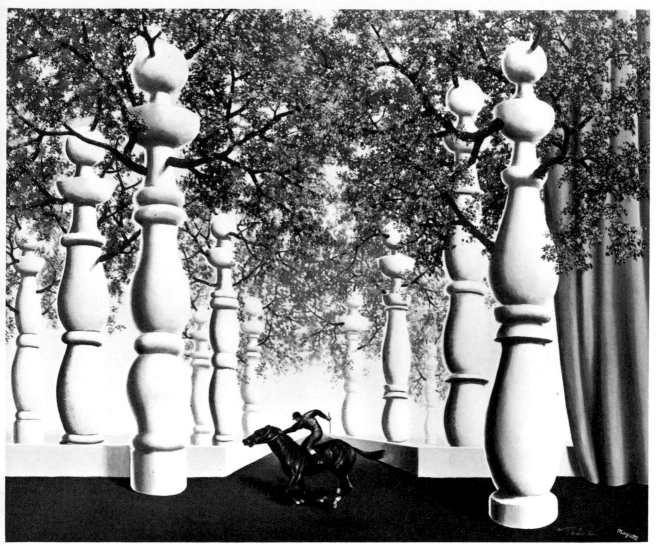

5 The Lost Jockey · *Le jockey perdu* 1940

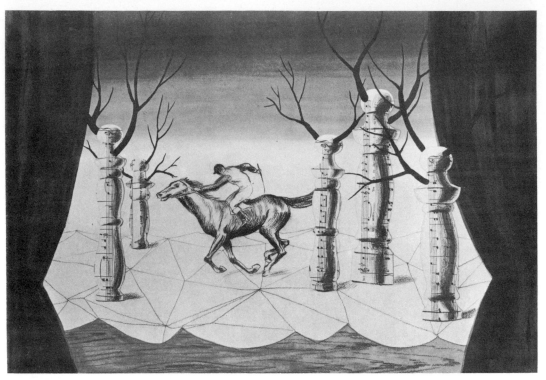

16 The Lost Jockey · *Le jockey perdu* 1926

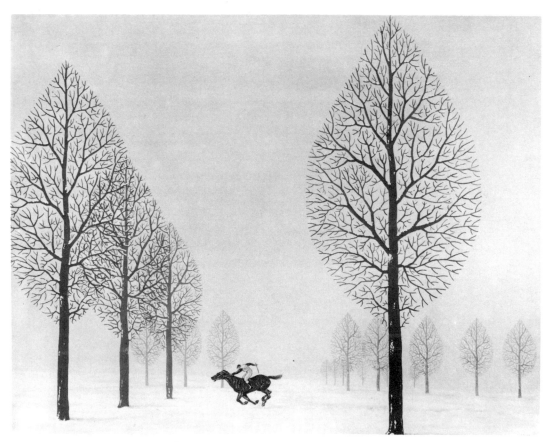

17 The Lost Jockey · *Le Jockey perdu* 1942

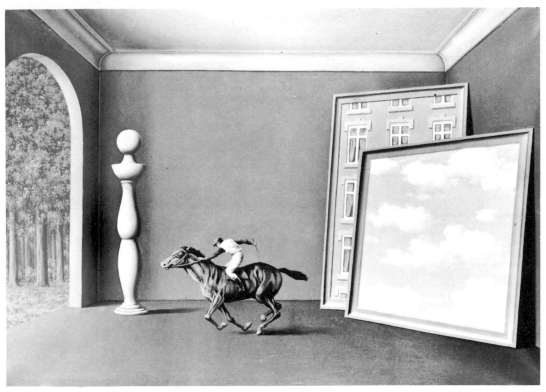

18 The Childhood of Icarus · *L'enfance d'Icare* 1960

19 The Secret Player · *Le joueur secret* 1926

20 The Wrath of the Gods · *La colère des dieux* 1960

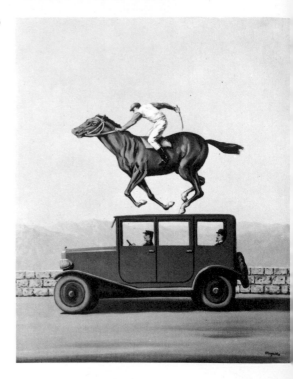

21 The Secret Agent · *L'agent secret* 1958

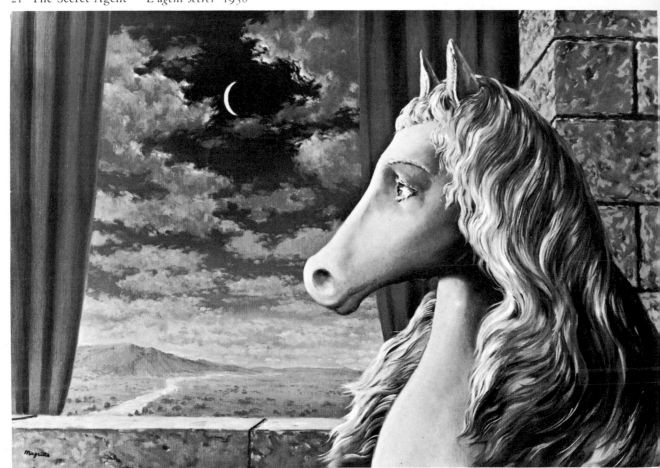

22 Carte Blanche · *Le blanc-seing* 1965

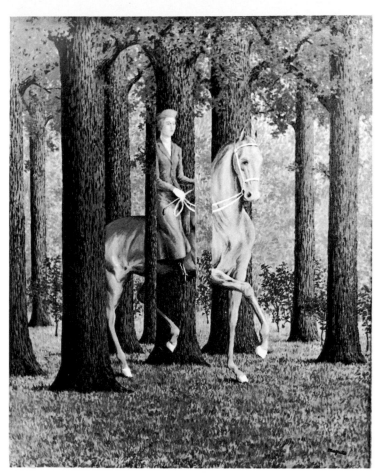

23 The Endless Chain · *La chaîne sans fin* c. 1939

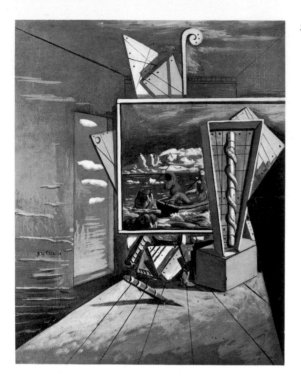

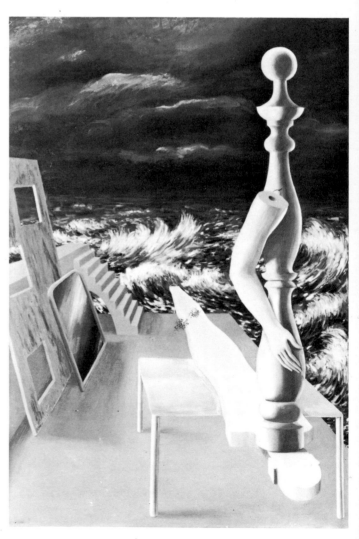

25 The Birth of the Idol
La naissance de l'idole 1926

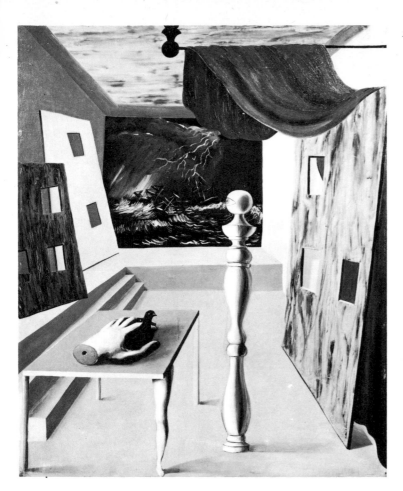

26 The Difficult Crossing
La traversée difficile 1926

27 The Difficult Crossing
La traversée difficile 1963

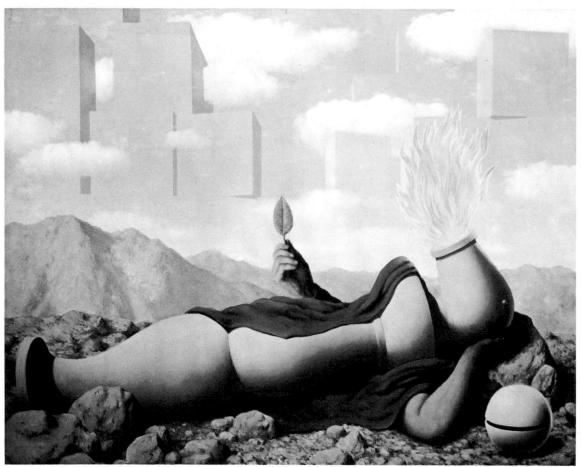

28 Elementary Cosmogony
Cosmogonie élémentaire 1949

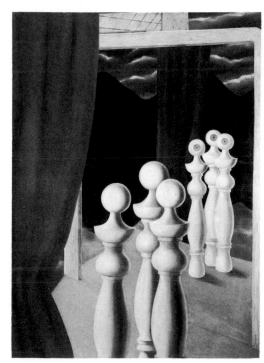

29 The Encounter · *La rencontre* 1929

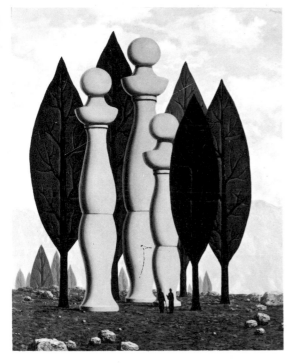

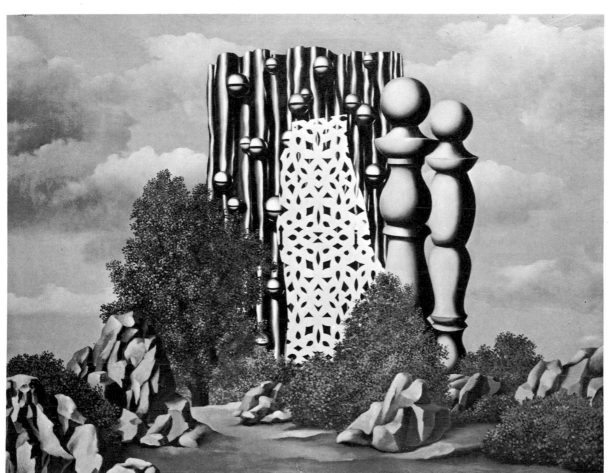

31 The Annunciation · *L'annonciation* 1929

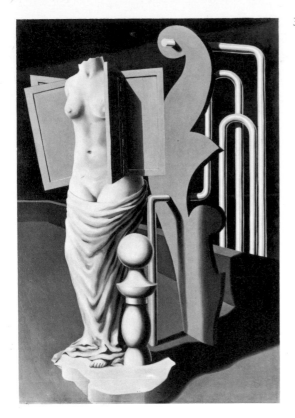

32 The Flying Statue · *La statue volante* 1927

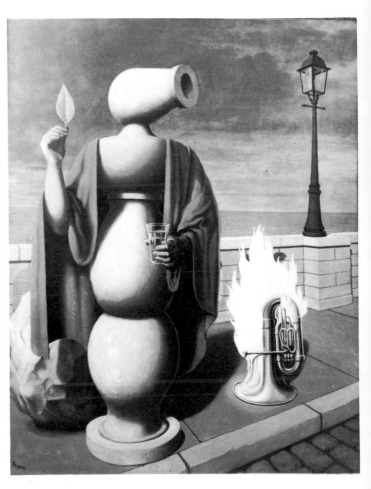

33 The Rights of Man · *Les droits de l'homme* 1947

34 GIORGIO DE CHIRICO The Two Sisters 1915

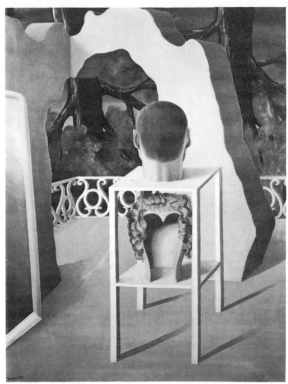

35 The Midnight Marriage
Le mariage de minuit 1926

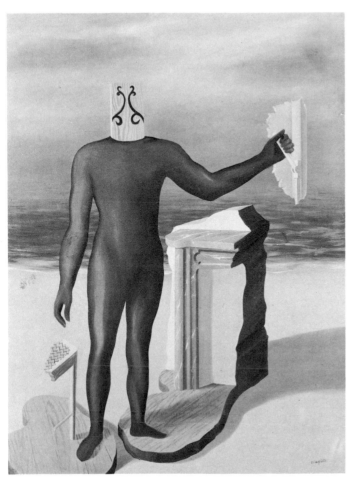

36 The Man of the Open Sea
L'homme du large 1926

37 GIORGIO DE CHIRICO Song of love *c.* 1913–14

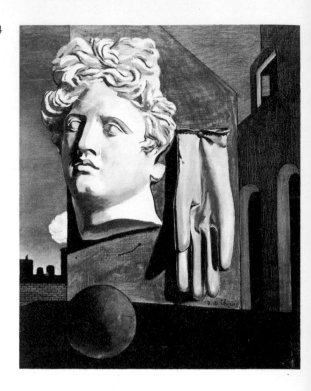

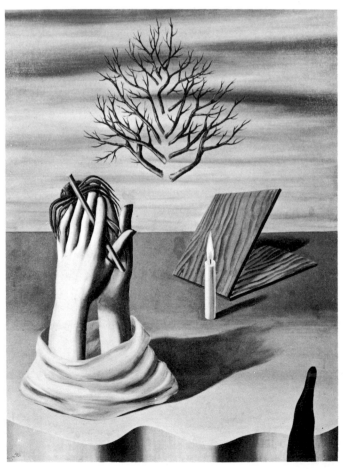

38 Dawn at Cayenne · *L'aube à Cayenne* 1926

Beside the horseman, I placed an American Indian in the same position, and I suddenly divined the meaning of the three shapeless masses that I had placed on the horse at the beginning of my investigation.

23 I knew they were horsemen and thus I settled on *The Endless Chain*. In an atmosphere of desert land and dark sky, a plunging horse is ridden by a modern horseman, a knight of the dying Middle Ages and a horseman of antiquity.

22 In 1965 the Lost Jockey reappeared as a woman dressed in formal riding habit astride a horse in *Carte Blanche*. The painting is curiously reminiscent of Corot's equestrian portrait in a woodland setting, *Monsieur Pivot on Horseback*, which is in the National Gallery in London. However, we are witness

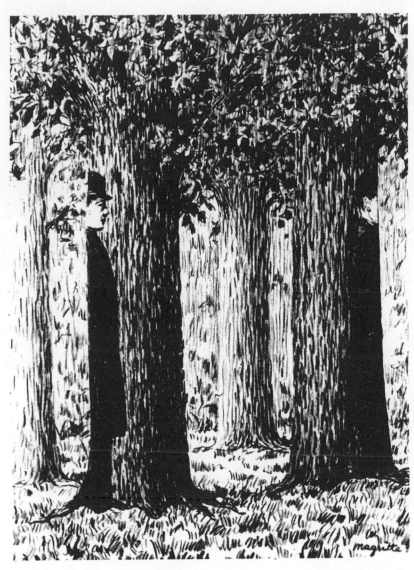

to one of Magritte's cunning dislocations, since the horse has been segmented and the fragments ambiguously placed, so that it seems to be in front of, as well as behind, the trees (or neither). On close scrutiny, the horsewoman would seem to be merely painted on the trunk of the tree. We are thrust into a conflict between reality and illusion – a problem which fascinated Magritte. Perhaps he is asking whether or not the external world really exists.

Magritte

During this first important period of the late 1920s, Magritte was overwhelmed with the premonitory stirrings of so many ideas that he used the quickest possible means to expedite the torrent of new images. In fact, virtually all the component elements, sub-images and pilot themes of his future work appeared in some form at this time. He managed to paint nearly one painting a day, and in 1927 had his first one-man show at the Galerie Le Centaure in Brussels. Among the pictures exhibited were *The Lost Jockey* (original version), *The Difficult Crossing*, *The Signs of Evening*, *The Threatened Assassin*, *Dawn at Cayenne*, *The Flying Statue* and *The Birth of the Idol*, plus about one dozen collages. The show had little success, but as he was now financially supported by the owner of the gallery, P. G. van Hecke, he was able to devote himself entirely to painting.

15
26, 65, 39
38, 32, 25

It was during this time that Magritte made contact with other Belgian Surrealists like Paul Nougé, Camille Goemans, Marcel Lecomte and Louis Scutenaire. In 1926 Scutenaire had sent some 'automatic' poems, written in a state of deliberate suspension of conscious control, to Goemans and Nougé, whom he did not know at the time. Nougé, suspecting a trick of some kind, went to Scutenaire's address to investigate, and they at once made friends. A few days later, Nougé introduced Scutenaire to Magritte and to the others in a café near the Bourse.

Not long afterwards, Magritte left Brussels to join the Surrealist milieu in Paris. In August 1927 he settled in Perreux-sur-Marne, a suburb just outside the city, associating chiefly with André Breton and Paul Eluard. At that time the Surrealists under Breton were fanatical activists, and many of them were politically involved on the extreme Left. Moreover, they were continually subject to a constant inner ferment which impelled them to issue violent denunciations and condemnations of each other. Magritte himself avoided all political affiliations, with the exception of a short-lived and nominal membership in the Belgian Communist Party in 1945. The French Surrealists joined the Communist Party to give meaning to

their protest – they saw socialist revolution as being more effective than anarchism as a means for changing the fabric of society. The Belgians, however, like Nougé and Goemans, never followed suit.

The heroic period of Surrealism was between 1924 and 1929, between the first and second Surrealist manifestos of Breton. This was the heyday of the music halls and *jazz-bandettes*, the tango, Josephine Baker and the charleston. It was the Paris of vamps and 'pataphysics and *Le Bœuf sur le toit*, Charlie Chaplin and Rudolph Valentino, and especially of *Fantômas*, the extraordinary thriller series which made its first appearance in novel form in 1913, was later produced in the cinema, and then became wildly popular in Paris during the mid-1920s. Indeed, the character of Fantômas was actively taken up by the Surrealists as one of their major heroes.

After his initial contact with the Surrealists, Magritte never faltered again over the question of what to paint, nor were the means of expression any longer a problem. The majority of works from this so-called 'first' period, spanning approximately the years 1925–30 – which Magritte himself has called 'Cavernous' – are melodramatic, bizarre and often macabre scenes (still tinged with eroticism) that are generally dark in both mood and colour. The whole climate of what might be called *l'époque de Fantômas* is characterized by synthetic horror and a brazen black humour, partly attributable to the influence of silent films and detective novels. Mysterious events occur in a shallow space, like that of a stage play or *tableau vivant*, which soon replaces the uneasy perspectives of the earlier, Chirico-derived pictures. Images like *Gigantic Days* – which suggests a violent assault or a Kafkaesque metamorphosis of the woman into a man – or the slightly earlier picture called *Pleasure* in which an archetypal Alice-in-Wonderland figure is devouring a live bird, call to mind, even more than scenes from *Fantômas*, both the visions of gratuitous atrocity in Lautréamont's *Les Chants de Maldoror* and the hallucinatory poetics of Max Ernst's early collages. I shall need to deal with all of these 'sources' in turn; however, I do not propose that any of them were ever explicitly used by Magritte (with the exception of the *Fantômas* cover that he appropriated for *The Backfire*). Magritte from the beginning pursued his own ends; but, when considered as sources, these do shed an interesting light on the climate of his imagination.

47

45

41

40

Both Ernst and Magritte, and virtually all the Surrealists, were influenced in some way by the writings of Lautréamont. In 1938, an edition of his *Œuvres complètes* was pub-

Illustration for Les Chants de Maldoror

lished in Paris by G.L.M., with illustrations by many of the Surrealists and with an introduction by Breton, to which Magritte contributed a drawing called *The Rape*. Ten years later an edition with seventy-seven illustrations entirely by Magritte was published in Brussels.[4]

The Comte de Lautréamont was the pen-name of Isidore Ducasse, who was born in 1846, the son of a minor official in the French consulate in Montevideo, Uruguay, and died at the age of 24. His novel-length prose-poem *Les Chants de Maldoror* has been called a 'phenomenology of aggression', and it became a kind of Bible for the Surrealists. They likened it to the 'song of an octopus riding the waves'; beside it they considered everything else 'insipid and contrived'.

The images in *Maldoror* are of an involuntary and fundamental absurdity, as Lionel Abel (who wrote the first important essay on it in America) has pointed out. They express the impact on language of something intractable, 'something that has not really yielded to it, something bleak, evasive, menacing – the darkness of the human mind, evil, if you will'.[5] This special quality of absurdity in Lautréamont arises partly from the way in which he artificially linked objects that appeared to have no previous connection with each other – exemplified by his now-famous phrase 'as beautiful as . . . the fortuitous encounter upon an operating-table of a sewing machine and an umbrella'. This quality, along with a similar enigmatic linking of objects in De Chirico, became one of the focal points of Surrealism. In fact, the whole technique of Surrealist collage, especially as it was practised by Ernst, was a logical extension of this Ducassian theory of the image, whereby an image is born, not of a comparison, but through the bringing together by chance of two more or less remote realities. Ernst has acknowledged his debt to Lautréamont in *Au-delà de la peinture*:

A ready-made reality, whose naive destiny would seem to have been fixed once and for all (an umbrella), finding itself in the presence of another reality which is very remote from it and no less absurd (a sewing machine), in a place where both of them must feel disorientated (on an operating table), will escape by this very fact from its own naive destiny and from its identity; and will pass from a false absolute, by detour of the relative, to a new absolute which is true and poetic.[6]

If its connections with the rest of the world have been broken in some brutal or insidious way, an object will become separated from the field in which it normally functions. And

once removed from its habitual field, it will collaborate with unforeseen elements. When objects are isolated in this way, both from their usual surroundings and from their recognized function or role, a certain ambiguity is produced, and an irrational element is introduced on the plane of concrete reality. The resulting image thus escapes from the principles of reality, but without having lost its reality on the physical plane. This principle, discovered in *Maldoror* and in the early paintings of De Chirico, was then taken up by Magritte and by certain other Surrealists, who used it as a means of provoking shock or surprise. The Surrealists' assault upon our expectations can be traced in part to the figure of Maldoror, who derived his inspiration entirely from 'exceptions in the physical and moral order'.

For Lautréamont, as for Breton much later, beauty was not conveyed so much by tranquillity as by an apocalyptic fusion of the terrible and the sublime which would render it 'convulsive'. Maldoror is a kind of infernal machine, incarnating a mixture of divine blood with repressed sexual desires and sadistic impulses. He is filled with rages and anxieties, and even persecutes God with his threatening games. He inflicts gratuitous suffering without suffering himself; he contradicts all laws, both human and divine. The poetic inspiration in Lautréamont derives specifically from the rupture between imagination and good sense: cruelty develops in the context of peace; physical and biological nature are perverted; natural laws are transgressed. Everything is in perpetual mutation, somewhere between animal and human life. Moreover, the enigmatic images resist interpretation. Breton has described how 'this work ... which is the actual place of all mental interference, inflicts a tropical climate on the sensibility'. This is partly due to the intensity of instinctual feeling, as well as to the constant metamorphoses of the hero Maldoror, who will sometimes appear as a monster, or with the face of a hyena, or will even become an eagle or a crab or a shark. (Gaston Bachelard once counted 435 references to animal life and 185 different animals named in the book.) In addition, there is in *Maldoror* a rich iconography of vegetalization and petrification, episodes of somnambulism, inertia and mummification, atrocious scenes of amputation, decapitation, and dislocation and fragmentation of living flesh. There are also recurrent visions of amphibious creatures and riders on horseback who fill the air with the accelerated motion of frenzied flight or pursuit. All this suggests extensive analogies with Magritte's imagery.

Magritte

Illustrations for Les Chants de Maldoror

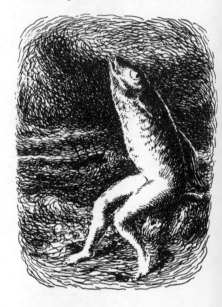

46

The special power of Maldoror was that he could take on any disguise. In this he was like Fantômas, who would sometimes assume the appearance of a well-known figure, or appear as two different people at the same time. But, exactly who and what he was was impossible to say, since he was everywhere and nowhere. Maldoror possessed

. . . a special faculty for taking on shapes unrecognizable by expert eyes. Superior disguises. . . . He knew that the police, that shield of civilization, had been looking for him perseveringly for a number of years, and that a veritable army of agents and spies were eternally on his trail. Without, however, succeeding in finding him.

The identity of Maldoror mystified everyone, because he had no substantial reality. His identity was constantly changing, and he often exchanged his personality with the narrator (see Magritte's illustrations). Moreover, he was exempt from the normal contingencies of time and space:

Today he is in Madrid, tomorrow he will be in St Petersburg; yesterday he was in Peking. . . . This bandit is perhaps seven hundred leagues away from this country; perhaps he is a few steps away from you. . . . Mesmerizing the flourishing capitals with a pernicious fluid, he reduces them to a state of lethargy in which they are not able to look out for themselves as they should: a state the more dangerous as it is unsuspected.

Maldoror has much in common with Fantômas, the other evil genius of crime, whom the Surrealists also made their hero. Fantômas would almost seem to be a popularized Maldoror, made more accessible to a general public. However, it is unlikely that the authors of *Fantômas* had ever encountered the works of Lautréamont when they began writing their series in 1912. There is no real likelihood that Maldoror served as a model for Fantômas, which makes the spiritual kinship even more curious, therefore, in the later light of Surrealism.

42 Louis Feuillade's *Fantômas* was Apollinaire's favourite film. Like Maldoror, Fantômas revelled in the delights of cruelty and human treachery; he was the perfect criminal who never
41 got caught. The thirty-two volumes which comprise the written series were actually composed by two authors, Pierre Souvestre and Marcel Allain, at the rate of one volume per month until 1914, when they were interrupted by the First World War and by the death of Souvestre. The novels had been a joint enterprise until then, with each author writing alternate chapters. There was a secret code which

indicated who had done the writing: Souvestre's chapters carry the word *néanmoins* on the first page, and Allain's the word *toutefois*. (Both mean 'nevertheless'.)

Fantômas was no ordinary hero. Like Maldoror, he operated to reverse human values. In more conventional thrillers, the hero is always the detective who triumphantly restores law and order. But Fantômas, far from being the detective, was a diabolical criminal who constantly brewed misfortune and never got caught. Like Maldoror, Fantômas was a genius of evil – a devil who could enter through any keyhole and commit lurid and brilliant crimes without leaving a trace. Crime was a sport at which he excelled. He was continually refining the rules of human treachery, constantly seeking to surpass his own record and to invent some even more daring atrocity with which to petrify the mob. (Parallels could be drawn here with the anarchic and destructive activities of the Surrealists, and their continued efforts to mystify society. The Surrealists' recourse to scandal, and their deliberate acts of defiance against conformism and the bourgeois system in general, were ways of seeking out the queer unsupervised roads along which the mind might escape from its captivity.)

The Surrealists admired Fantômas because he could outwit the forces of the law. Even if the police managed to seize him and get him convicted, he always escaped at the last moment, substituting some imbecile who would take his place on the guillotine. Magritte has written his own description of Juve (the famous inspector of the Sûreté who had succeeded in capturing many dangerous criminals, and was also an expert at disguising himself) in pursuit of Fantômas:

A THEATRICAL EVENT. Juve has been on the trail of Fantômas for quite some time. He crawls along the broken cobblestones of a mysterious passage. To guide himself he gropes along the walls with his fingers. Suddenly, a whiff of hot air hits him in the face. He comes nearer.... His eyes adjust to the darkness. Juve distinguishes a door with loose boards a few feet in front of him. He undoes his overcoat in order to wrap it round his left arm, and gets his revolver ready. As soon as he has cleared the door, Juve realizes that his precautions were unnecessary: Fantômas is close by, sleeping deeply. In a matter of seconds Juve has tied up the sleeper. Fantômas continues to dream – of his disguises, perhaps, as usual. Juve, in the highest of spirits, pronounces some regrettable words. They cause the prisoner to start. He wakes up, and once awake, Fantômas is no longer Juve's captive.

Juve has failed again this time. One means remains for him to achieve his end: Juve will have to get into one of Fantômas's dreams – he will try to take part as one of its characters.[7]

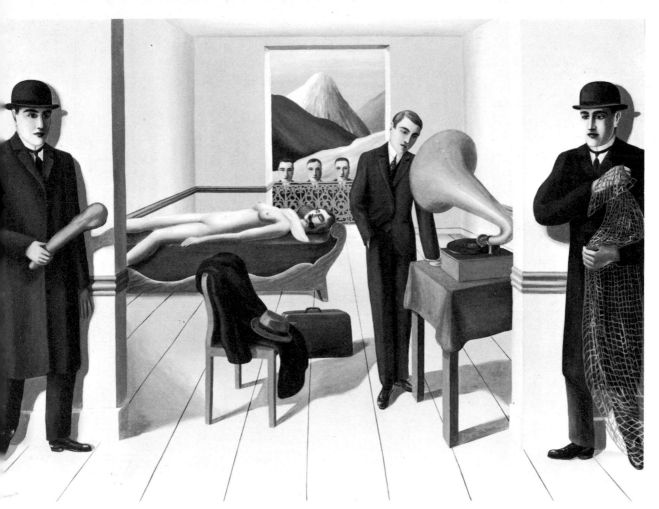

9 The Threatened Assassin · *L'assassin menacé* 1926–27

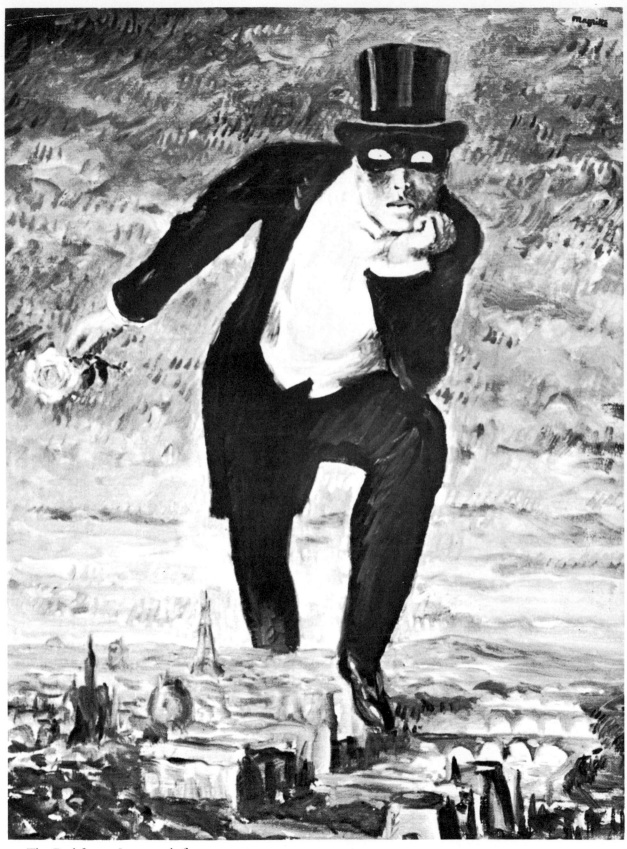

40 The Backfire · *Le retour de flamme* 1943

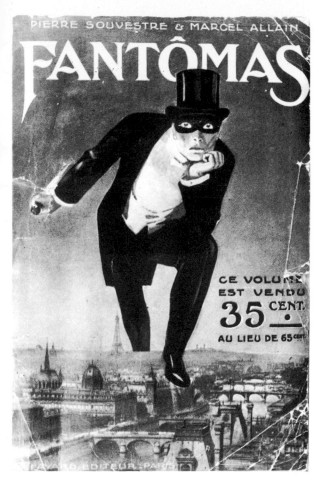

41 *Fantômas* · Book cover 1912

42 *Fantômas* · Still from film serial 1913-14

43 Magritte in 1938 beside The Savage · *Le barbare c.* 1928

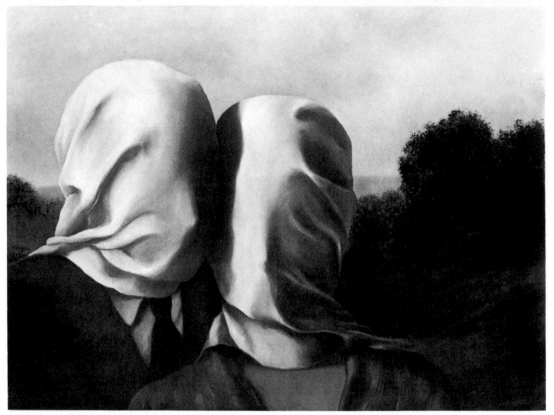

44 The Lovers · *Les amants* 1928

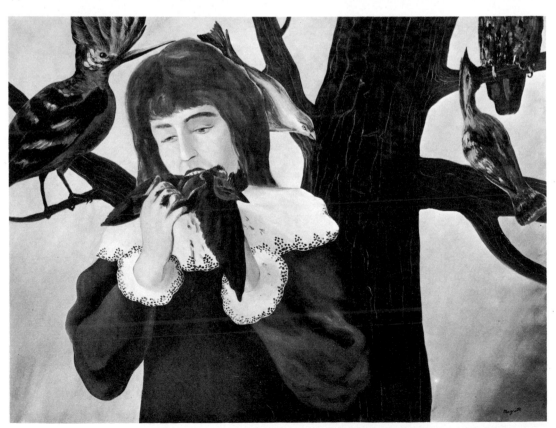

45 Pleasure · *Le plaisir* 1926

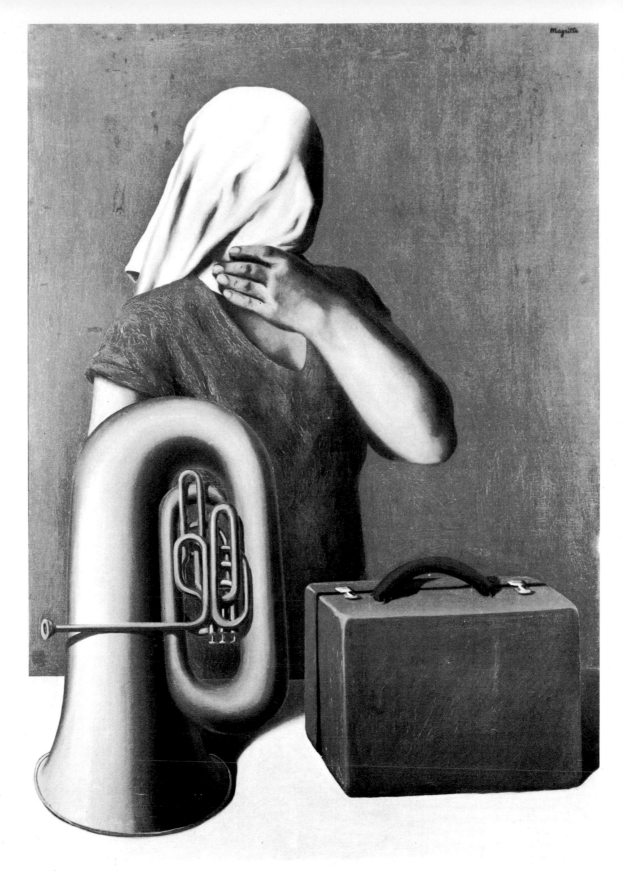

46 The Heart of the Matter · *L'histoire centrale* 1928

47 Gigantic Days · *Les jours gigantesques* 1928

48 The Voice of Silence
La voix du silence 1928

49 Man Reading a Newspaper
L'homme au journal 1927-28

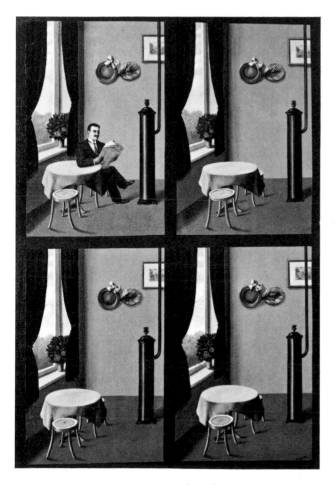

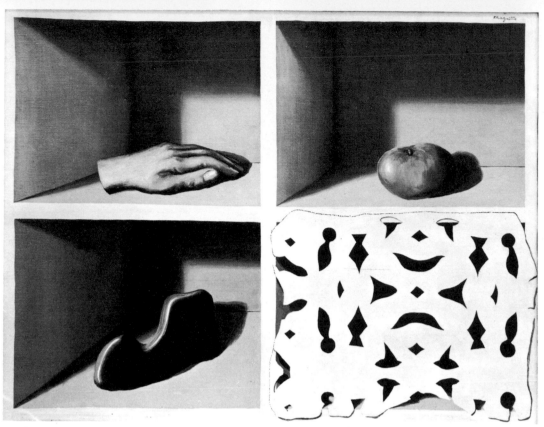

50 A Night's Museum · *Le musée d'une nuit* 1927

51 The End of Contemplation · *La fin des contemplations* 1927

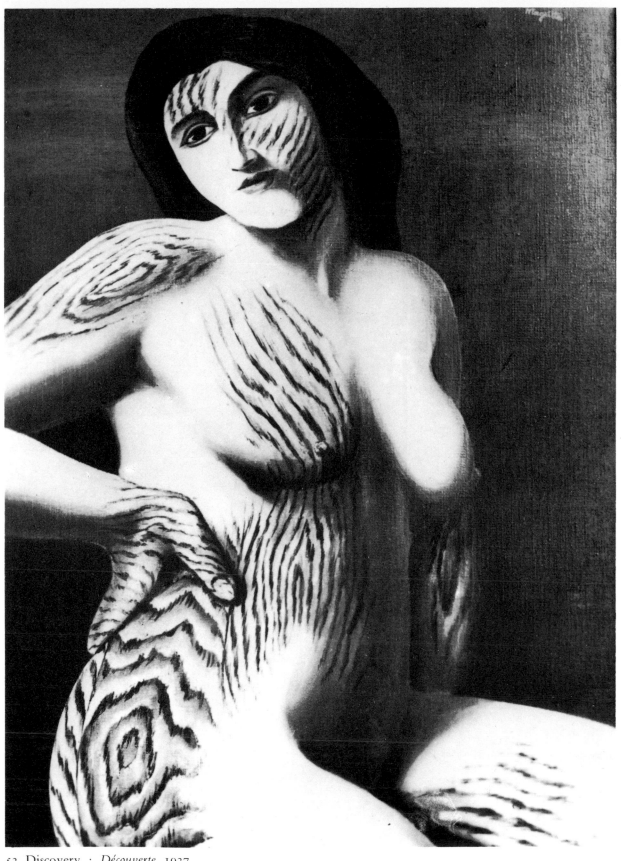

52 Discovery · *Découverte* 1927

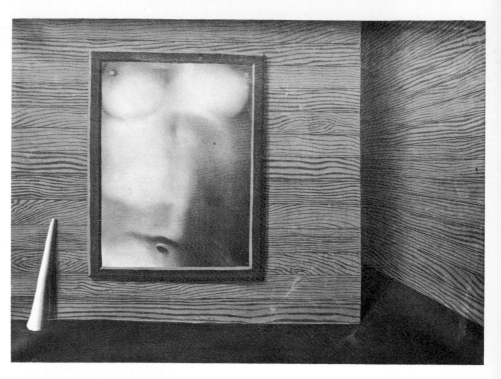

53 A Courtesan's Palace
Le palais d'une courtisane
1928–29

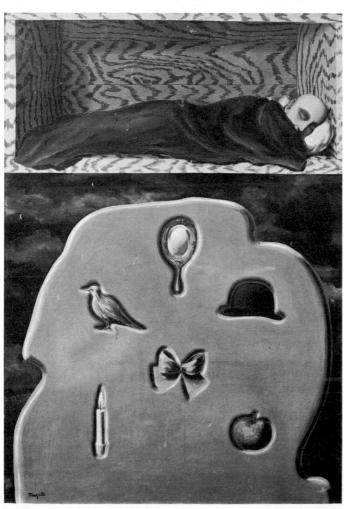

54 The Reckless Sleeper · *Le dormeur téméraire* 1927

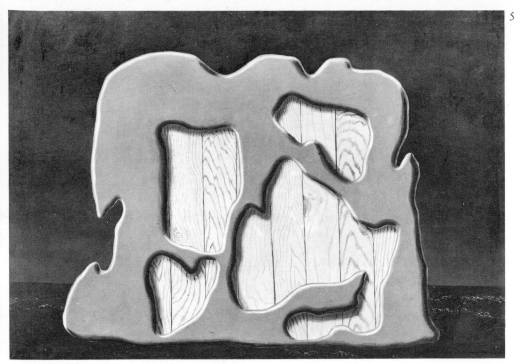

55 The Imp of the Perverse
Le démon de la perversité
1928

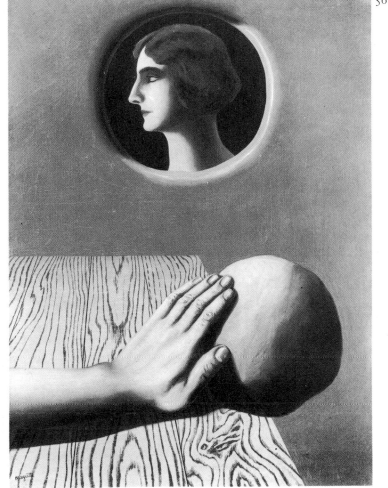

56 The Salutary Promise
La promesse salutaire 1927

57 MAX ERNST The Habit of Leaves 1925

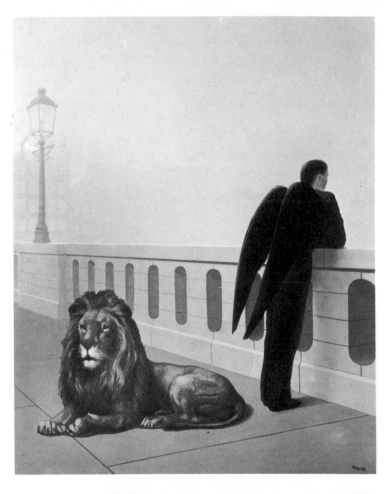

59 MAX ERNST Collage from 'Dragon Court', *Une semaine de bonté* 1934

60 MAX ERNST Collage from 'The Lion of Belfort', *Une semaine de bonté* 1934

This was written a year or two after *The Threatened Assassin* was painted – a scene which certainly seems to suggest some melodramatic episode from *Fantômas*. The invaders, presumably detectives, await their moment outside the room. They are two virtually identical bowler-hatted men, except that one is carrying a club in the form of a human limb, and the other a net. Inside the room a lurid female corpse is sprawled on the bed, and a somewhat equivocal man stands listening to a record on the gramophone. His hat and coat on a nearby chair, and a valise on the floor, suggest the possibility of disguise or escape. Three men observe the scene from outside a window at the far side of the room. It all has the character of one of those psychological games in which one is supposed to make up one's own story from the image.

46 An equally strange painting from the same period is *The Heart of the Matter*, consisting of only three elements: a tuba, a valise, and a woman whose face is covered with a cloth. This *44* spectral image recurs in *The Lovers*, where the heads of the lovers are covered in a like manner. There could be two possible sources in Magritte's imagination for this image: *42* certain fugitive but striking impressions of Fantômas in films disguised with a cloth or stocking over his head or, more likely, the unconscious memory of his mother, who drowned with her nightgown wrapped round her face.

In any case, it is clear that Magritte was fascinated by the character of Fantômas. One of the rare cases in which he made *40* direct use of a source was in *The Backfire*, painted much later *41* on. It is an almost literal transposition from a cover of one of the novels, except that a rose has been substituted by Magritte *43* for the dagger in Fantômas's hand. *The Savage* suggests the ability of Fantômas to pass unseen through matter: he suddenly materializes through a brick wall. Magritte has written about Fantômas:

He is never entirely invisible. One can see his portrait through his face. . . . When memories pursue him he follows his arm, which drags him away. His movements are those of an automaton; he brushes aside any furniture or walls which are in his way. . . . Fantômas's science is more valuable than his language. We do not guess, and we cannot doubt, his powers.

Given the Surrealists' interest in the unconscious as a source of creative activity and as a repository of evil and dangerous tendencies in man, it was quite natural for them to choose as heroes two malefactors so brilliantly skilled in destruction.

Fantômas and Maldoror were renegades whose spiritual and moral blasphemy was extreme. Maldoror, especially, embodied those radical and elementary instinctual forces which are normally strictly repressed by society, and which had been elucidated by Freud. The Surrealists continually exalted the spirit of perversity in man; it was no accident that Magritte entitled one of his paintings *The Imp of the Perverse*, after Poe's story (which had been translated into French by Breton under the title *Le Démon de la perversité*). The predisposition to do wrong for wrong's sake is a universal human tendency that Poe, for one, found difficult to explain. In Maldoror this same destructive perversity is personified and lived out in gratuitous acts of atrocity; what would seem to be an inherent tendency of the mind towards depravity purges itself through contact with reality. Perversity is an innate and primitive principle of human behaviour which, according to Poe, is both paradoxical and irresistible. It is the tendency in man to persist in acts just because he should not persist in them. This pure perversity, which would seem to have no intelligible principle or rational explanation behind it, was the inspiration for much Surrealist activity.

Underlying the Surrealists' commitment to the irrational and the absurd was an intention to destroy the Western dualistic view of good and evil. Equally, they sought to destroy the existing dichotomy between reason and madness, sleep and waking, seriousness and humour. In fact, this paradox of the denial of opposites (or the necessary union of contradictions) is the dialectical key to Surrealism. 'There is a certain point for the mind,' Breton wrote, 'from which life and death, the real and the imaginary, the past and the future, the communicable and the incommunicable, the high and the low, cease to be perceived as contradictions.' The attempt to fuse these dichotomies – to destroy any division between the crude and the sublime – marks most Surrealist enterprises. It also accounts for their delight in black humour, a tradition that has been explored more by writers than by painters, with the possible exception of Magritte.

The influence of the cinema was evident at this time in Magritte's work in still another sense: his use of multiple images, which in a painting called *Man Reading a Newspaper*, for example, distinctly suggests the frames of a motion picture film. (The narrative scheme of non-event would now suggest a film by Andy Warhol.) The image of a man reading a newspaper in the first frame (who is absent from the next three) was cribbed from an engraving in a popular health

manual; it was probably chosen by Magritte because of its reference to a painting he especially liked, André Derain's *Man Reading a Newspaper*. Compartmentalized images had

50

also appeared in a slightly different form in *A Night's Museum*, where objects are shown in a grid of three-sided boxes.

49

Moreover, the use of repeated images in paintings like *Man*

51

Reading a Newspaper and *The End of Contemplation* seems to foreshadow Warhol's serial imagery. Another of Magritte's attitudes which in a sense anticipated Warhol was his disdain for the unique work of art. Since it was only the idea which counted for him, he often said that a reproduction would serve as well to communicate his intention as the original painting. On the other hand, he showed little enthusiasm for printmaking, since he felt it placed too great an emphasis on technical knowledge and mechanical processes.

Besides De Chirico, the one artist whose work Magritte admired was Max Ernst (in his early works), although he himself did not share Ernst's taste for experimental techniques and for 'professional' discoveries. For Magritte, Ernst's first collages – those he made from old magazine engravings as illustrations for Paul Eluard's *Répétitions* and *Les Malheurs des immortels* – had shown that everything which gave traditional painting its prestige could be abandoned. Ernst had created a new kind of image, emancipated from the function of illustration, which operated outside the conventions of representational painting. Later, in 1926, Ernst published *Histoire Naturelle*, with images based on *frottage*, a technique which he had invented. Referring to 'the suggestive powers of simulated mahogany' by which he was overcome while contemplating the floor of a hotel room he once stayed in in Brittany, Ernst has described how as a result of this experience he invented *frottage* in 1925 by making a rubbing of the floorboards. By this somewhat mechanical method, he was able to extract poetic visions from physical reality. (It is commonly known that Leonardo da Vinci advised young painters to study the cracks in old walls for inspiration, instead of making sketches.)

For Magritte, such a technique could play only an episodic role: 'Materials which have been manipulated by a painter,' according to him, 'do not acquire any significant new quality as a result.' Nevertheless, it is interesting that by chance, Magritte also had a similar 'intolerable meditation' in a bar in Brussels, in the same year, 1925. 'The mouldings of a door', he has written, 'seemed to me to be endowed with a mysterious existence, and for a long time I was in touch with their

63

reality.' (Materials, according to Baudelaire, speak a mute language, like flowers, skies, sunsets. Furniture appears to dream; it might be said that it is endowed with a somnambulist life, like the vegetable and the mineral.)

The texture of simulated mahogany features prominently in a number of Magritte's works of that period. In *The Imp of the Perverse* an unnameable and resistant object is pictured in the form of an abstract and perforated relief reminiscent of Arp's biomorphic shapes. Through it one sees a recessed plywood panel. In *The Reckless Sleeper*, an inventory of familiar objects is imbedded in a similar low-relief, while above a mummified man sleeps inside a coffin-like plywood box. In *A Courtesan's Palace*, a section of a nude female torso is either reflected in, or painted on, a panel hung in a plywood corridor. In *Discovery*, the nude woman's skin is slowly changing into the texture of wood.

Intellectually the aims of Magritte and Ernst were dissimilar in many respects, and there exists no basis for an assumption that either ever consciously influenced the other. Yet a curious overlapping of iconography occurred between them which persisted well into the 1930s. Ernst was exhibiting his work in Paris at that time, but the two did not actually meet very often. Nevertheless, they shared a preoccupation with the frontier of the animate and the inanimate, and both made hybrid figures that combined the animal and the vegetable, or the anatomical and the botanical. Magritte's leaf-birds, for instance, a theme he evolved at length in the 1940s, bear an affinity to certain of Ernst's *frottages* and to Ernst's painting *Nature at Dawn*, made in 1936. *The Habit of Leaves*, a *frottage* by Ernst in which the rubbing of a single leaf is set on the horizon like a tree (or a feather), recalls Magritte's tree in the shape of a leaf, as in *The Art of Conversation*.

The more erotic and melodramatic images, on the other hand, like *Gigantic Days* and *The Heart of the Matter*, from the same period as the 'plywood' pictures, have a spiritual affinity with the collage-novels of Max Ernst: *La femme 100 têtes*, published in Paris in 1929, *Rêve d'une petite fille qui voulut entrer au Carmel* (1930), and *Une semaine de bonté* (1934). Also, the picture-within-a-picture theme explored by De Chirico in his *Metaphysical Interiors* and by Magritte in such pictures as *A Courtesan's Palace* and *The Childhood of Icarus* is a strong sub-element in *Une semaine de bonté*. The Icarus-figure meditating on the bridge in Magritte's *Homesickness* resembles the winged man in *Une semaine de bonté*, while the seated lion resembles Ernst's Lion of Belfort. These resemblances, how-

55

54

53

52

102

57

104

47, 46

24
53, 18

58
59
60

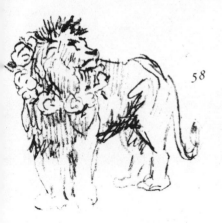

58

Lion with Flowers Lion fleuri *1962*

107

ever, are no more than 'pure coincidence', according to Scutenaire, who assures me that all efforts to establish points of departure for Magritte's work, or to relate it to other painting, are not only conjecture, but superfluous and even misguided as well. Scutenaire suggests further that if it is necessary to seek out a 'source' for *Homesickness*, it would be more likely that the lion was taken from the Belgian national coat-of-arms, or from a lion which was pictured on pre-war coins worth two centimes that were in circulation during 1914–18. As for the title of 'the painting with the lion and the bird-man', Magritte himself wrote at the time he was making it: 'I am hesitating between two titles: (1) *The Spleen of Paris or Philadelphia* (this is a complete title) and (2) *Pea Soup*.' Ultimately, he called the painting *Le mal du pays*, or *Home-sickness*, and he added elsewhere that 'a good title for a painting or a magazine – if one were so disposed – would be *La Ménopause*'. In fact, *Homesickness* was painted in 1941, during the German occupation of Belgium; the evocation of the Belgian coat-of-arms and the winged man nostalgically contemplating his freedom all suggest the reality of the moment when it was painted. An identical lion, complete with upturned forepaw, reappears in a later painting called *Remembrance of a Journey*.

Magritte's relations with the Surrealists were, at best, sporadic. Ultimately, he became repulsed both by the artificiality of some of their methods, and by the idea of premeditated dreams, drugs and magic. It is not surprising, therefore, that he left Paris after only three years, and returned to live in Brussels. The gallery run by Goemans which had been supporting him in Paris had been forced to close after the 1929 crash; but the pretext for his departure in 1930 was an altercation he had with Breton. Magritte had taken to badgering Breton, who was a fanatical anti-Catholic, on questions of religion. On the evening in question, Georgette appeared at one of the regular Surrealist meetings wearing a gold cross which she had inherited from her grandmother. Without actually naming Georgette, Breton remarked that it was bad taste to wear religious emblems. Magritte became angry, muttered a retort to Breton, and took Georgette out of the room. They never returned, although Aragon tried to patch things up. Shortly afterward, the Magrittes left for Brussels, where they soon made new friends among the Surrealists there: Paul Colinet, Marcel Marien, Achille Chavée, Raoul Ubac and Jacques Wergifosse. The group took to meeting

regularly on Saturdays, mostly under Magritte's aegis. However, his chronic metaphysical disgust would overtake him periodically, as he wrote much later to Colinet:

The question of our Saturdays needs to be worked on, and I am without the mental resources to undertake this properly. I am possessed of a greater vacuity every day. It would be most alarming if something were to depend on the efforts which I, for one, am incapable of making.

One night with Scutenaire, Magritte burned all the possessions which recalled to him his Surrealist period, including letters, tracts, and even an overcoat, in the gas heater. According to Scutenaire, they would probably have burned themselves as well, if Georgette hadn't intervened.

Since every artist's work is identifiable as part of a continuing activity or enterprise in a larger dialectical continuum, that of art history, it is well to examine individual achievement as belonging to a constellation of ideas which precede and follow it, rather than as an isolated phenomenon or a unique invention. The main historical currents of any period are formed by the different phases of effort on a particular problem. The problem itself is revealed in the unfolding of successive solutions, since these tend to form sequences of related ideas which ultimately establish an intelligible continuity. With Magritte, it will be necessary to consider certain issues of Surrealism out of which his work has evolved, as well as the subsequent emergence of Pop art.

Surrealism, according to one of its foremost luminaries, Max Ernst, has enabled painting to travel with seven-league boots a long way from Renoir's three apples, Manet's four sticks of asparagus, Derain's little chocolate women and the Cubists' tobacco packets. André Breton, its leader and greatest spokesman, claimed that one of the chief functions of Surrealism was 'to deal drastically with *that hatred of the marvellous* which is rampant in some people'. But the real discovery of Surrealism was the manner in which it overthrew the assumption that the artist may find his model only in the external world.

The Surrealists fully embraced Hegel's notion that the skilful copying of nature is 'a superfluous labour' and 'a presumptuous sport', and not the true function of art at all. Hegel had put forward the view that reality for man must traverse the medium of perception and ideas, which alone confers permanence on a work of art, wedding it to 'the most universal intuitions respecting the world'.

In this process, it is quite indifferent whether attention is claimed by immediate external reality, or whether this effect is produced by another means – that is, by images, symbols, and ideas, containing or representing *the content* of reality. Man can frame to himself ideas of things that are not actual as though they were actual.[8]

For the Surrealists, the one painter whose work seemed to take the Hegelian aesthetic into account, abandoning the straightforward representation of nature in favour of a new poetic strangeness, was De Chirico. For Magritte in particular, De Chirico was the first artist to consider that what should be painted was more important than how to paint. Painting before De Chirico had been limited to the measure of optical reality: external appearance was exploited for the *aesthetic* benefit of the painting. The object functioned as an interior model present in the mind of the painter. As such, it gave existence to the painting even *before* the latter was painted, and it fixed in advance the terms of the image. The importance of De Chirico for the Surrealists was that he alone had succeeded in abandoning the artificial, predictable order of ideas connected with our daily perception of objects, and had piloted his painting on to more dangerous ramps of reality – towards what Baudelaire called 'the marvellous construction of the impalpable'. De Chirico was the first painter to question the familiar identity of objects. For this reason the work that he did during the period 1911–17 – seven years before Surrealism itself became an established movement – enjoyed a unique prestige among the Surrealists.

24, 34

During the years 1918–21, according to André Breton in *Le Surréalisme et la peinture*, at the spearhead of artistic research a point of crisis was reached in the artist's choice of subject-matter. Previous models, which had been borrowed from the external world, no longer seemed valid; that which would succeed them, taken from the internal world, had not yet been discovered. 'What', Breton asks, 'is the position of the object in De Chirico with respect to this crisis? Without reacting in the external world, neither is it possessed, however, of all the characteristics of the imaginary.'

Magritte himself has written: 'Surrealist thought, as I conceive it, must be imagined but it is not imaginary – its reality is of the same "kind" as that of the universe. That reality is irrational. Its irrationality is not imaginary, but it must be imagined.' What fascinated painters like Max Ernst, Magritte and Yves Tanguy – each of whom has acknowledged a debt to De Chirico – was the unprecedented way he endowed the world of appearances with poetic mystery. Later on, the Surrealists actually *invented* objects; in De Chirico's paintings, they were still faithfully reproduced, with their external appearance left intact. Yet somehow they assumed a greater significance than their counterparts in real life.

Objects in De Chirico took on a separate excitement, a metaphysical remoteness, and a new accessibility to experience. Familiar and banal objects became enigmatic and strange, mainly through isolation – by being removed from their functional roles in the world and placed where we would not *37* expect to find them. For example, in *The Song of Love*, the combined presence of a plaster head of the Apollo Belvedere, a surgeon's rubber glove, and a green ball, in an architectural setting imparts a profound sensation of irrational events. The displacement, in other paintings, of enormous bananas or artichokes into a piazza, or of still-life objects into the centre of an arcade, cause these otherwise familiar objects to become hallucinatory – 'things no longer cherished for themselves'. Once objects have been diverted from their symbolic and useful associations, the phenomenon of collaboration tends to upset conventional relationships and to reveal unforeseen affinities between objects.

The works of De Chirico and Ernst, certain paintings by Derain – *Man Reading a Newspaper*, among others, where a real newspaper was originally placed in the hands of a painted person – and the discoveries of Picasso, all mark the beginnings of Surrealist painting. There was also the anti-artistic activity of Marcel Duchamp, who quite simply proposed to use a Rembrandt as an ironing-board. More importantly, he proposed, as art, objects which were indistinguishable from the ordinary objects of everyday life, except for the fact that he had singled them out, calling them 'readymades'. Slowly but surely, Surrealism began to rob painting of its purpose and identity, through a desire, shared by a growing number of artists, to reverse the rational order of things. Hitherto unused elements of surprise, contradiction and disorientation began to make their appearance. The Surrealists were unified, less by their methods or techniques, than by a certain community of aims. The real nature of the movement was aggressive, in that it wanted to sow confusion and discomfort in a capitalist society for which it felt only contempt. With the Surrealists, revolution, and not art, was at stake. Unlike the Pop movement which came later, Surrealism was a truly collective and highly organized discipline. It was doctrinaire, articulate and authoritarian in its operations. It spanned the period from the early 1920s to 1940; and although the height of Surrealist activity was in the 1920s, active traces of it can still be found today. Paris was the centre, but there were offshoots in other countries, including Belgium. In fact, 'soluble fish' and 'white-haired revolvers' began to turn up everywhere, as

man, 'the definitive dreamer', took a new interest in hallucin-
atory phenomena, insanity and dreams, all of which repre-
sented freer and less inhibited forms of thought. Art soon
exalted the incongruous and the unpredictable as being more
true to nature than causality, and irrationality as being more
authentic to the mind than reason. Unlike Pop artists, the
Surrealists radically mistrusted the banal and the conventional,
preferring to explore the frontier between the internal and the
external worlds, between the conscious and the unconscious.
They systematically sought out that 'spontaneous, extra-
lucid insolent relationship which occurs under certain con-
ditions between one thing and another', and which normally
common sense prevents us from apprehending.

One of the best methods which the Surrealists discovered
for eliminating preconceived ideas and provoking revelations
was the use of chance techniques. (Everything happens
through chance, according to Magritte, whether it is foreseen
or not. In reality, nothing escapes the universal coincidence.)
For Magritte, the chance encounters between certain objects
which could be used to evoke surprise were far more strange
when they were imputed to everyday experience. He was
uninterested, therefore, in the studied use of chance which
gave rise to 'pure psychic automatism', the other branch of
Surrealism exemplified in the work of Matta, Masson and
Miró. Known as 'organic' or 'biomorphic' Surrealism, this
aspect of the movement was concerned with 'automatic'
drawing and calligraphy as a free expression of the uncon-
scious – a technique which ultimately led, via the transitional
figure of Arshile Gorky, to Jackson Pollock and to Abstract
Expressionism. The aspect of Surrealism with which Magritte
is more closely identified is characterized in a general way by
concrete and dream-like images, and comprises those artists
who were inspired by De Chirico. Magritte himself considered
his own work the result of an order of activity as remote
from automatism as it was from the catatonic, trance-like
images of Paul Delvaux, or the tainted fantasies of Salvador
Dalí, or the hallucinatory landscapes of Yves Tanguy. He
rejected as unauthentic the would-be spontaneity of auto-
matism, in that it seemed to him contrived – the ultimate
result of too mechanical and mediumistic a process. In
Magritte's view, automatism confused so-called spontaneity
('so-called' because it is subject to a theory of automatic art)
with spontaneous thought. ' "Automatic" writing', according
to Magritte, 'claims to know an experimental method for
"making thought speak", as if the mind were a machine, and

as if the interest of what might appear through writing or painting did not always depend on an unforeseen interest.'

Breton saw in Surrealism the possible resolution of two states, contradictory in appearance, dream and objective reality, in a sort of absolute reality which he called '*surréalité*'. If dreams are a translation of waking life, equally waking life is a translation of dreams. For Magritte, references to unconscious activity only satisfy the persistent habit of explanation. The world does not offer itself up like a dream in sleep; nor are there waking dreams.

The word 'dream' is often misused concerning my painting. We certainly wish the realm of dreams to be respectable – but our works are not oneiric. *On the contrary*. If 'dreams' are concerned in this context, they are very different from those we have while sleeping. It is a question rather of *self-willed* 'dreams', in which nothing is as vague as those feelings one has when escaping in dreams. . . . 'Dreams' which are not intended to make you sleep but to wake you up.

Magritte's paintings, then, do not pretend to imagine a world that proposes to be truer than the world itself, such as the objects invented by Tanguy, to which it is always difficult to give a name, and which plunge the spectator into an unbelievable spectacle. Nor are they like the 'closely pigeon-holed worlds' of Matta, as Breton has called them, 'a general bristling of spikes'. He does not invent techniques of systematic displacement to intensify the irritability of the mental faculties, as Max Ernst used *frottage* and collage. As Breton has pointed out, Magritte never cuts out anything at all. He begins to paint as if everything were already cut out. To Magritte, all the possible acts of the mind – displacement, explanation, etc. – are indifferent unless they directly evoke mystery. Painting manifests that moment of lucidity, or genius, when the power of the mind declares itself by revealing the mystery of things that appear, until that moment, familiar. This moment of lucidity is something which, according to Magritte, no method can bring about.

Although the influence of De Chirico's work on the development of Surrealism, and on Magritte's work in particular, can hardly be overstated, the admiration and regard the Surrealists showed for De Chirico's pictures was not returned in kind. In fact, when he was once asked to explain the Surrealists' enthusiasm for his work, he replied: 'Humphf. I never thought Surrealism was more than a bottled joke.' It is ironical that De Chirico, who was considered, along with Lautréamont, as one of the two 'fixed points' of Surrealism

and a 'great sentinel' along the route, should have had such an unsatisfactory relationship with the movement. Apollinaire had hailed him as 'the most astonishing painter of the younger generation', even often giving evocative titles to his pictures. Yet De Chirico's meeting with the Surrealists was nothing short of a disaster. Moreover, the evolution of his work did not correspond with their expectations, and they later denounced him violently. It is characteristic of Magritte's own equivocal relationship with the Surrealists that he never opposed De Chirico's later works, and continued to support them for a long time.

Surrealism formed, of course, the historical setting within which Magritte's painting evolved. His feelings about Surrealism, as we have seen, were rather ambivalent. But he was positively displeased at being counted a father of American Pop art, when it emerged in 1961. He made the mistake (with many others) of thinking that Pop was a joke, and that it lacked genuine artistic credentials.

The Pop artists wish to be contemporary, very much a part of their time, influenced by advertisements for Coca-Cola. Something rather miserable which inspires them. I myself think the present reeks of mediocrity and the atom bomb, but perhaps all times have been more or less the same. I don't want to belong to my own time, or for that matter, to any other.

These remarks express a general feeling that Pop was modish, commercial and without historical value, but he was still more explicit in an interview on Belgian television in 1964.

If we ignore the appearance nearly fifty years ago of Dadaism, then Pop art seems like a novelty. The humour of Dadaism was violent and scandalous. The Dadaists decorated the *Mona Lisa*, for example, with a moustache, or they exhibited a urinal as a work of art. The humour of Pop art is rather 'orthodox'. It is within the reach of any successful window decorator: to paint large American flags with a star more or less does not require any particular freedom of mind and does not present any technical difficulty. . . . Are we permitted to expect from Pop Art anything more than a sugar-coated Dadaism? Undoubtedly, anything is always possible. Provided we forget Dadaism, and, since they claim a kinship with me, that we forget about me as well, the Pop-art people will one day show us, perhaps, unexpected images of the unknown, and thus they will satisfy our desire for efficacious poetry.

As with De Chirico's ambivalent relationship with the Surrealists, it is ironic that Magritte should have entirely missed

the point of Johns, whose pre-occupations belong within the same constellation of ideas as his own: exploring the necessary relation between representation and that-which-is-represented, or between a picture and its object. It is a further irony that, as evidenced by the tone of the following letter, De Chirico proved as indifferent to the work of Magritte, who was his enthusiastic and lifelong admirer, as Magritte was himself indifferent to the admiration bestowed on his work by artists like Johns.

Dear Sir and Colleague,

Excuse me for the delay in answering your kind letter of last December 31st.
I have been to see your interesting exhibition and I congratulate you. Your paintings are quite witty and are not unpleasant to look at, as are so many paintings of the kind known as 'Surrealist'.
Monsieur Del Corte has informed me that you will soon be in Rome. I hope that on that occasion I can meet you personally.

Sincerely yours,
Giorgio de Chirico

Piazza di Spagna 31

The Surrealists had attempted 'a total revolution of the object' mainly by dissociating it from its use. Objects were presented, not as art, but as an attempt to undermine the value of conventional things. In place of traditional representation, the Surrealists evolved the notion of 'found objects' and 'readymades'. They also devised 'irrational', 'assisted' and 'interpreted' objects, but always with the same intention: subversion, marked by contempt for everything that society stood for. It is in this sense that the primary aim of Surrealism, 'to change life and to transform the world', has always been considered extra-artistic. Because society was, for the Surrealists, nothing more than 'a cultivated and stratified scab', they remained very much outside it. By contrast, one of the main characteristics of Pop art is its total assimilation, in fundamentally uncritical terms, of the contemporary urban environment – an implied acceptance of society. Pop encompasses a range of imagery taken from everyday life and from the mass media, which had previously been excluded from the sphere of fine art. In the case of Johns, for example, an ordinary lightbulb or flashlight is chosen *because* of its familiarity. Johns chooses 'things the mind already knows'; these objects become art by being introduced into an art context.

Pop was never a movement in the sense that Surrealism was. There were no platforms to change the world, no group demonstrations and no manifestos. However, both in turn rejected the notion of aesthetics for its own sake, and both tried to destroy any separation between art and actual experience. The mystique of the common object which figures so prominently in Pop art can be traced from Surrealism via Duchamp and Magritte, but the original intention of the Surrealists to make us *beware of the habitual and the conventional* has been completely reversed in Pop.

Magritte

The work of a small number of exceptional individuals can always be found to anticipate, and in fact to lay the foundations for, the problems that will preoccupy successive generations. Magritte was such a precursor. He did not contribute any formal inventions to the syntax of picture-making (as did so many of his contemporaries), but his work prefigures in imaginative projection the entire chain of problems whose ultimate solutions lead to the central fact of twentieth-century art: the collapse of the conventional devices of illusionistic representation.

In Magritte's paintings, questions as to the relational identity of objects and symbols, equivalent resemblances, and the whole validity of 'representational seeing' are continually being raised. Again and again the crisis that has beset art's established procedures is prophetically defined in his pictures.

61 For example, *The Human Condition I* actually formulates the contradiction between three-dimensional space, which objects occupy in reality, and the two-dimensional space of the canvas used to represent it. The ambiguity in Magritte's image suggests that something is irreconcilable in the confrontation between real space and spatial illusion. In this single image he has defined the whole complexity of modern art – a complexity which has led to a devaluation of the imitation of nature as the basic premise of painting. Another important

109 picture, *The Use of Words I*,[9] deals with a related problem: it points out the disjunction between an object and its symbol. By painting a pipe with the inscription directly beneath it that 'this is not a pipe', Magritte has called into question the whole process of representation or depiction, whereby an image can 'stand for' an object and, when combined with a false use of language, may even be taken for the object itself. In *The Use of Words I* Magritte demonstrates that an image is not the same as the object it is meant to represent, nor do the two perform the same function (or can you smoke it?). (On the other hand, when Marcel Duchamp was in Los Angeles, he signed real cigars and then everybody smoked them.)

Conventional modes for establishing a reciprocal relation between real surface and illusory depth began with the introduction of perspective during the Renaissance. Since then, a dialectical crisis has evolved, which at present takes the form of a total rejection by many artists of the representational function of art. (The development of photography has accounted in part for this crisis, by eliminating the need for painting to create likenesses.) Art has now been displaced from the sphere of representational illusionism to that of autonomous objecthood, whereby works of art are made to exist in their own right as objects without depicting or resembling any other object. This is the consequence of a long-standing conflict between the conventions of painting and sculpture and the status of real objects. For, as E. H. Gombrich has pointed out, the real world does not look like a flat picture, though a flat picture can be made to look like the real world.

The contemporary notion of painting is of an autonomous entity which need not assert anything more than the fact of its own presence, without any representational intermediary or any optical concessions to reality (an example would be Frank Stella's *Jill*). This replaces the prior notion of painting as a window on reality; and, if considered in isolation, it would seem to be a complete rupture with all previous art. However, this is not the case. Despite its radically altered physical identity, this newer art can be understood as having reassembled the components of prior artistic assumptions in such a way as to render the earlier, partial solutions obsolete. At the same time, this new synthesis has created new fields of potential action. However, for such a radical revision of tradition to occur, a number of intermediate positions had to be assumed along the way, many of which were imaginatively projected beforehand in Magritte's work.

The tension between reality and illusion which Magritte continually formulated and explored in his work is not a new problem in either philosophy or art. The 'window on reality' notion of painting which was passed down from the Renaissance perpetuated the idea of representation as an 'agreeable cheat'. The Cubists were the first to undermine this premise. They invented a pictorial space to supplant the perspectival one that had been used since the Renaissance. Picasso, also, was trying more than fifty years ago to overthrow the concept of 'fooling-the-eye' (*trompe-l'œil*), when he pasted real bits of newspaper to his Cubist pictures, replacing traditional *trompe-l'œil* (or painted illusionism) with what he called

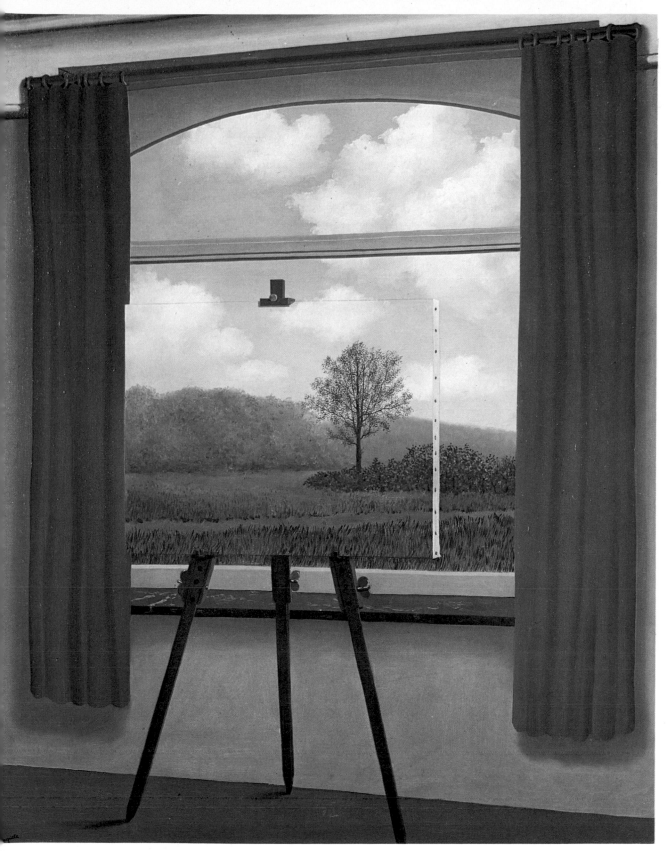

51 The Human Condition I · *La condition humaine I* 1933

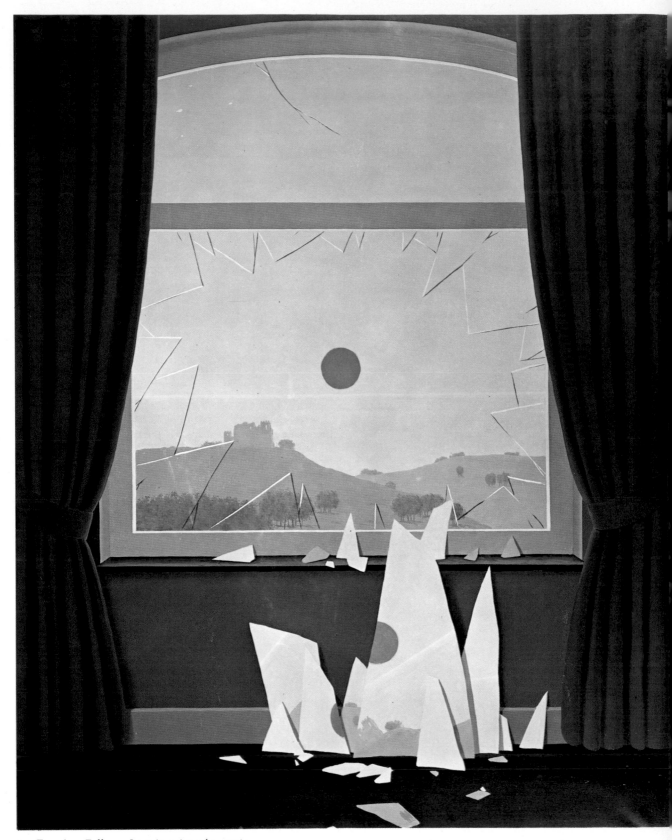

62 Evening Falls · *Le soir qui tombe* 1964

63 The Domain of Arnheim
Le domaine d'Arnheim 1949

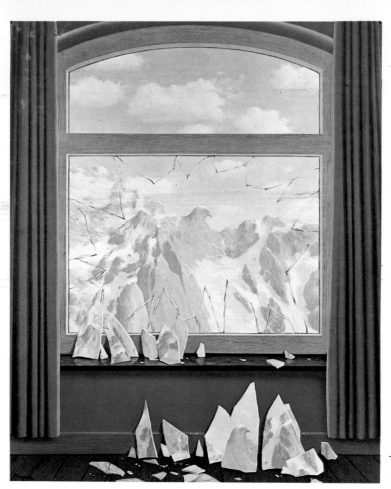

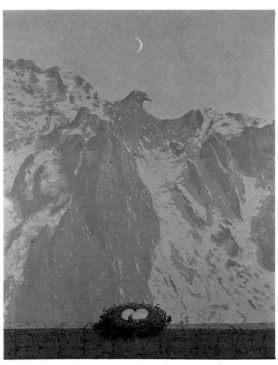

64 The Domain of Arnheim · *Le domaine d'Arnheim* 1962

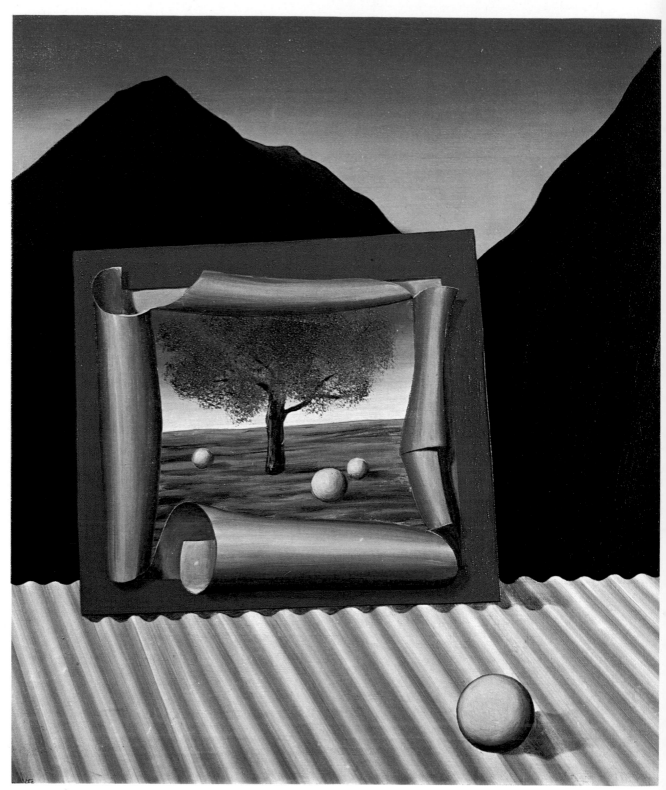

65 The Signs of Evening · *Les signes du soir* 1926

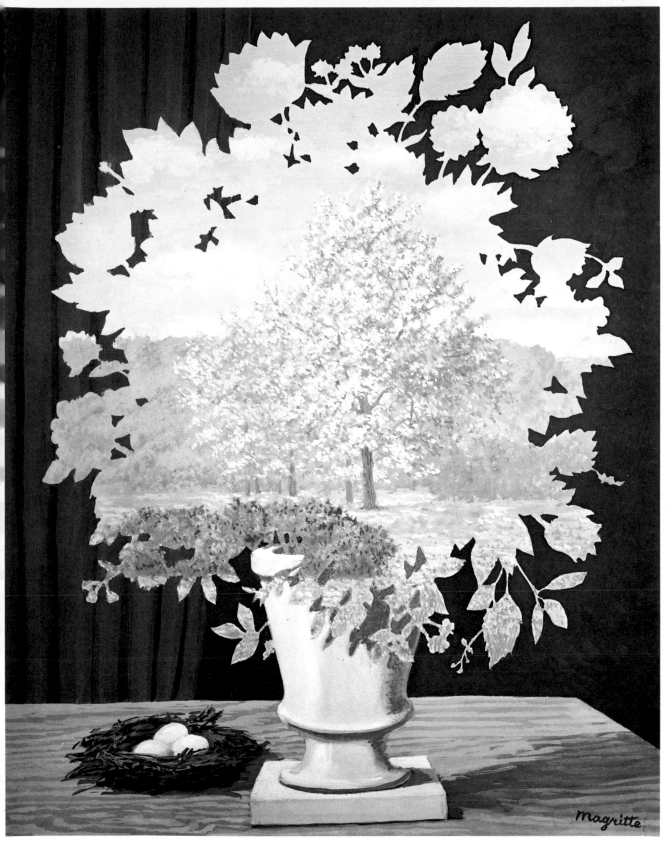

66 Plagiarism · *Le plagiat* 1960

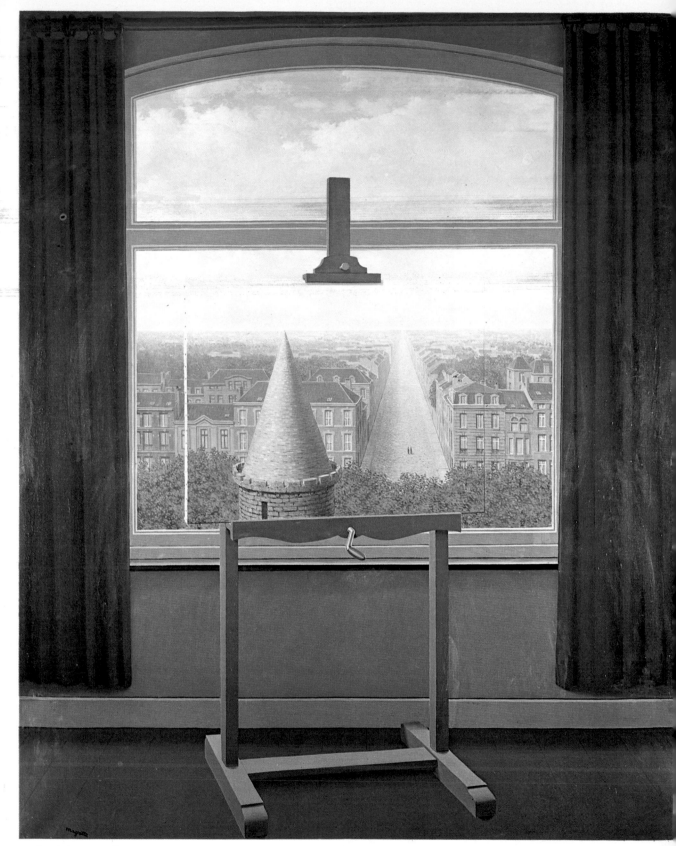

67 Euclidean Walks · *Les promenades d'Euclide* 1955

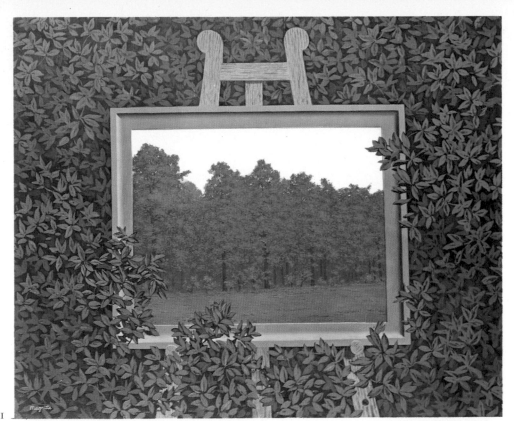

68 The Waterfall
La cascade 1961

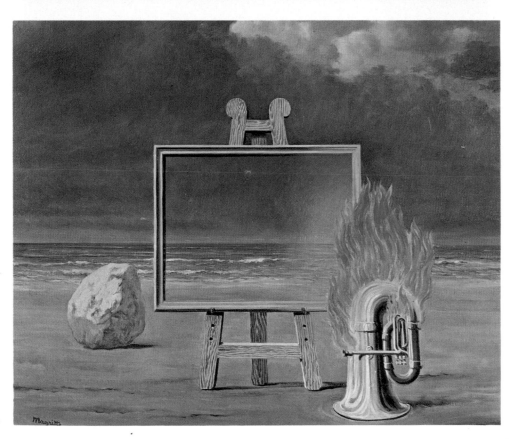

69 The Fair Captive
La belle captive 1947

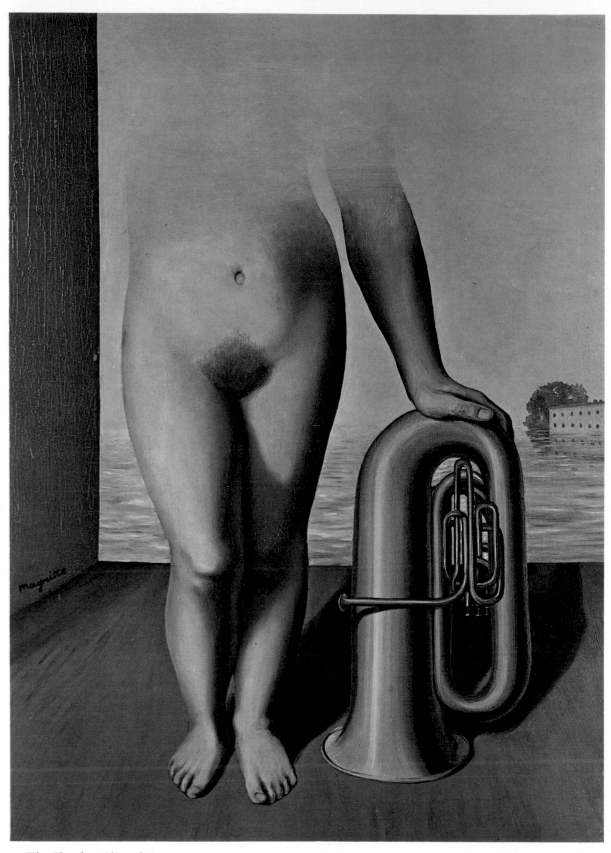

70 The Flood · *L'inondation* 1931

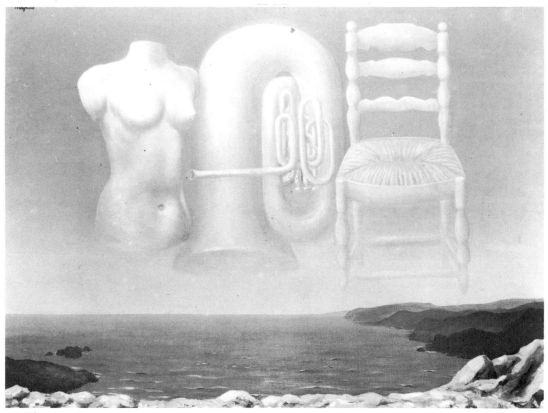

71 Threatening Weather · *Le temps menaçant* 1928

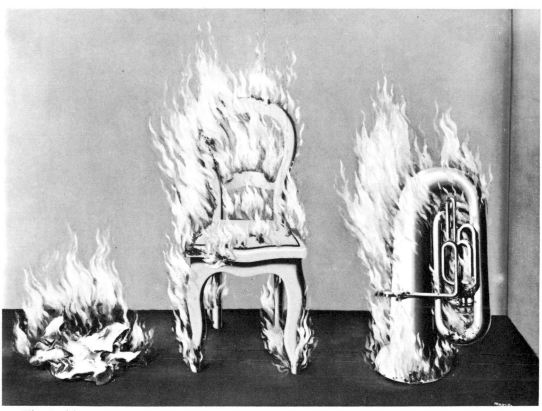

72 The Ladder of Fire I · *L'echelle du feu I* 1933

73 Magritte arranging a still-life,
still from Luc de Heusch's film
La Leçon des choses ou Magritte 1960

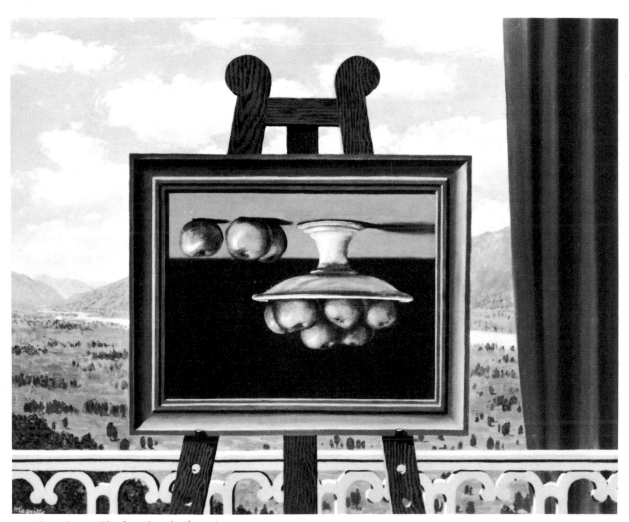

74 The Alarm Clock · *Le réveil-matin* 1957

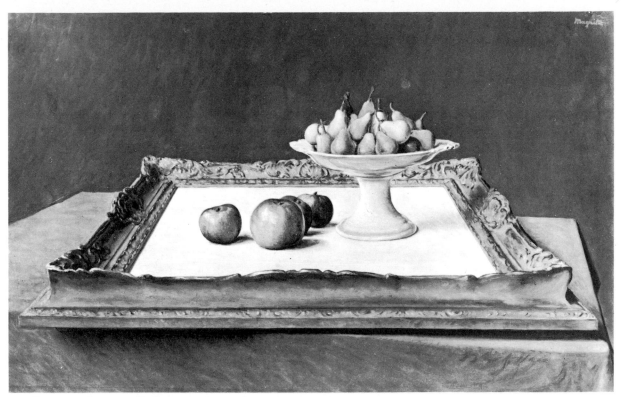

75 Common Sense · *Le bon sens* 1945-46

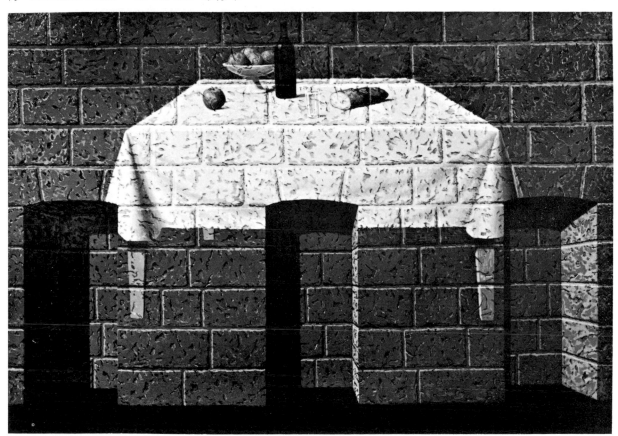

76 The Sweet Truth · *L'aimable vérité* 1966

77 The Field-glass · *La lunette d'approche* 1963

78 MARCEL DUCHAMP Fresh Widow 1920

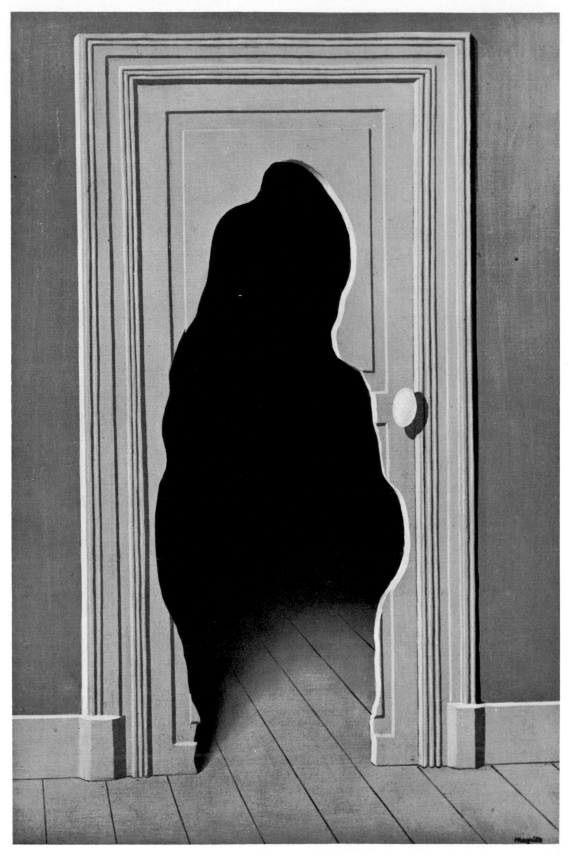

79 The Unexpected Answer · *La réponse imprévue* 1933

80 Amorous Perspective · *La perspective amoureuse* 1935

81 ROBERT RAUSCHENBERG The Bed 1955

82 JASPER JOHNS Flag '54 1954

83 FRANK STELLA Jill 1959

84 JASPER JOHNS Painted Bronze 1964

trompe-l'esprit ('fooling-the-mind'). When 'reality' itself was introduced into the work, the whole concept of illusionism was thrown open to question. 'Not only did we [the Cubists] try to displace reality; reality was no longer in the object. Reality was in the painting.'

Ever since this obtrusion of the real into the painting itself, the use of the picture plane as an intermediary for presenting identical painted equivalents of life has seemed a lame sort of mediation, like letting five count for an even number. A progressive displacement of real objects into the actual work of art came to be considered the specifically twentieth-century form of illusionism. However, once painted surfaces were no longer the restricted arena in which duplication of the visible world took place, the well-defined relation between a painting and that which it represents was no longer stable. To reconstitute this relation became the focal problem of art. Magritte's work in retrospect presents us with astonishing philosophical insights about these problems. The dialectical crisis which has caused a complete reversal of the illusionist premise was prefigured both imaginatively and pictorially in his work. This partly accounts for the increasing relevance of so many of his pictures to contemporary developments.

Eventually, the replacement of illusionism by actual objects precipitated the collapse of representational art and caused a whole new set of dialectical solutions to emerge. In the words of Harold Rosenberg, the work of art became more and more 'a thing added to the world of things rather than a reflection of things that already exist'. In 1954–55, the creation of two separate works can now be seen to have been a turning point in this crisis of symbol and object: Robert Rauschenberg's *The Bed* and Jasper John's *Flag '54*. *The Bed*, which caused endless disturbance at the time it was made, unexpectedly contracts aesthetic experience by eliminating the previous distinction, or separation, between the real object and that which represents it. Rauschenberg hung an actual bed, incrusted with paint, on the wall, instead of painting the image of a bed on canvas. The blow struck to the hierarchy of previous artistic assumptions by this act at first seemed absolutely wild, a little like being harnessed to a shark. However, more than a decade has served to thicken its identity to the point of respectability.

Johns, on the other hand, brought the revolution full circle when he made his American flag in 1954, and the now-historic Ballantine ale cans in 1960. *Flag '54* abrogated all the traditional rules of picture-making: it altogether eliminated

81, 82

84

93

compositional or illusionist devices. Instead, the physical
character of the flag as an object is asserted, even though it is
painted. The important thing, as Robert Morris has pointed
out, is that it is not a painting *of* a flag; the work is looked *at*
rather than *into*, and painting had not done this before.

Johns took painting further toward a state of non-depiction than
anyone else. . . . That is, these works were not depictions according
to past terms which had, without exception, operated within the
figure-ground duality of representation. Johns took the background
out of painting and isolated the thing. The background became the
wall. What was previously neutral became actual, while what was
previously an image became a thing.[10]

It remained for Johns to invert the whole premise of illusion-
ism, which is what he did in the bronze sculpture of the beer
cans. By 'reconstructing' real cans – that is, casting them in
bronze and then painting the castings to look exactly as the
cans had looked before he cast them – Johns made objects
appear so true to life that a genuine confusion arises about
their identity. The question is continually raised as to whether
they are real cans, bronze sculptures, or *trompe-l'oeil* paintings.
Thus, instead of making sculpture which tried to duplicate
real objects, he had turned the original object into a replica
of itself, making it seem as if 'objects [were] trying to become
sculpture', as John Cage has put it, so that 'sculpture stopped
dead and objects began'.[11] 'My beer cans', says Johns, 'have no
beer in them.' They look like beer cans, but aren't.

Recently, a Japanese artist by the name of Keiji Usami
described in a letter to Johns his intention to make a hologram
of the beer cans, an idea which advances the dialectic of
illusionism (in the Hegelian sense that is, of endlessly can-
celling out one viewpoint by another) still further. He proposed
to produce, by means of mirrors and laser beams, a three-
dimensional image of the beer cans existing only within
connecting wave bands, but which would give the impression
of a real object, since we would be seeing the image in three
dimensions. It would in fact be intangible, since the object
would be merely 'conjugated in the air'. The hologram is a
compound double-take on illusionist art, since the 'image' in
this case is an apparently real, three-dimensional object which
is, in fact, only an illusion. (Conjugating objects in the air
would seem to have been foreshadowed by Magritte as early
as 1928, in *Threatening Weather*.)

All this bears directly on the context of Magritte's work, in
that the concrete solutions found by Johns and Rauschenberg

to the problem of illusionism were projected imaginatively in many of his paintings. Before Johns, traditional art had always used illusionistic modes for representing real objects; he succeeded in changing the terms of depiction so that the object and the means of representing it were in more rigorous alignment. Eventually, when the premise of illusionism was reversed, real objects found themselves used in an illusionist context. Magritte himself had suggested the limits of pictorial

75 representation in his painting *Common Sense*, in which still-life objects, instead of being painted on the canvas, are shown standing on top of a blank, framed canvas which is lying on a table. The crisis of twentieth-century art arises from exactly the conditions Magritte has pictured here – the fact that real objects are three-dimensional and have depth, while a canvas is

76 flat. In *The Sweet Truth* he presents this problem in a different way: the painting depicts still-life objects on a table covered with a white cloth (an image inspired, it would seem, from looking at Leonardo's *Last Supper*), but the objects and the table are merely painted on a brick wall, implying that they are without any substance, as if they were two-dimensional. The effort to resolve this conflict, according to Clement Greenberg, is what caused painting to make itself abstract. That is to say, once painting gave up striving for realistic illusion, its space became two-dimensional and flat, so that three-dimensional objects could no longer exist in it.

Magritte had foreshadowed a crisis in *Common Sense* when he represented still-life objects standing upon the framed canvas. The Pop artists found a more direct solution to the problem: they incorporated actual objects from the environment, and these quite naturally extended outside the frame of the canvas. When Jim Dine, for example, attached a real china wash basin to a painting, he effected a new measure of realism which equated the image with the actual thing. The real object acts directly on experience, instead of being something that stands for it. 'It doesn't look like a painting *of* something,' Roy Lichtenstein has said, 'it looks like the thing itself.' 'I use real objects in my work,' says Tom Wesselmann, 'because I need to use objects, not because objects need to be used My rug is not to be walked on.' Johns, on the other hand, paints only what is flat (numbers, flags, targets); when it is a question of depicting three-dimensional objects, he uses the actual objects, thus making very clear the same distinction between image and object that Magritte was trying to formu-

109
75 late variously in such paintings as *The Use of Words I*, with the pipe, and *Common Sense*.

It has already been pointed out how Magritte had tried to define, within the parameters of a single picture, the ambiguity which exists between a real object, one's mental image of it, and the painted representation, of which the most lucid example is *The Human Condition*. As with most of Magritte's key works, there is a series of variations which form a complex system of cross-references, incorporating and superimposing related elements. The 'painting-within-a-painting' theme is a stunning contraposition to the Renaissance concept of painting as a 'window on reality'. Is the landscape we see one which is painted on the canvas inside the room, or is it one which is outside the window? In *The Human Condition* we are observing the correlation of two phenomena which occurs at the interface between subjective and objective – a diffusion of identities between inside and outside worlds.

Magritte presents this correlation in a way that suggests the study of philosophy. 'Where does the thought take place?', he would seem to be asking, since the ambiguity of the image expresses a concern with the nature and the locality of thought. 'Thought takes place in the head,' would seem to be the logical answer; but Wittgenstein, grappling with the same problem, is at pains to point out the grammatical misunderstanding which underlies this answer.

I ask you, is the subject-experimenter observing one thing or two things? (Don't say that he is observing one thing both from the inside and from the outside; for this does not remove the difficulty.)
 I can say 'in my visual field I see the image of the tree to the right of the image of the tower' or 'I see the image of the tree in the middle of the visual field.' And now we are inclined to ask 'and where do you see the visual field?'[12]

There is no evidence that Magritte ever read Wittgenstein, although he was well versed in philosophy. Yet the similarity between the preoccupations of both men is striking, to the point where even the images they use often correspond. The resemblance is all the more curious since Wittgenstein was actually dictating *The Blue and Brown Books* to his students in Cambridge at the time when Magritte completed *The Human Condition* and *The Key to the Fields* (not illustrated), the initial version of *Evening Falls*, both of which deal with experiencing the mental phenomena of 'inside' and 'outside'. Although this theme emerges definitively in the painting of *The Human Condition* in 1933, in combination with the problem of 'representational seeing', both themes had appeared in a

62

65

rudimentary form as early as 1926 in *The Signs of Evening*. In Magritte's own words, *The Human Condition* was the solution to the problem of the window.

I placed in front of a window, seen from inside a room, a painting representing exactly that part of the landscape which was hidden from view by the painting. Therefore, the tree represented in the painting hid from view the tree situated behind it, outside the room. It existed for the spectator, as it were, simultaneously in his mind, as both inside the room in the painting, and outside in the real landscape. Which is how we see the world: we see it as being outside ourselves even though it is only a mental representation of it that we experience inside ourselves. In the same way, we sometimes situate in the past a thing which is happening in the present. Time and space thus lose that unrefined meaning which is the only one everyday experience takes into account.

A window marks the interface between inside and outside; the door performs a similar function. The idea of a hybrid window-door was a favourite theme of Marcel Duchamp. *77* In *The Field-glass*, Magritte has created a window-door which *78* calls to mind Duchamp's *Fresh Widow*, a miniature French window with a wood frame and eight panes of glass covered with black leather. As a window it invites us to look through it, but the leather panes obstruct the view like a closed door. In *The Field-glass* Magritte plays upon a similar ambiguity. The skyscape on the left-hand pane might be either a view seen through the glass, or a painted covering applied to the pane in some way (as is Duchamp's leather), or a reflection on the glass from another source. However, the painting itself defies the logic of any of these possibilities, in that the right-hand pane, slightly ajar on the darkness beyond, simultaneously negates all these speculations.

79, 80 In *The Unexpected Answer* and *Amorous Perspective*, Magritte deals directly with the problem of the door. The important thing about doors is not that they are wooden and rectangular, but that they allow us passage. He has pointed out:

A door could very well open on a landscape seen upside down, or the landscape could be painted on the door. Let us try something less arbitrary: next to the door let us make a hole in the wall which is another door also. This encounter will be perfected if we reduce these two objects to a single one. The hole takes its position, therefore, quite naturally in the door, and through this hole one can see the darkness. This image could be enriched still more if one were to illuminate the invisible thing hidden by the darkness.

Magritte explored the inside-outside theme, stated in *The Human Condition*, in numerous variations, with sometimes more than a single version of each, but always working out some new aspect of the problem. For example, in *Plagiarism*, he used the device of the double image to synthesize the experience of 'inner' and 'outer', where the flowers in a bouquet on the table are replaced by a tree-filled meadow. Thus, events normally experienced separately in time become simultaneous; interiors and exteriors coincide, just as things happen concurrently, both inside and outside the mind. (Time, then, is merely the device which keeps everything from happening at once. Also, if we take the trouble to search, we can always find an inward and an outward cause for any event in life.)

Magritte
61

66

Another Surrealist painter, Salvador Dalí, has often exploited the same device of the double image, but with interesting differences. Dalí contrives that the two images should be interchangeable, in such a way that the second image will completely replace the first in a given moment of perception. With this method he hopes to induce a paranoid state in the spectator, who is naturally confused and uncertain as to what he has just seen. As a result, Dalí's world, in contrast to Magritte's, is one in which nothing is what it seems to be because everything is really something else. Identities are continually shifting, and the image of a horse is at the same time the image of a woman, by a clever sleight of the eye. Magritte's double image, on the other hand, far from being an artful stratagem for inducing a simulated state of paranoia, is used as an instrument of metaphysical knowledge, to evoke the power of thought, which is capable of being in two places at the same time.

Another variation on *The Human Condition* is *The Fair Captive*, of which, again, there are several versions; it incorporates into one of the original themes (the problem of 'representational seeing') another frequently-used element: the tuba, a recurrent image sometimes shown, as here, in flames. Fire is always an image of primary sexuality; it is apocalyptic among all phenomena – the only one to which the opposing values of good and evil can be simultaneously attributed. Thus, it can contradict itself; it is one of the principles of universal explanation. Fire in Magritte's work is always an element of transcendence, the transition between the inanimate and the animate, one of the cosmic mysteries. The tuba seen out of its normal context has a disquieting presence; on fire it is even more disturbing, because of the

69

deviation from its normal behaviour. In our experience, certain objects burn easily (paper, wooden chairs), but tubas do not (*The Ladder of Fire I*); moreover, a child on fire, according to Magritte, 'will surely move us more than a distant planet burning itself out'. Since the flames of the burning tuba in *The Fair Captive* leave a *reflection* on the 'canvas', we are brought again to the notion of the canvas both as a pane of glass which allows the spectator to 'see through' reality, and as a metaphor for painting as a window on reality – as with Duchamp's *Large Glass* (1915–23). The *Large Glass* is less a picture than a transparent window, synthesizing the inner world of the artist's intentions (etched into the glass) and the outer world which is visible through it. It is like a mystical experience, in which different but corresponding planes of reality converge on an illumined zone of consciousness and endow the spectator with second sight. 'In this state of illusion', Novalis has written, 'it is less the subject who perceives the object than, conversely, the objects which come to perceive themselves in the subject.'

In *The Waterfall*, the painting-within-the-painting, which this time depicts a forest, is set on an easel among the trees. Thus, the representation is no longer superimposed on the reality, as if reflecting the supra-sensible world behind it, as in *The Human Condition*: it is situated right within it. This new juxtaposition points up still more emphatically the different character of the image from the thing it is supposed to represent. Magritte has written:

The different natures of the two presences (that of the painting-within-the-painting and that of the leaves which surround it) are of a spatial order, but they are so linked that the spatial order ceases to be a matter of indifference: it is only thought itself which can see itself simultaneously in the forest and away from the forest. As for the title of the picture, *The Waterfall*, I merely meant to point out that the thought which conceives such a painting undoubtedly overflows like a waterfall.

In *Evening Falls*, the window has shattered; there is no canvas in front of it as there is in *The Human Condition*, but fragments of the landscape reappear on the broken bits of glass as they fall inside the room. (This is a version made in 1964 of an earlier painting called *The Key to the Fields*, originally done at the time of *The Human Condition*. The earlier version is virtually identical but has no sunset.) In another version, painted in 1949, Magritte has combined the theme of the broken window with the theme of a different painting,

The Domain of Arnheim. The title *The Domain of Arnheim* was inspired by Edgar Allan Poe's story of the same name; so was the image, in which an enormous mountain assumes the exact shape of a bird with its wings spread. The fusion of the two ideas in *The Domain of Arnheim* is an excellent example of the way in which Magritte constantly cross-fertilized themes and superimposed separate elements, but the final realization is not always successful, as in this case it is not. Each of the two images seems more powerful when used in isolation; when combined, they become somewhat claustrophobic and overbearing.

Magritte

63, 64

67

In *Euclidean Walks* we return again to a scene where part of the view outside a window is hidden by a canvas portraying the identical view inside the room. But again, a new element has been added, in that Magritte here has invoked certain correspondences: the shape of the street seen in receding perspective exactly resembles the conical form of the tower. Sometimes, when different images are brought together, they create analogies in the mind with the insistence of indisputable evidence. A sudden fusion of ideas will insinuate into the unconscious many principles and parallels: mathematics began, for example, according to Bertrand Russell, when it was discovered that a brace of pheasants and a couple of days have something in common – the number 2. Insight is a form of gestalt, involving the sudden active perception of new relationships. It is structured by the union of a mental and a visual perception, which underlies the best of Magritte's images.

In all these paintings, Magritte has tried to polarize the mind in such a way that it will not confuse reality with the means used to represent it; or, to put it differently, he has explored the negative rapport between a real object and the painted illusion. For example, Magritte once made a small painting of a piece of cheese. He titled it 'this is a piece of cheese' and placed it under the glass dome of a cheese dish. He has also written:

If someone thinks of a slice of buttered bread, and wishes to communicate this thought, several means are open to him. He can show a slice of bread and some butter, or paint a slice of bread, and spread butter on it; or he can paint the butter on a real slice of bread. The image of a slice of bread and butter is assuredly not something eatable, and conversely, to take a slice of bread and butter and exhibit it in an art gallery changes nothing about its actual aspect, and it would be foolish to believe it was capable of allowing the description of any thought whatsoever to appear.

The Human Condition Magritte was the only Surrealist who was not absorbed in the technical innovations of his contemporaries, most of whom have already assumed a fixed position in history. Those other Surrealists who had allied themselves more closely to the movement than he ever did were generally involved in experimenting with techniques which have now exhausted their usefulness and are tied to a period style. Magritte restricted his technique to the most scrupulous depiction of appearances; however, the rigour and relevance of his thought have ultimately afforded his work more options for the future, so that his full stature has not, even now, become apparent.

7 The Object Lesson

Magritte had found his track in 1925 after his discovery of De Chirico. The subsequent pictures, as we have seen, had been dark and explosive, haunted by strange profiles and menacing silhouettes that suggested a source in silent films and detective novels. The paintings of the next phase, ending in 1936, were linked to Magritte's systematic search for a 'bewildering' poetic effect, which would run parallel with Lautréamont's 'accidental encounter' between two mutually distant realities. The 'bewildering' effect was specifically obtained by displacing an object borrowed from reality and resituating it outside the field of its own power. Familiar objects were thus undermined without actually having their appearance altered. The vision of the world which was created in this way did not openly contradict the facts of ordinary observation.

This 'coming of age' of the object, weaned from its source and left to seek out relations other than familiar ones, was a major achievement of Surrealism. Breton had raised the problem of the Surrealist object as early as 1924. At that time he defined the ambition of Surrealism as the rehabilitation of the object: alienating it from its habitual context so that its purpose would become unknown, or would at least be altered. This would serve to awaken the latent life in objects. It would also serve to enlarge our experience of them, which otherwise tends to be bound by utility and guarded by common sense. For the Surrealists, the object was considered a concrete reality which must somehow be recreated rather than represented. By juxtaposing unrelated objects – in the manner of Lautréamont's sewing machine and umbrella – they revealed unexpected affinities between different objects. Moreover, the process relates to Baudelaire's concept of imagination (as distinct from fancy): 'an almost divine faculty which perceives at once, quite without resort to philosophic methods, the intimate and secret connections between things, correspondences and analogies'. The Surrealists devised numerous methods for provoking these chance revelations. They also

invented the 'found' object, which represented the material expression of benevolent chance between the object and its 'creator'. However, according to Magritte, 'as removed as one may be from an object, one is never entirely separated from it'.

| The actual image of the object | Intermediary: vision, more or less accurate | The final interpretation |

Magritte made a very particular contribution to this complex group of Surrealist ideas. In this view, every object is linked, even in ordinary experience, to another object with which it has rational, if unacknowledged, connections that need to be discovered: the cage and the egg, the tree and the leaf, the aperture and the door. This discovery led him to think of pictures as problems. It involved him in a systematic search for the particular psychological or morphological evidence, obscurely attached to an object, which would yield up the unilateral and irreversible poetic meaning of that object. Thus, in what may be considered his second period, Magritte no longer juxtaposed *dissimilar* objects in what had become the classic Surrealist manner; he now explored the hidden *affinities* between objects – the relation of shoes to feet, or of the landscape to the picture, or of the female face to the

89
61, 87

female body. It was at this point that Magritte developed a methodology that was entirely his own. The element of shock or surprise became more rigorous, more conscious and controlled than it had ever been in De Chirico's work. The notion of bewildering disorientation (*dépaysement*) no longer seemed applicable. '*Nous sommes là chez nous*', Magritte has said: 'here is where we really belong.'

Thus Magritte evolved his own complex mental operation for calling objects into question. It was more premeditated and deliberate than the automatic and chance methods used by the other Surrealists. His method was essentially that of trying out assumptions in a series of speculative drawings until an answer was found to each familiar object. The underlying principle for nearly all the work that followed was based on a kind of Hegelian dialectic of contradictions, in which a union of opposites operated as the mainspring of reality. He pursued these investigations until just before his death, and the examples shown span thirty years. For Magritte's work did not evolve, in the usual stylistic sense. Except for those deviations in style during the 1940s which are discussed in Chapter 9, Magritte spent his time refining and elaborating the same philosophical method.

He had actually been doing 'problem' pictures, like the door in *The Unexpected Answer* and the window in *The Human Condition*, for quite some time before he was fully conscious of what he was doing. The turning-point, when he became aware of his own method, came in 1936, when he painted a picture called *Elective Affinities* (the title is that of a novel by Goethe).

79
61

One night in 1936, I awoke in a room in which a cage and the bird sleeping in it had been placed. A magnificent error caused me to see an egg in the cage instead of the bird. I then grasped a new and astonishing poetic secret, because the shock I experienced had been provoked precisely by the affinity of two objects, the cage and the egg, *whereas previously I used to provoke this shock by causing the encounter of unrelated objects*. Ever since that revelation I have sought to discover if objects other than the cage could not likewise manifest – by bringing to light some element peculiar to them and rigorously predetermined – the same evident poetry that the egg and the cage were able to produce by their meeting.

This element to be discovered, this thing among all others obscurely attached to each object, suddenly came to me in the course of my investigations, and I realized that I had always known it beforehand, but that the knowledge of it was as if lost in the recesses of my mind. Since this research could yield only one single exact response for each object, my investigations resembled the pursuit of

the solution to a problem for which I had three data: the object, the thing attached to it in the shadow of my consciousness, and the light wherein that thing would become apparent.

Thus, an image for Magritte would often be the result of complex investigations – an authentic revelation after a long period of calculated reflection. For certain paintings the solution was already tacitly comprised in the problem but remained to be found; for example, in trying to find a way to paint a bicycle, the solution which finally presented itself was the rapprochement of a bicycle and a cigar. Preliminary thoughts which had suggested themselves were a bicycle on top of a banana, or a valise, or astride two masked apples (an image used in other paintings), or a chair riding on the seat of the bicycle.

But none of these 'solutions' proved correct until the cigar suggested itself, thus creating *State of Grace*. (It can happen that a bicycle passes over a cigar thrown into the street. Any circumstance, Proust has written, consists of one-tenth chance and nine-tenths the disposition to fall in with it.) It is false, according to Breton, to pretend that it is the mind which seizes the rapport between two realities. To begin with, nothing has been seized consciously. It is out of the juxtaposition of the two terms, in a way which is in some manner felicitous, that a light is kindled: the light of the image. In that light the idea makes its visible appearance.

Magritte
85

Painting has no thickness: thus my painting with the cigar, for example, has no perceptible material thickness. *The thickness of the cigar is in the mind*. This is not lacking in importance if a preoccupation with the truth has any importance. In fact, a painting conceived and painted with this preoccupation must have the unequivocal character *of an image*. It is not a cigar which one sees, but *the image of a cigar*.

In just the same way, the image of a pipe is not the same thing as a real pipe. Hence Magritte's inscription 'this is not a pipe'.

109

What one sees in an object, then, according to Magritte's calculations, is another object hidden. In the case of the violin, for example, what was needed was a white tie and starched collar: *A Little of the Bandits' Soul*. The idea of a knot had been clairvoyantly implicit throughout. At intermediate stages in the development of the final idea, the violin appeared knotted into a girl's hair-bow, and intertwined with a snake, until finally the knot resolved itself as part of the bow tie on the starched collar of the violinist.

93

Magritte's intention was to create, from the flux of existence, autonomous and fixed images whose existence would no longer depend on any knowledge we might have and would be independent of our ideas about objects. In this way, forms of the visible world would bypass their contingent functions and be restored to their absolute identity. To use Hegel's term, they would become 'concrete universals'.

The problem of 'rain' produced a view of a rainy landscape with an enormous stormcloud on the ground (*The Song of the Storm*). The problem of 'woman' yielded *The Rape*. In it, the features of a woman's face are composed of various parts of her body: the eyes have been replaced by breasts, the nose by the navel, and the mouth by the sexual organ, as if in some erotic metamorphosis of consciousness.

100
87

Drawings for A Little of the Bandits' Soul *1960 (pl. 93)*

Sometimes, an image was born in a single vision, in a kind of rapid hallucination – although these occasions were rare. For example, the automobile surmounted by a jockey on his horse, in *The Wrath of the Gods*, appeared to Magritte as a sudden and complete image, without the usual long period of reflective examination. *The Wrath of the Gods*, therefore, was not exactly an answer to the 'problem of the automobile', in that both elements in the combination were given spontaneously, by inspiration. (The problem of the automobile, if it had been posed, would no doubt have yielded up something quite different after long research.) Another example of an image born from a sudden vision is *Time Transfixed*, in the Tate Gallery, London, where a miniature locomotive thrusts itself through a fireplace.

Magritte never dealt with single, static identities. His images incorporate a dialectical process, based on paradox, which corresponds to the unstable, and therefore indefinable, nature of the universe. Thesis and antithesis are selected in such a way as to produce a synthesis which involves a contradiction and actively suggests the paradoxical matrix from which all experience springs. The fundamental dynamism of Magritte's images depends on an exploitation of the free field of possibilities, or potentialities, which lies outside the range of what are usually considered 'normal' situations. The fact that a possibility is not a reality means only that the circumstances which are affecting it at a given moment prevent it from being so. If, however, the possibility is freed from its bonds and allowed to develop, a utopian idea is likely to emerge. In Magritte, the synthesis through paradox which brings conflicting possibilities into a unified focus is intended to suggest the ambivalent nature of reality itself. For example, he puts forward the 'possibility' that one thing can also be two things. In *The Seducer* the sea takes the form of a ship. In *Plagiarism*, a bouquet on a table has been replaced by the landscape outside. In this painting the antithetical concepts 'inside' and 'outside' (or 'here' and 'there') have been synthesized in a single image, but they are also still understood as two images by the mind.

But a single conceptual image will not express the synthesis of two or more conceptual images unless it occurs at the intersection of a paradox. That is, in order that something become two things, an 'active compound' must be created within the interpenetrating images. It is also possible to reduce the images to binary structures, as with the tower and

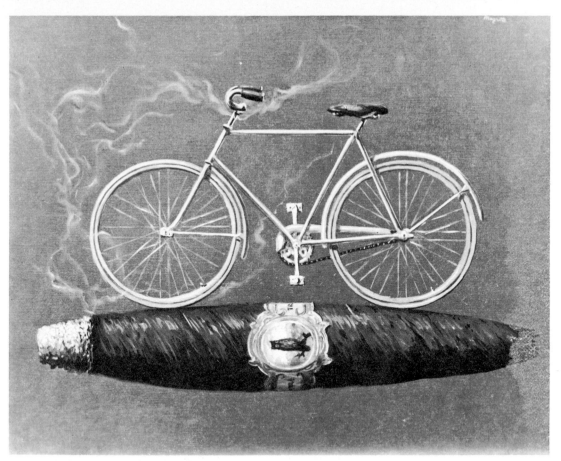

85 State of Grace · *L'état de grâce* 1959

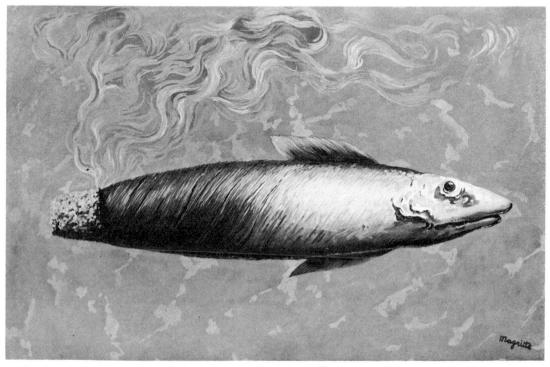

86 Homage to Alphonse Allais · *Hommage à Alphonse Allais* 1964

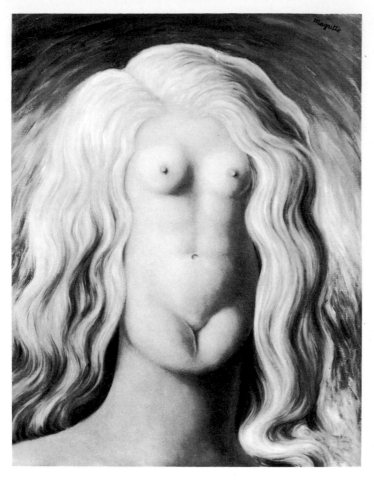

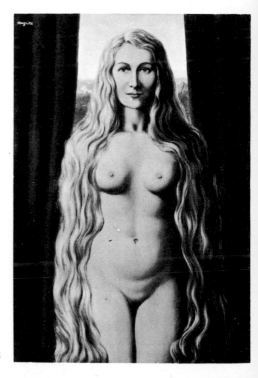

88 Natural Knowledge · *La connaissance naturelle* c. 1938

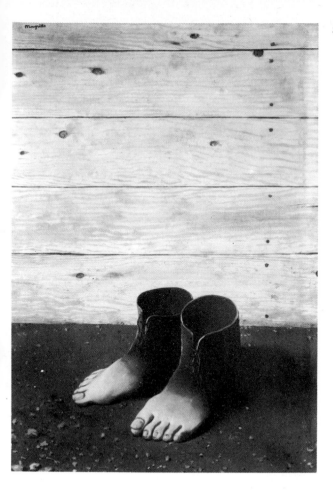

89 The Red Model · *Le modèle rouge* 1935

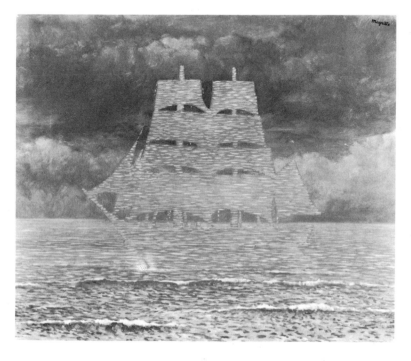

90 The Seducer · *Le séducteur* 1950

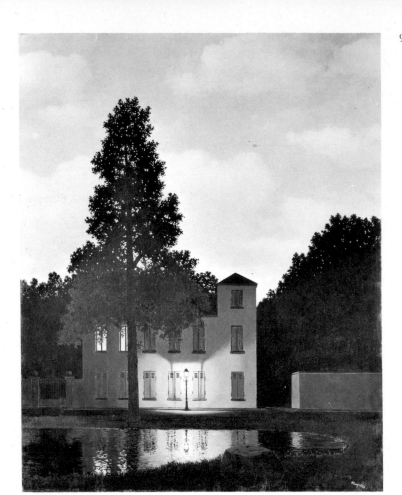

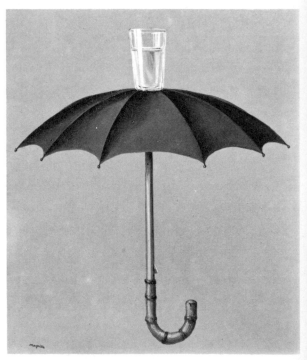

92 Hegel's Holiday · *Les vacances de Hegel* 1958

93 A Little of the Bandits' Soul · *Un peu de l'âme des bandits* 1960

94 Collective Invention
L'invention collective
1935

95 The Natural Graces
Les grâces naturelles
1963

96 The Explanation · *L'explication* 1952

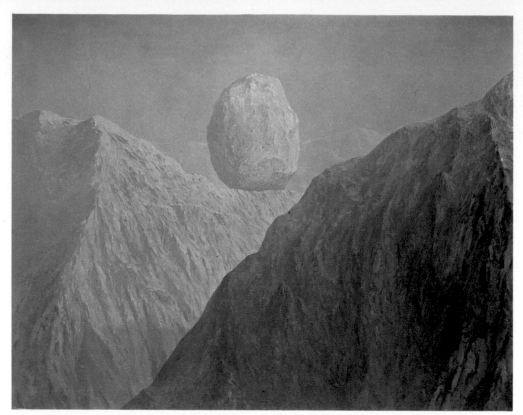

97 The Glass Key · *La clef de verre* 1959

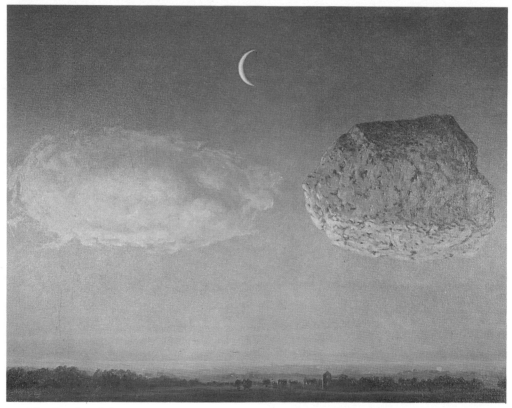

98 The Battle of the Argonne · *La bataille de l'Argonne* 1959

99 Heartstring
La corde sensible 1955

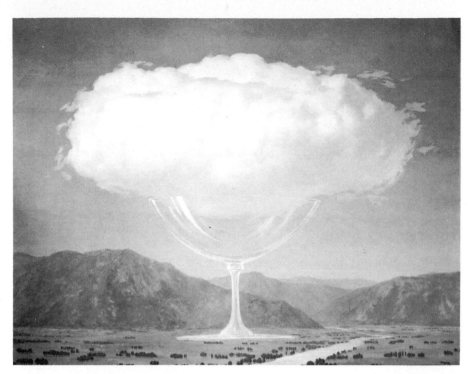

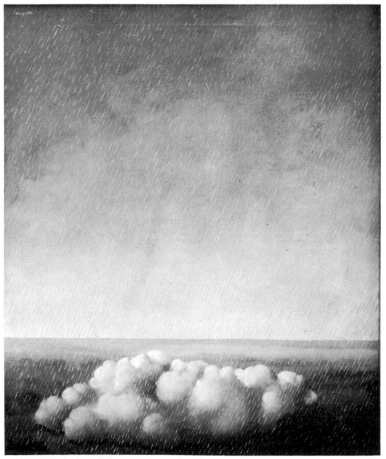

100 The Song of the Storm · *Le chant de l'orage* 1937

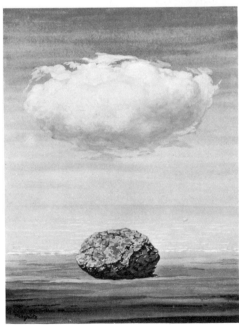

101 The Origin of Language · *L'origine du langage* 1963

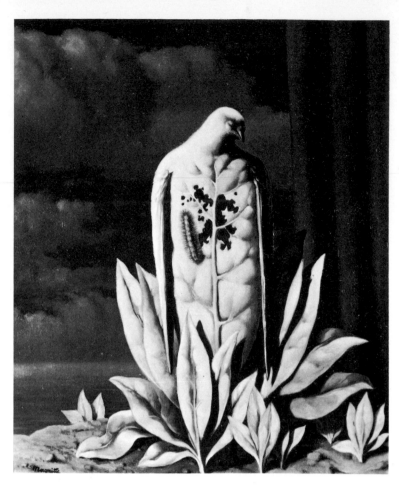

102 The Flavour of Tears
Le saveur des larmes 1948

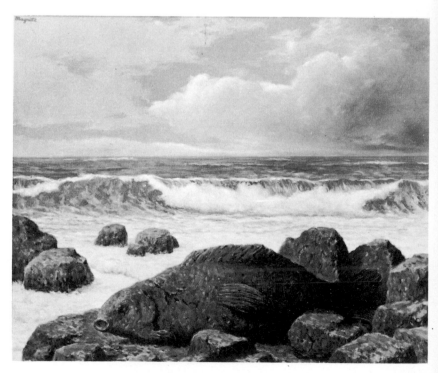

103 The Lost Steps
Les pas perdus 1950

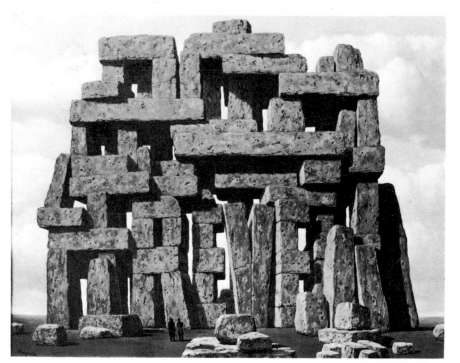

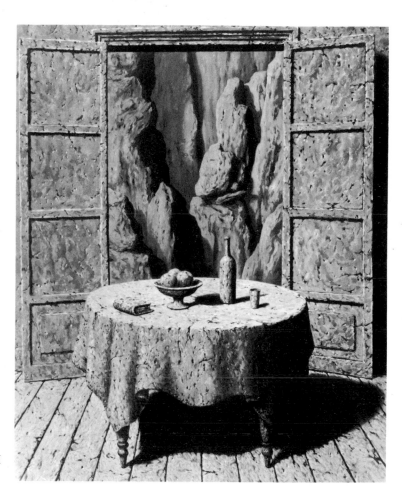

105 Remembrance of a Journey III
Souvenir de voyage III 1951

106 The Haunted Castle · *Le château hanté* 1950

107 Remembrance of a Journey · *Souvenir de voyage* 1955

the street which both become cones in *Euclidean Walks*. This results in a different double-reading, based upon a hidden calculus of relations. The bipolar nature of reality is also expressed in the juxtaposition of night and day within the same picture: in *The Empire of Lights*, a street at night appears under a daylight sky. In *Hegel's Holiday*, Magritte has evoked a hidden correspondence between two seemingly unrelated objects: a glass of water and an umbrella.

91

92

Magritte writes in the letter reproduced here:

My latest painting began with the question: how to show a glass of water in a painting in such a way that it would not be indifferent? Or whimsical, or arbitrary, or weak – but, allow us to use the word, with genius? (Without false modesty.) I began by drawing many glasses of water, always with a linear mark on the glass. This line, after the 100th or 150th drawing, widened out and finally took the form of an umbrella. The umbrella was then put into the glass, and to conclude, underneath the glass. Which is the exact solution to the initial question: how to paint a glass of water with genius. I then thought that Hegel (another genius) would have been very sensitive to this object which has two opposing functions: at the same time not to admit any water (repelling it) and to admit it (containing it). He would have been delighted, I think, or amused (as on a vacation) and I call the painting *Hegel's Holiday*.

In his old age Hegel found the spectacle of a starlit sky dull – 'which is precisely so', according to Magritte. But the image of a starlit sky need no longer be dull if that image were to evoke mystery. The mystery would result from the lucidity of a painter who was able to paint the commonplace image of a starlit sky in such a way that it might have evocative power. Hegel saw only a 'constant' image without the intervention of the mind. Since he probably valued only the manifestation of the mind through ideas, he might have been agreeably distracted (as a sort of holiday relaxation) by looking at images.

Magritte's paintings are a systematic attempt to disrupt any dogmatic view of the physical world. By means of the interference of conceptual paradox, he causes ordinary phenomena to inherit extraordinary and improbable conclusions. (It is only when we once pass through this baptism, the Zen philosopher D. T. Suzuki has written, that a single hair of the tortoise begins to weigh seven pounds and an event of one thousand years ago becomes a living experience of this very moment.) What happens in Magritte's paintings is, roughly speaking, the opposite of what the trained mind is accustomed to expect. His pictures disturb the elaborate compromise that exists between the mind and life. In Magritte's paintings, the world's haphazard state of consciousness is transformed into a single will.

For example, qualities normally associated with rocks are heaviness and immobility. In Magritte's paintings the law of gravity is defied through levitation – the paradoxical antithesis of gravity – so that rocks can suddenly float in the air like clouds, as in *The Battle of the Argonne*. They also lose their quality of seeming to have a fixed or final location; we can

98

never be completely sure whether they are floating upwards or falling downwards or merely suspended in space. Just as with the ambiguity of 'inside' and 'outside', Magritte avoids any absolute finality of placement by playing on the bipolarity of 'here' and 'there'. As in *The Empire of Lights*, where he has used two apparently irreconcilable events (night and day) observed from a single point of view to disrupt our sense of time, in paintings like *The Battle of the Argonne* Magritte has similarly disrupted our sense of space.

This plural significance of experience, in which spatio-temporal measurement is seen as the relation between observer and phenomena, corresponds to Einstein's theory of relativity in physics, which abolished the 'absolute' space and time of Newtonian theory. Relativity represented the demise of any view of the universe as static and predictable. It represented the shift from a timeless, Euclidean world in which all is precise, determinate and invariable, to a dynamic universe where everything is relative, changing and in process. Magritte's paradoxical combination of precision and indefiniteness is perfectly adjusted to the crisis of modern physics, in which the necessity of causal relations has had to be abandoned in favour of probability statistics. Although his style and temperament were attuned to exactitude, it could be said that apart from and beyond this quality everything was indefinite.

Rocks are inanimate. Magritte used this fact to reverse the natural properties of the living world in a series of paintings in which absolutely everything has turned to stone: *Remembrance of a Journey*. As if by an invisible catastrophe, the nicely arranged world of merely objective nature has reverted to a mineral state, where even the stones are sexual and seem to see and hear, just as people believed they did in the Middle Ages. In one version the man dressed in an overcoat and carrying a book was Magritte's friend, the poet Marcel Lecomte.

It is living and not living, according to Breton, which are the imaginary solutions; existence is elsewhere. However, these improbable events reflect the unrealized potentialities of nature, in which analogous visual deceptions do exist and serve mostly as a means of escaping detection. Processes of adaptation, which operate between the animal and plant kingdoms for the benefit of each, often entail changes in structure, behaviour or coloration to secure an effective resemblance. Various forms of mimicry and protective colouring that serve as deterrent and camouflaging techniques in plants and animals recall the stone fish in *The Lost Steps* and

91

98

105

107

103

the leaf-bird in *The Flavour of Tears* and *The Natural Graces*. *Magritte*
102, 95
In the deserts of South Africa, for example, there are succulent
plants known as 'living rocks'; they have fleshy leaves whose
shape and surface markings resemble the stones among which
they grow, and by this means they escape the notice of desert
animals which would otherwise eat them for their water
content. A South American nightjar, which nests on top of a
tree stump, escapes detection by brooding throughout the
day without moving, its head pointing upwards so that it
looks like a continuation of the stump. By means of adaptive
mimicry, certain grasshoppers imitate decaying leaves;
insects and caterpillars often look like twigs; certain spiders
behave like ants. In the Amazon, a leaf-fish gets within striking
distance of its prey by looking like a dead leaf drifting along
the current. There is an Australian seahorse which is pro-
tected from attack by the fact that it resembles marine vege-
tation and sprouts imitations of three different kinds of seaweed
from various parts of its body. Thus we can see that many of
Magritte's utopian ideas are less improbable than they seem,
for in the same way that nature produces its own orderly
miracles, Magritte presents images of mystery which are as
removed from the hypotheses of science as from the approxi-
mations of poetry; but they resemble those presented to us
by nature every day.

Large birds, states a Surrealist proverb, make little Venetian
blinds; and several children, wrote Eluard, make an old man.
In *The Red Model*, the image starts by being a foot, and ends *89*
up, through a process of hybridization, with the properties of
a boot. 'The problem of shoes', Magritte has written, 'demon-
strates how the most barbaric things pass as acceptable through
the force of habit. One feels, thanks to *The Red Model*, that the
union of a human foot and a leather shoe arises in reality from
a monstrous custom.' In this case, the container (boot) and
the thing contained (foot) merge to create a new object. In
The Explanation, a carrot and a bottle are combined to produce *96*
a bewildering new object. In *Collective Invention*, a fish and a *94*
woman combine to produce the opposite of a mermaid – a
fish with human legs instead of a woman with a fish's tail.

For Magritte, painting was not an end in itself; it was the
means of formulating an awaited response so that objects
could exist with maximum impact. A crisis of the object
could be brought about in any of the following ways: (1)
Isolation. An object, once situated outside the field of its own *93*
power and removed to a paradoxically energetic field, will be

freed of its expected role. (2) Modification. Some aspect of the object is altered. A property not normally associated with a particular object is introduced (human flesh turned to wood or stone); or, conversely, a property normally associated with an object is withdrawn (gravity from a rock). (3) Hybridization. Two familiar objects are combined to produce a third, 'bewildering' one. (4) A change in scale, position or substance creates an incongruity (an enormous champagne glass in a mountain landscape or an apple which fills the room). (5) The provocation of accidental encounters (a rock and a cloud meet in the sky). (6) The double image as a form of visual pun (a mountain in the form of a bird or the sea in the form of a ship). (7) Paradox. The use of intellectual antitheses as in the delicately balanced contradictions of the glass and the umbrella. (8) Conceptual bipolarity. The use of interpenetrating images where two situations (a landscape outside and a bowl of flowers inside) are observed from a single viewpoint, modifying spatio-temporal experience.

8 The Use of Words

Language is a system of communication adapted to the empirical world; however, as Wittgenstein has shown, as a constructed model it does not necessarily tally with reality. It is not a static natural feature of the universe, but covers a great range of different functions. Moreover, if fragments of language are extracted from situations of actual use, they will seem inert. The conventions of language are demonstrably related to the problems of philosophy, insofar as philosophy consists of a very general analysis of the powers and limitations of human thought. If the philosopher is to clarify ideas, therefore, he must understand both the structure of concepts and the complex network of rules that underlies the way in which words are used. Wittgenstein considered his whole philosophy as a 'battle against the bewitchment of our intelligence by means of language'. In his paintings with words and images, Magritte also sought to illuminate the confusions and oversimplifications which are so deeply rooted in our habits of language that they are not even noticed. As with most of his important themes, these explorations had already made an appearance by the late 1920s.

Non-paradoxical statements about reality are merely selective conclusions attempting to proclaim that the universe is *only* this or *only* that; this notion was irreconcilable with Magritte's vision. What appears inevitably true in one sense, because it has been endorsed by reason, is an oversimplified and limited notion of the possibilities of experience, since it does not take into account the ambivalent, paradoxical nature of reality. In Magritte's paintings, everything is directed towards a specific crisis in consciousness, through which the limited evidence of the common-sense world can be transcended. For example, although common sense loves precision, 'the intelligence of exactitude does not prevent the pleasure of inexactitude'.

Parallel with his explorations in the 1930s of metaphysical theories about reality and illusion, Magritte was also questioning the ways in which everyday language disguises thought.

Seated figure

In human communication, it is possible to refer to objects in two entirely different ways. They can either be denoted by a name, or represented by a picture showing some likeness or resemblance to the object. But the relation between the name and the thing named is an arbitrarily established one, since the correlation between any word and the thing it stands for exists only by virtue of semantic convention.

In a series concerned with relations between words and objects, or between linguistic and pictorial systems of representation, one of the pilot paintings is *The Key of Dreams*. *113, 114* Two versions are illustrated; both show images of four unrelated objects in a grid; the images are labelled as in a child's picture-book. The first three objects are incorrectly named: picture and label do not designate the same object. In the fourth instance, the object pictured and the label beneath it correspond. Along with the contemporaneous *The* *109* *Use of Words I*, illustrating a pipe that is labelled 'this is not a pipe', *The Key of Dreams* launched one of the most philosophically significant and intellectually difficult of Magritte's themes. Here, he is dealing with the kind of errors which arise from the arbitrary structure of language and thus lead to philosophical misunderstanding. These errors are rooted in features which are so much a part of ordinary thinking that they have become hidden through being too familiar. Wittgenstein has written (but the statement could have as easily been written by Magritte) that 'the aspects of things that are most important for us are hidden because of their simplicity and familiarity. (One is unable to notice something – because it is always before one's eyes.)'[13] That is to say, new and unusual things get noticed; ordinary events do not.

The painted image of a pipe, which makes us think with such precision of a pipe, also causes us to say, by a significant abuse of language, 'This is a pipe'. But an image, according to Magritte, is not to be confused with something tangible. For this reason he has written 'This is not a pipe' beneath the *image* of a pipe. (Magritte's passion for exactitude has for years made him the *bête noire* of certain critics who have accused him of obscurantism and of betraying our own confidence in what we see.) However, it is language itself which provides the trap. Like Wittgenstein, Magritte was concerned with the way in which logic could be used to break the tyranny of words and reveal the confusions which originate in the very forms of our language – confusions which would never be discovered if no one were able to see the philosophical problems involved. The word 'dog', for

example, as William James once pointed out, does not bite. Nor is there anything especially pipe-like in the word 'pipe'. Both Magritte and Wittgenstein had embarked contemporaneously, but without knowledge of each other, on a therapeutic analysis of the specific logical disorders produced by language. Magritte used certain paradoxical formulations which arise out of hidden inconsistencies in the structure of thought and language, rather than those paradoxes (or antinomies) which occur in formalized systems like logic or mathematics.

Wittgenstein's propositions often took the form of the nonsensical. He intended them to be used as steps on a ladder which would be thrown away once it was climbed. In *The Use of Words I*, Magritte has undertaken a similarly nonsensical activity with the pipe: he names what does not need to be named (because it is already familiar), and does so by denying that it is what it is. Nevertheless, the 'logic' is indisputable: that pipe will never be smoked. Normally, a label associates together those objects which it applies to, but in this case a characteristically paradoxical situation arises. There is nothing but a representation of a pipe, situated in an undefined and uncommitted space, together with the inscription. Although the image and the text are demonstrably related, it is difficult to say that the assertion in the text is either true or false. It is neither a contradiction, a tautology, nor a necessary truth, since nothing can be a pipe and not a pipe at the same time. In a later elaboration of the same idea, *The Air and the Song*, Magritte continues to correct the same paradoxical 'error': he draws a picture which will never *be* a pipe (because it is only a representation) and affirms that it is *not* a pipe. (You can point out the moon with your finger, states a Zen proverb, but you must be careful not to mistake the finger for the moon.) This time the pipe has been carefully placed in a framed space, which is intended to define its character as an *image*. At first glance this would seem no more than a simple contradiction which violates the same basic law of logic. However, if we examine more closely what has been so clearly defined this time, by its rather jokey frame, as *the image of a pipe*, we discover that Magritte has now stepped outside the frame of the paradoxical formula. The pipe casts a shadow as if it were a real three-dimensional object and not an image; and a puff of smoke issuing from the pipe has wafted its way outside the frame, suggesting that it is 'real' smoke! But being and representing are not the same, nor does an object perform the same function as its image.

109

111

108 The Proper Meaning IV · *Le sens propre IV* 1928–29

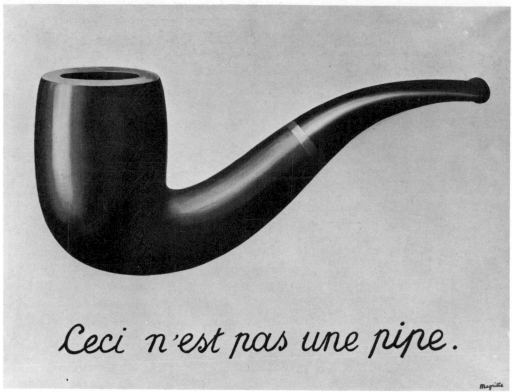

109 The Use of Words I · *L'usage de la parole I* 1928-29

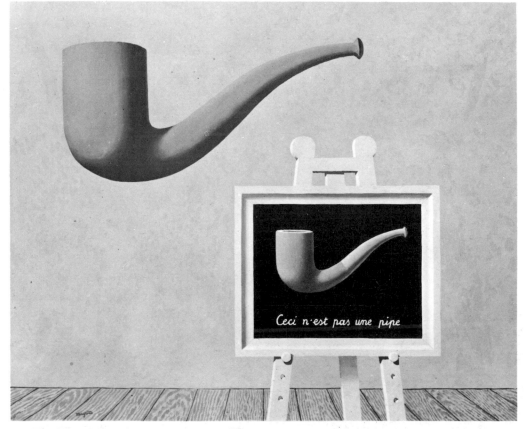

110 The Two Mysteries · *Les deux mystères* 1966

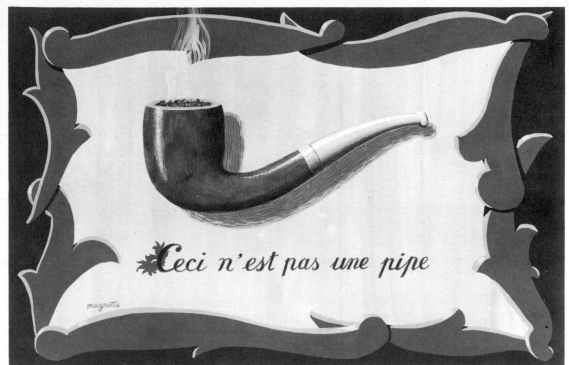

111 The Air and the Song · *L'air et la chanson* 1964

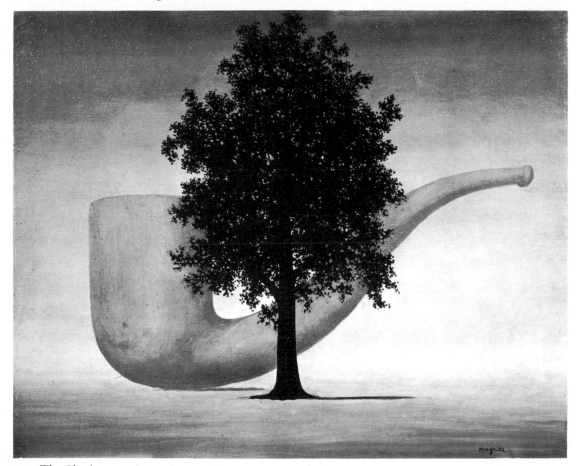

112 The Shadows · *Les ombres* 1966

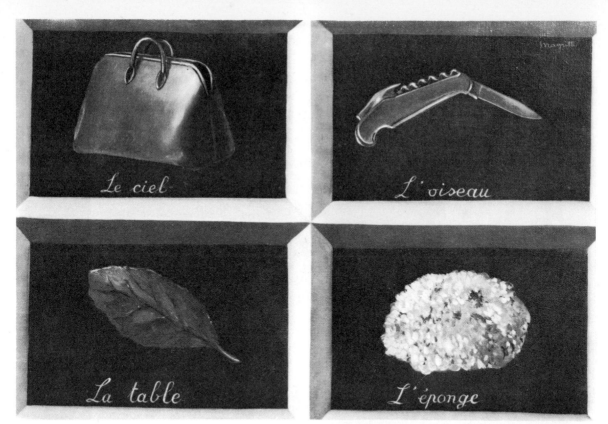

113 The Key of Dreams · *La clef des songes* 1930

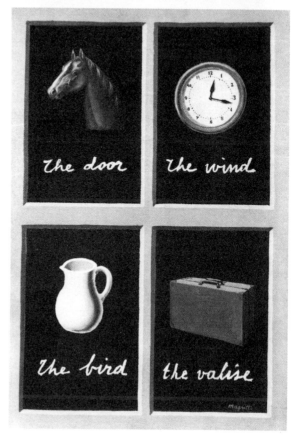

114 The Key of Dreams · *La clef des songes* 1936

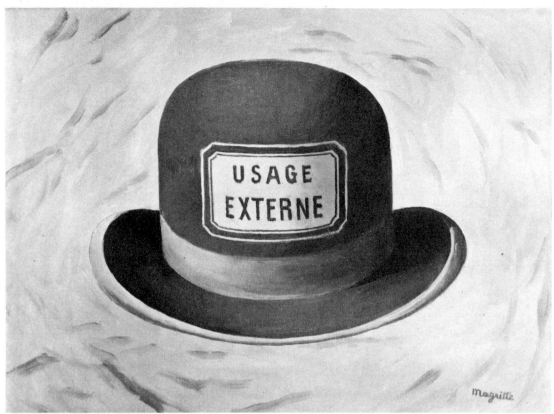

115 The Fright Stopper · *Le bouchon d'épouvante* 1966

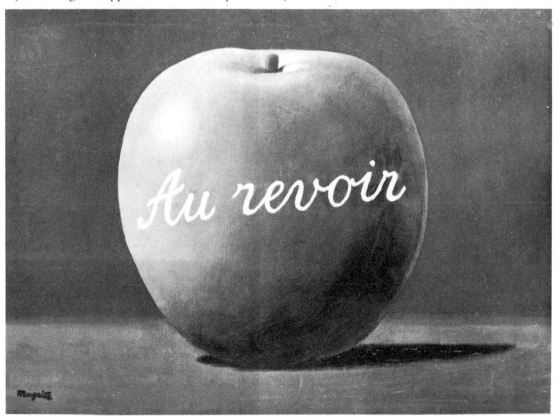

116 Guessing Game · *Le jeu de mourre* 1966

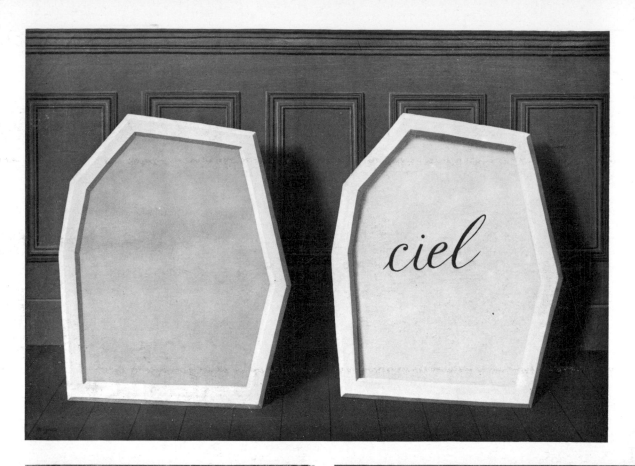

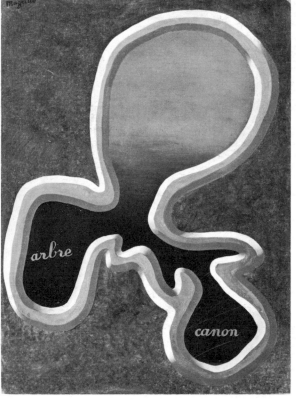

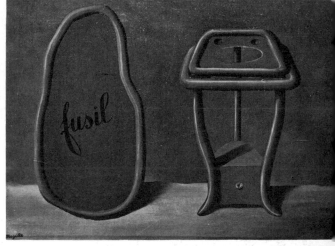

117 The Palace of Curtains III
 Le palais des rideaux III 1928-29

118 The Blue Body · *Le corps bleu* 1928

119 The Duo · *Le duo* 1928

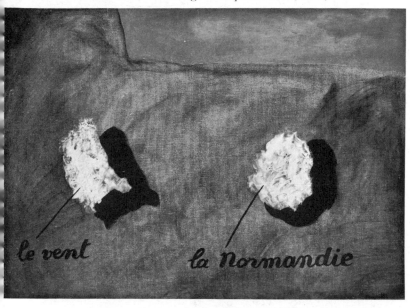

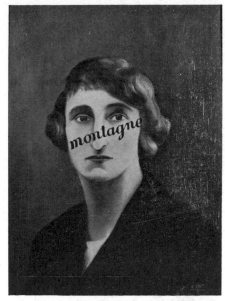

121 The Phantom Landscape
Le paysage fantôme 1928-29

122 Figure Walking towards
the Horizon
*Personnage marchant
vers l'horizon* 1928-29

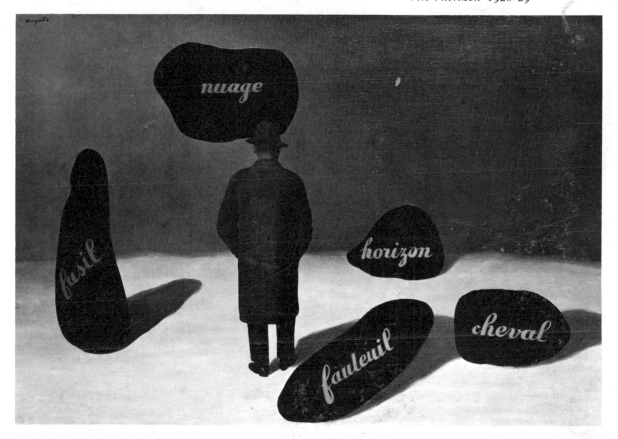

123 The Imprudent One · *L'imprudent* 1927

de Bruxelles, recevez et partagez avec eux et avec mes amitiés.

Merg.

ci-joint un plan de pipe:

Section drawing of a pipe

An image is more like another image than it is like the thing it represents. (An image may represent a pipe, but the pipe does not represent the image.) In fact, an image may represent anything at all, as Magritte has shown in *The Key of Dreams*. His pictorial representations and his verbal descriptions have been arbitrarily realigned so that they no longer correspond in the usual way. The image of a horse is labelled 'door'; a clock is labelled 'the wind'. Normally objects are classified under words like 'tree' and 'shoe', and also under pictures that represent them. The more stereotyped these labels and their uses are, the more likely it is that the represented will be confused with the representation. The resulting confusion is generally called 'realism': when it is present in the highest degree, the two are indistinguishable.

114

To say what a thing is, according to Magritte, does not eliminate the incapacity to say what a thing is. Words do not render objects, but remain foreign and indifferent to them. (Johns has also explored various forms of representational and verbal contradiction in his paintings about colours, where for example the word 'red' is applied in yellow to identify a blue patch.) These paintings show that representation is a complex process which involves more than mere mirroring or the imitation of objects. It is a symbolic relationship that is both relative and variable. For a picture to represent an object, it must be part of a known system of representation, a system which classifies objects rather than one which imitates them. Magritte has written a splendid essay in elucidation of the hazards of both pictorial and linguistic systems of representation. It is quoted here in full.[14]

An object is not so possessed of its name that one cannot find for it another which suits it better:

There are objects which do without a name:

A word sometimes only serves to designate itself:

An object encounters its image, an object encounters its name. It happens that the image and the name of that object encounter each other:

Sometimes the name of an object takes the place of an image:

A word can take the place of an object in reality:

An image can take the place of a word in a proposition:

An object can imply that there are other objects behind it:

Everything tends to make one think that there is little relation between an object and that which represents it:

The words which serve to designate two different objects do not show what may distinguish those objects from one another:

In a painting the words are of the same substance as the images:

One sees differently the images and the words in a painting:

Any shape whatever may replace the image of an object:

An object never performs the same function as its name or its image:

The visible contours of objects in reality touch each other as if they formed a mosaic:

Vague figures have a meaning as necessary and as perfect as precise ones:

Sometimes, the names written in a painting designate precise things, and the images vague things:

Or the contrary:

Magritte's tract reveals the nature of his preoccupations in the word-and-image paintings. It is also a brilliant analysis of the vagueness and ambiguity of language. (This vagueness causes us to see words whose meanings fluctuate like shapes in a mist.) It closely resembles Wittgenstein's concept of language as a collection of language-games instead of a picture of facts, in which he postulates that knowing the names in a language is less than learning how to speak it, just as learning the names of playing-cards, or of the pieces in chess, is not learning to play bridge or chess. In the same way, a name without a criterion for its proper use (that is, for which no rules exist) has no meaning unless it has a context. The meaning of a sentence depends on the way in which it is used, rather than on what it refers to. For example, a sentence without application, like 'red is industrious', is without meaning. Words have uses and these uses are largely determined by the rules of language and the particular relations of the words. Thus, 'agreement or disagreement with reality' would be something different in different languages. In Wittgenstein's view, it is misleading to talk of words 'standing for things' or 'having meanings', since everything depends, not on the words themselves, but on the way in which we use them.

118, 108 Magritte takes a similar attitude, especially in paintings like *The Blue Body* and *The Proper Meaning IV*, where written words designate, or take the place of, things. The fact that for example the words 'sad woman' can replace the image of a sad woman proves that resemblance is not a necessary feature of reference.

Representations are pictures that function in much the same way as verbal descriptions. For a picture to represent an object, it must be a symbol for it and must refer to it in some way; but resemblance alone is not enough to establish a relationship of reference. In fact, representation is entirely independent of resemblance, since almost anything may stand for anything else. Any object may be called by any name (the chief of a certain African tribe was called Oxford University Press and there were girls in Nyasaland whose name was Frigidaire). Or, as Magritte has shown, a name can replace the image of an object. In the same way, almost anything can be used as a sign, provided there is agreement about its use; signs do not have a meaning in themselves. Their meaning derives from agreement about their use.

Everything now tends to make us think that there is little relationship between a real object and that which represents it.

According to Magritte, almost everybody likes a resemblance,
even when there is none. A portrait tries to resemble its
model. But one may also wish the model to try to resemble
his portrait. (To a complaint that his portrait of Gertrude
Stein did not look like her, Picasso is said to have answered:
'No matter; it will.') Magritte rarely painted portraits; he
thought there were enough already in the world. In his only
known self-portrait, he portrayed himself eating dinner with *132*
four arms.

Resemblance and representation are not the same: an
object resembles itself, but it does not usually represent itself.
As Magritte put it:

We usually attribute resemblance to things which may or may not
have a common nature. We say 'as alike as two peas in a pod' and
we say, just as easily, that the fake resembles the authentic. This
so-called resemblance consists of relations of comparison, whose
similarities are perceived by the mind when it examines, evaluates
and compares. . . . Likeness is not concerned with agreeing with
'common sense' or with defying it, but only with spontaneously
assembling shapes from the world of appearance in an order given
by inspiration.

In an early picture entitled *The Imprudent One*, an image *123*
resembling a person (with his arm in a sling) is seen side by
side with his reflection (as in a non-distorting mirror). This
person and his reflection are on a terrace where a mountain
and a sky form the boundary of the vision. 'If I must "in-
terpret" this image,' Magritte has written, 'I would say (for
example) that the appearance of the figure rediscovers its
mysterious virtue when it is accompanied by its reflection. In
effect: a figure appearing does not evoke its own mystery
except at the appearance of its appearance.' (This calls to
mind once again Duchamp's theories of meta-reality, when he
speaks of 'the picture as the apparition of an appearance'.)

This question of resemblance *versus* identity, suggested by
the image in Magritte's *The Imprudent One*, was also raised by
Rauschenberg in 1957 when he made two quite identical
paintings. Andrew Forge, in his recently published mono-
graph on Rauschenberg, writes about *Factum I* and *Factum II*:

Typically [Rauschenberg] is voicing a contradiction which he
then immediately contradicts. Two paintings *can* be as like as two
peas. No two peas are identical. Given identical ingredients, what
remains that makes this picture this picture, and that one that
one?[15]

Resemblance, however, unlike representation, must be self-reflexive. In *The Shape of Time*, George Kubler maintains that the universe keeps its form by being perpetuated in self-resembling shapes – otherwise our perceptions would be reduced to chaos. However, he writes:

No two things or acts can be accepted as identical. Every act is an invention. Yet the entire organization of thought and language denies this simple affirmation of non-identity. We can grasp the universe only by simplifying it with ideas of identity by classes, types and categories, and by rearranging the infinite continuation of non-identical events into a finite system of similitudes. It is in the nature of being that no event ever repeats, but it is in the nature of thought that we understand events only by the identities we imagine among them.[16]

Similarity, then, is not evidence of identity; nor do like objects represent each other. A symbol exists by virtue of repetitions, and its identity depends upon the same meaning being attributed to a particular form by different users. Magritte has demonstrated the fallibility of this in many ways: by giving concrete names to amorphous shapes, or by placing a label (FOR EXTERNAL USE ONLY), normally associated with medicaments, on a bowler hat, as in *The Fright Stopper*, and disrupting its usual meaning. In the end, resemblance depends more on our mental constructions and modes of representation than it does on actual verisimilitude – pictures look more like the way nature is painted than like nature itself. However, it is true that our modes of representation for the most part tend to generate resemblance; they are really coded systems for establishing principles of recognition. But this is a matter of convention, however, because as Wittgenstein has pointed out, language is not a 'picture' of reality, but is a tool with many uses. To understand a proposition means to know, not necessarily what it pictures, but what it does, what function it has, what purpose it serves. 'One cannot guess how a word functions,' Wittgenstein has written. 'One has to *look* at its use to learn from that. But the difficulty is to remove the prejudices which stand in the way of doing this.' Once again, we could almost take this as a description of the difficulties proposed by Magritte in his word-and-image pictures; according to Magritte, an image of resemblance shows what the resemblance is: namely an assemblage of forms which does not imply anything. Here he is again saying much the same thing as Wittgenstein, only he paradoxically reverses the situation. 'Whatever the strokes, the words and the

117–119

115

colours arranged on a page, the figure obtained is always full *Magritte* of meaning':

And, he goes on, 'To want to interpret it – in order to prove some kind of freedom – is to fail to recognize an inspired image, and to substitute for it a gratuitous interpretation which might become in turn the object of an endless series of superfluous interpretations.'

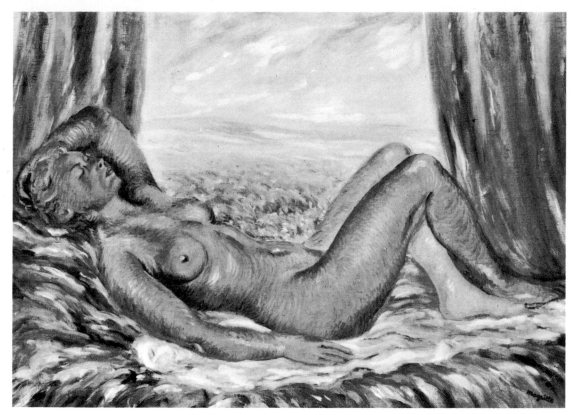

124 The Harvest · *La moisson* 1943

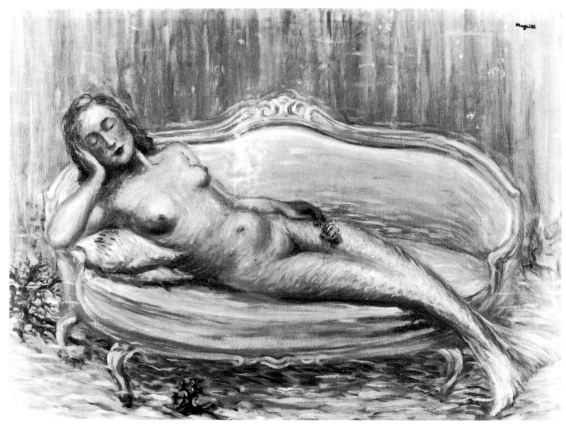

125 The Forbidden Universe · *L'univers interdit* 1943

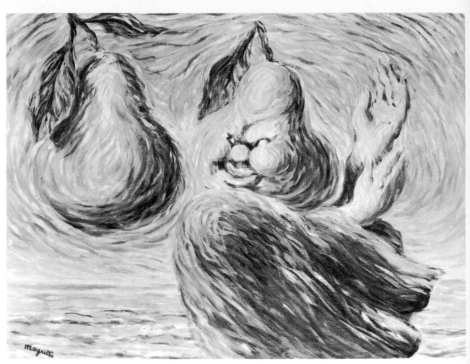

127 The Treatise on Sensations
Le traité des sensations 1944

128 Lola de Valence 1948

129 The Pebble · *Le galet* 1948

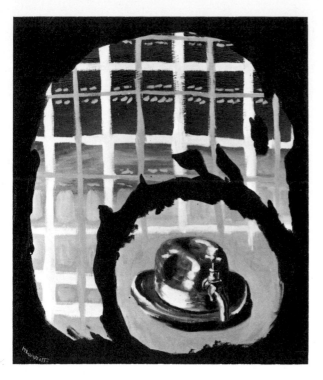

130 The Suspect · *Le suspect* 1948

131 The Rainbow · *L'arc-en-ciel* 1948

Like Duchamp, Magritte needed to have his idea in mind before he painted it. (They both had an aversion to the improvisational aspect of Abstract Expressionism.) In fact, Magritte took a dim view of all abstract art. He wrote at one point:

An ever-prevalent stupidity manifests itself of late in the supposition that painting is now being replaced by a so-called art which is said to be 'abstract', 'non-figurative', or 'informal'; it consists of manipulating 'materials' on a surface with some degree of fantasy and conviction. But the function of painting is to make poetry visible, and not to reduce the world to its numerous materialistic aspects.

Magritte's own painting never evolved stylistically. For him, only ideas mattered, in terms of a subtle modification of daily reality which would simultaneously subvert the traditional relationships between objects and our mechanism of association, and ultimately alter our perception of the world. His early Cubist and Futurist investigations lasted nearly a decade, but remained unconvincing. Thereafter, the style he had adopted by 1926 hardly changed, except for a brief period when he attempted a kind of Surrealist painting, first 'in full sunlight', using the technique of the Impressionists, in 1942, and then in a kind of caricature of Fauvism in 1947. These inroads of style were linked with situations outside the realm of painting, however, and the content of his iconography did not change very much. Moreover, he abandoned these techniques after a few years on the grounds that they added an irrelevant element to the essence of the problems which were his real concern.

Magritte's strange experiment with Impressionism occurred during the German occupation of Belgium, and it was intended as an act of defiance against the abnormal psychological conditions then prevailing. It was meant to celebrate sun, joy and plenitude in opposition to the psychological oppression of the occupation. For Magritte, it was

a way of attempting to counter the ambitions of Hitler by pitting 'joy' against world tragedy and the horrors of the military. His change of style at this moment affirmed a long-standing belief that painting and poetry could change the world. His earlier paintings had expressed anxiety, and the harsh, dark colours had been meant to counter the false optimism of the pre-war years. It was a natural dialectic, therefore, which led Magritte to try to defeat pessimism and despair by changing the atmosphere of his paintings, while still retaining the provocative virtues of his earlier canvases. ('A man asked me again yesterday: "What painting is it which expresses happiness?" In spite of my good will I was unable to make him understand that it was painting which he was happy to look at.')

'The German occupation', he wrote, 'marked the turning point in my art. Before the war, my paintings expressed anxiety, but the experiences of war have taught me that what matters in art is to express charm. I live in a very disagreeable world, and my work is meant as a counter-offensive.' Such willed 'charm' was not without its dramatic effect. The idea was, in a way, scandalous – if not terrible: at a moment when horror was rampant, there was a certain absurdity in trying to charm. But it was not just a monstrous joke. It was quite in keeping with the provocative intentions of his more sombre work that Magritte should attempt to achieve, through images of pleasure and happiness, as strong an impact as he had 124–127 achieved through disturbing images. Thus, this period, which lasted through much of the 1940s, was characterized by gay flamboyant colours and meaty, swirling brushstrokes. The subjects were often sensuous and erotic – nude women reclining luxuriously as in *The Harvest* with multi-coloured 124 limbs like the brilliant feathers on a parrot. There were also iridescent landscapes, and one of the few instances in Magritte's painting of a nude man – a giant reclining figure whose erect penis is the figure of a woman (*The Ocean*, 1942). A number of important images originating in this period have already been discussed: *Common Sense*, the portrait of Fan- 75, 40 tômas, and the leaf-birds, as in *The Natural Graces*. But this 95 phase in Magritte's career has always aroused hostility, so much so that when the Museum of Modern Art in New York organized its Magritte retrospective in 1965, all examples of the Impressionist, or 'Renoir', period were suppressed. A Belgian critic, writing in 1944, at the time the work was made, reflected the general attitude critics have always taken in his manifest outrage at Magritte's 'exploitation' of Renoir:

'That which represented the final flowering of one of the most beautiful painters of all times, the last glow of a charming and sensual soul, is now the ridiculous tool of the most bigoted of disciplinarians.'[17]

No doubt a certain taste for Impressionist painting, and for Renoir in particular, intervened in Magritte's thought at this time. Even his subject-matter shows the influence of Renoir; many of Magritte's nudes suggest Renoir's bathers. It is also true that the later pictures of De Chirico, which he admired, were painted in a similar Renoiresque style. Magritte detested monotony, and a desire to change his style, without changing his spirit, also contributed to this move. He had had enough, not only of smooth and precise painting, but of painting altogether, and was seeking a means of self-renewal. In a sense it could be said that he called painting itself into question, much as he had previously called objects into question. The Impressionist style became itself subject-matter, in the same way that Roy Lichtenstein has used the Art Déco style of the 1930s. Thus, Magritte's 'sunlit' style (which is how he referred to it originally) served as a kind of detonator to induce a new pictorial ferment.

The *Vache* period which followed directly after it, in 1947, was the result of a similar impulse. It lasted, however, only for two weeks. Magritte coined the term *vache* himself, as a parody on the word *fauve*. (In French *fauve* means 'wild beast', while *vache* means 'cow'; in this particular context the word has usually been translated into English as 'nasty'.) He hoped the paintings would annoy the Parisians, who seemed to him at the time overly complacent and self-satisfied in their artistic tastes and habits. Magritte was attacking their facility by making a painting a day, crudely and uncensored by his usual deliberation. In a truculent technique of instant gestures and angry brushwork, he tried to caricature the Fauvist style. The subjects were often aggres-

129 sively erotic, as with the woman in *The Pebble*, who is holding her breast while licking her own shoulder, and the faucet

130 attached to the hat in *The Suspect*. These paintings look pseudo-decorative, with awkward and facile patterns as part

131 of the format. In *The Rainbow*, he parodies his own word-and-image theme, with ambiguous scrawled shapes which have been given the following sequence of labels: 'The Day-labourer', 'The Syphilitic', 'The Apostle', 'The Sybarite' and 'The Devout'. The fifteen oil paintings and ten gouaches which comprise the total output of this 'period' were exhibited in 1948 in Paris in the Galerie du Faubourg. (The

151

catalogue contained a satirical text by Scutenaire, who now owns almost all the paintings, having been one of their few admirers.) The exhibition had a scandalous effect on public and critics alike, and they reproached Magritte furiously, as it seemed, for being Belgian (and not French) and for not living in Paris (the artistic capital of the world). They reproached him further for 'painting like Renoir' and for the unforgivable vulgarity of the *Vache* pictures. But most of all, they reproached him for having once been a good painter. Even the Surrealists were critical. At the time of the exhibition, Magritte wrote to Scutenaire from Paris:

Eluard 'likes' my exhibition, but he would prefer to *buy* 'the Magritte of yore'. His equivocal word . . . must be taken in a good sense, he claims. He wouldn't like to have the exhibited paintings 'on his walls', even though he likes them (no doubt because we no longer look at paintings once they are on the wall).

In response to these critical reactions, Scutenaire wrote a mock biography in which he reinvented a life of Magritte designed to please the Parisians. Magritte was supposed to make illustrations to accompany the text, but he never did. It was to have had the form of a comic strip, modelled on the popular woodcuts of Epinal, for publication in a *revue de tracts*. In the text, Scutenaire recreates Magritte *as a Parisian*, for the pleasure of his critics. 'Magritte of Yore' – that is, Magritte who used to be able to paint – now lives in Paris and participates actively in the gay artistic life of the times. The text, which has never been published, is printed at the end of this book. It is distinctly anti-French, and travesties most of the attitudes which held sway in those milieux at the time.

In the end, the universally negative reception accorded to his work of this period left its mark, and Magritte responded with his usual resignation strongly tinged with irony. He wrote to the Scutenaires:

This is no doubt the last orthographic ejaculation I shall send you from Paris. Zero, if the results are measurable. . . . There are a few visitors at the exhibition (the young girls have a tendency to laugh, but they restrain themselves because it is inappropriate in an art gallery). There are the usual asinine remarks like 'It's less profound than it used to be', 'It's Belgian wit', 'You can tell it's not French', 'What a brushstroke!', 'What a beautiful torso'.

But finally he capitulated; again, not without irony:

Impressionist and 'Vache' Periods I should like to persist even more strongly with the 'approach' of my experiment in Paris – it's my tendency anyway: slow suicide. But there's Georgette to consider and the disgust I feel at being 'sincere'. Georgette prefers the well-made pictures of 'yore'; alas, *especially* to please Georgette I shall exhibit only the painting of yore from now on. And I'll certainly find some way to slip in a big fat incongruity from time to time. . . .

10 The Bowler-Hatted Man

Magritte was the most paradoxical of all the Surrealists. Where the others deliberately created scandal in life, he tried to remain outwardly inconspicuous. In more than one sense it could be said that Magritte's artistic biography ended when he left Paris in 1930. After his return to Brussels his life became more and more that of an ordinary bourgeois. He hated travelling; and he lived with only his imagination geared to change. It was as if he were deliberately trying to obscure himself from worldly success under the protective coloration of conventionality. His desire to live without history (even his own) and without style, was a calculated choice to render himself invisible – perhaps in the manner of Fantômas. There was nothing unusual about his physical appearance; he resembled nothing so much as the nondescript bowler- *133, 136* hatted man who appears in his pictures. By choice his life was outwardly uneventful, and consisted of a modest network of regular habits: the daily morning walk with his Pomeranian dog Loulou to buy groceries, an afternoon visit to the Greenwich Café where he would sit for hours engrossed among the chess-players, the ritual Saturday gathering of a few friends. The house in which he lived, along with the others surrounding it, resembles the houses in his paintings – a fact as touching, Scutenaire has observed, as it is unimportant. Inside, it was filled with department store antiques, com- *1, 2* fortable sofas and chairs, china vases, Oriental rugs and a baby grand piano. Magritte never had a special studio, but painted in the boudoir which adjoined the bedroom. (In previous houses he used to work in the kitchen or the dining-room – there was only an easel, a tray of paints and brushes, and a few bits of charcoal for sketching on the canvas, with hardly any outward trace of activity.) In many ways he seemed to live hypothetically, almost as if he doubted the existence of the external world. All the same he had a taste for fake situations, and was a master of the practical joke.

I have already shown how most of Magritte's major themes had made their appearance by the 1930s, and that the paintings which followed were mature elaborations of these earlier

intimations. As a result, the corporate body of his work contains many versions of one idea, which evolved at length through antitypes and derivatives, originals and copies, variants and transformations. Drawings like the following, made shortly before he died, illustrate very well this process of cross-breeding among his thoughts:

Magritte's reluctance to draw attention to himself is mirrored in the anonymity of the bowler-hatted man, a theme which

147

developed mostly during his later years, and which has since come to be identified with himself. The bowler-hatted man is rather like Ulrich in Robert Musil's long novel *The Man Without Qualities*: he has given up his 'qualities' as a man might give up the world. Magritte's bowler-hatted man is more like a figure in a book than a human being, but a figure with all the inessential elements left out. Like Ulrich and like Magritte himself, he seems to live the history of ideas rather than the history of the world. He suggests a man compelled to live against his own grain, although he lets himself drift along without any constraint. Impassive and aloof, he fixes the world in his gaze, but often his face is turned from view, dislocated, or otherwise concealed or obliterated by objects, as if expressing a universal disinclination, for which there exists no complementary inclination.

A metaphysical loneliness, bordering on the spiritual and the stoical, surrounds the bowler-hatted man, as though he had been born with a gift for which at present there is no outlet. It detaches him from experience with a certain haughty exclusiveness that is provocative in its very coldness. In this he suggests Baudelaire's concept of the 'dandy', for his very air of coldness implies opposition and revolt: the compelling need to combat and destroy triviality. According to Baudelaire, 'dandyism is a sunset; like the declining daystar, it is glorious, without heat and full of melancholy . . . a latent fire which hints at itself and which could, but chooses not to, burst into flame.' But in a sense, this refusal to 'be' anything also represents the human type that our time has produced. And so, the collective physiognomy of the bowler-hatted man becomes representative of a group soul, reflecting a pattern of submerged values of which it does not matter, in the last resort, whether or not they were intended by Magritte. The bowler-hatted man is a perfect vehicle for our projections. He takes on an increasingly mythological aspect; like Duchamp's bachelors in the *Large Glass*, he has come to represent all men.

He is an observer of phenomena, for whom the point of gravity seems to lie, not in the individual, but in those relations of uncertainty which at present reflect the philosophical mentality of modern physics. It has been shown in our time that everything in the physical world is relative to an observer, and that the spatial and temporal properties of physical occurrences are in large part dependent upon the observer. Moreover, relativity has radically altered the philosophical ideas of space and time and their relation to matter; where previously events could be ordered in time independent of

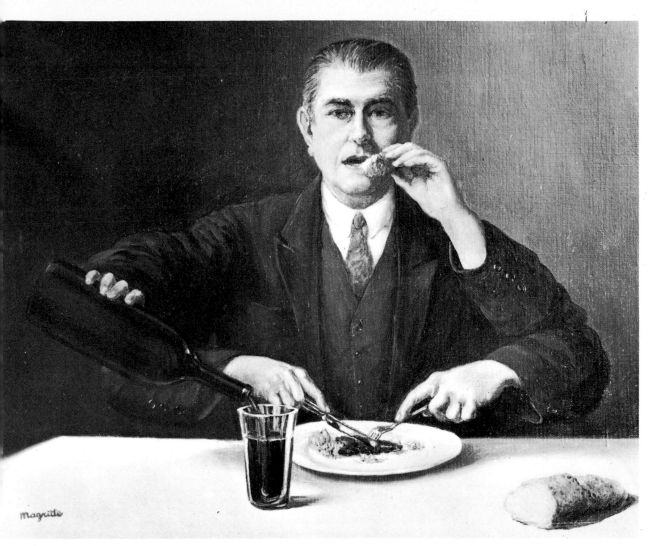

32 The Magician · *Le sorcier*

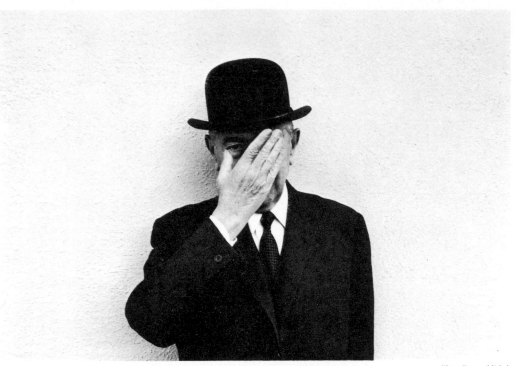

Photo Duane Michals

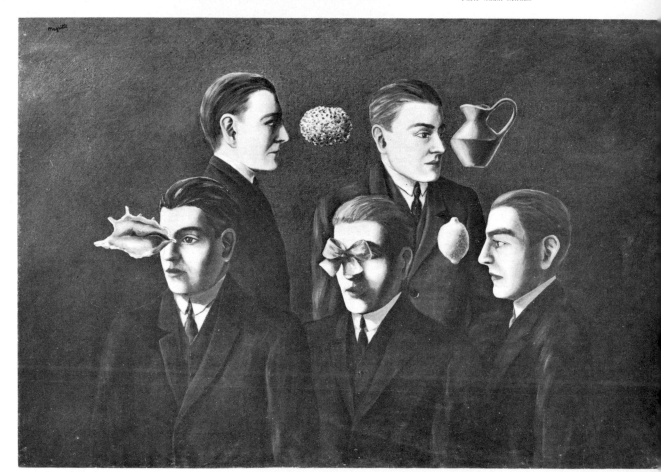

134 Familiar Objects · *Les objets familiers* 1927-28

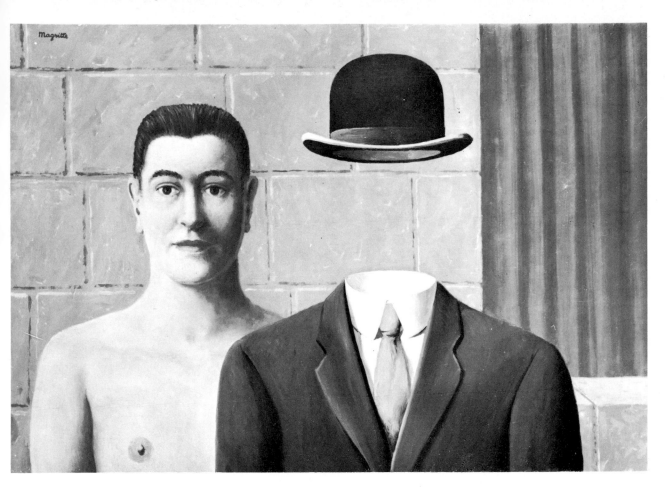

135
The Road to Damascus
Le chemin de Damas 1966

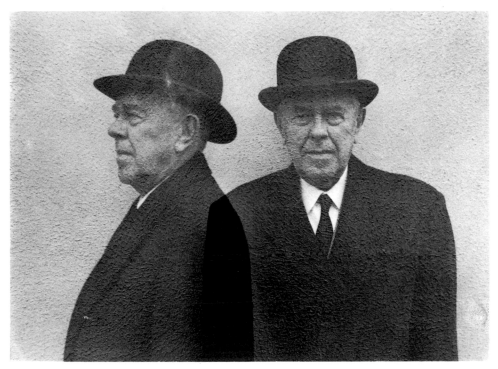

136 Double portrait of the artist, 1965

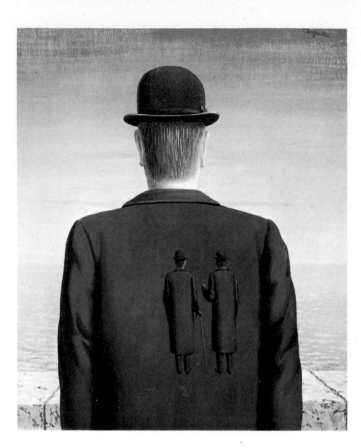

137 The Spirit of Adventure
L'esprit d'aventure 1960

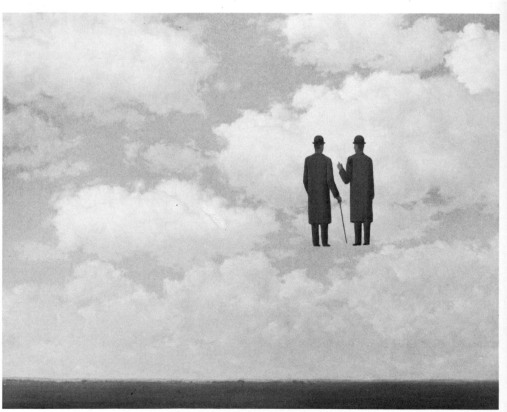

138 Infinite Gratitude · *La reconnaissance infinie* 1963

139 The Pilgrim · *Le pèlerin* 1966

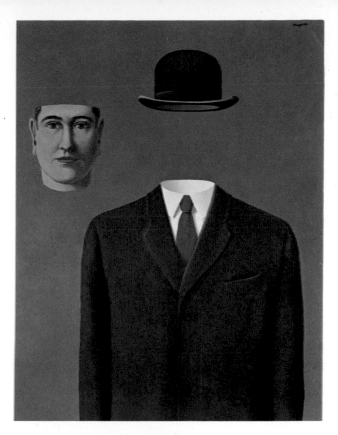

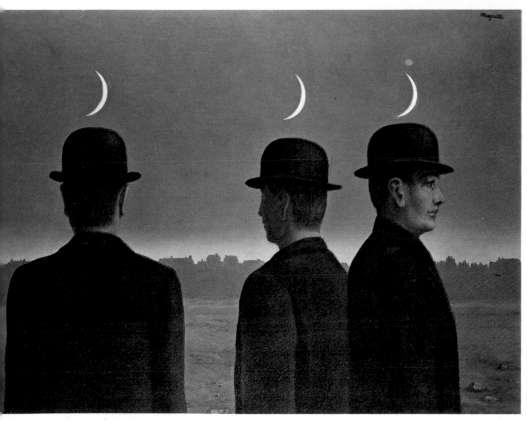

140 The Masterpiece or the Mysteries of the Horizon · *Le chef d'œuvre
ou Les mystères de l'horizon* 1955

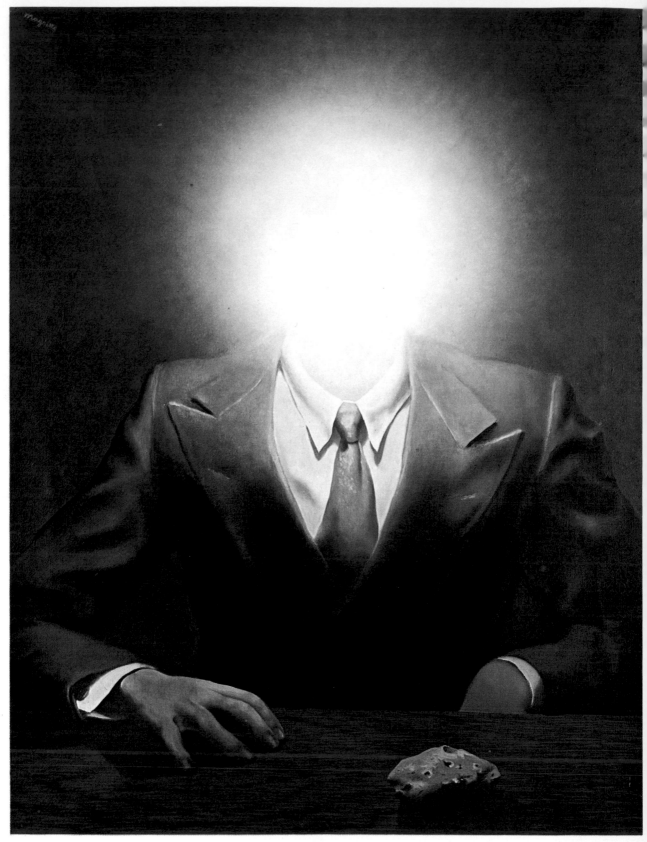

141 The Pleasure Principle · *Le principe du plaisir* 1937

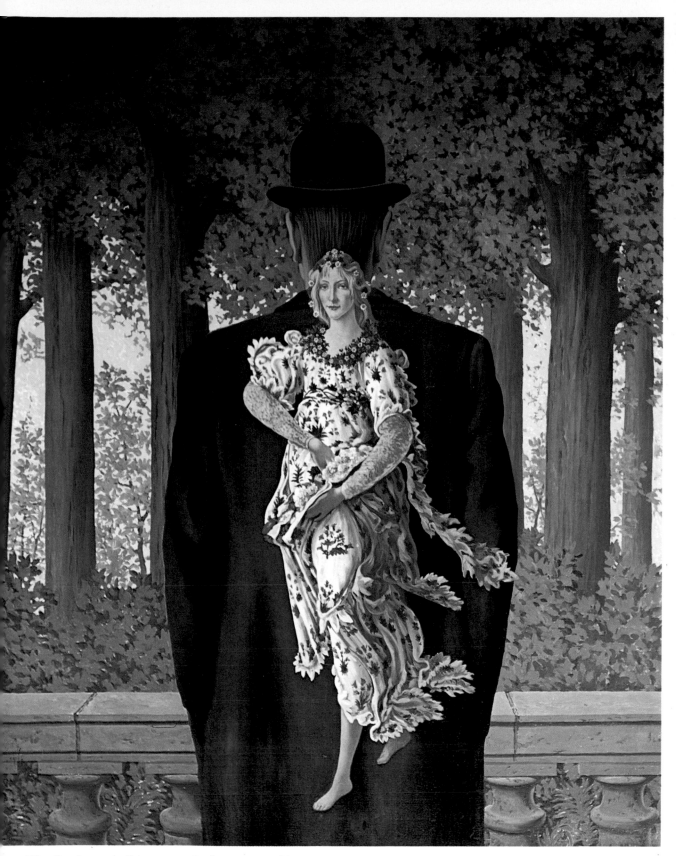

42 The Ready-made Bouquet · *Le bouquet tout fait* 1957

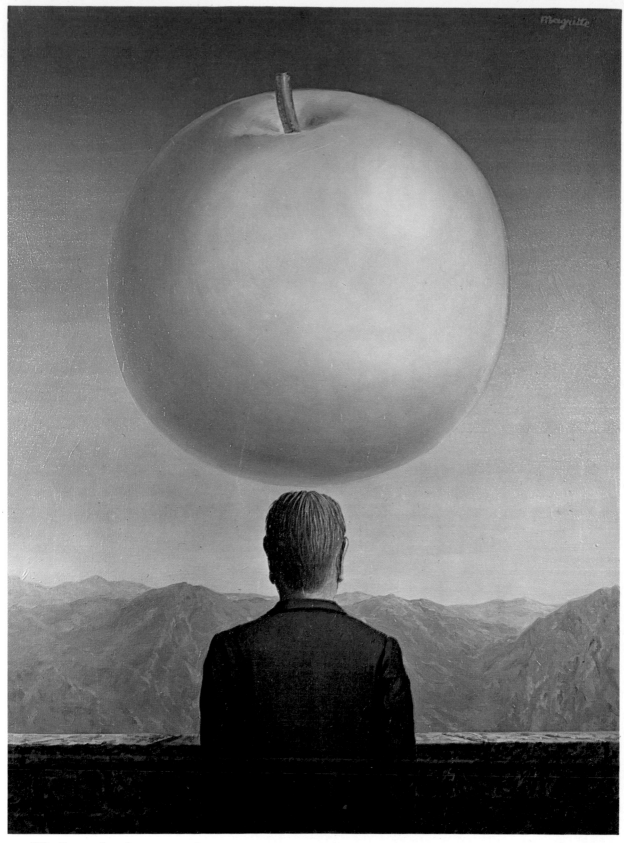

143 The Postcard · *La carte postale* 1960

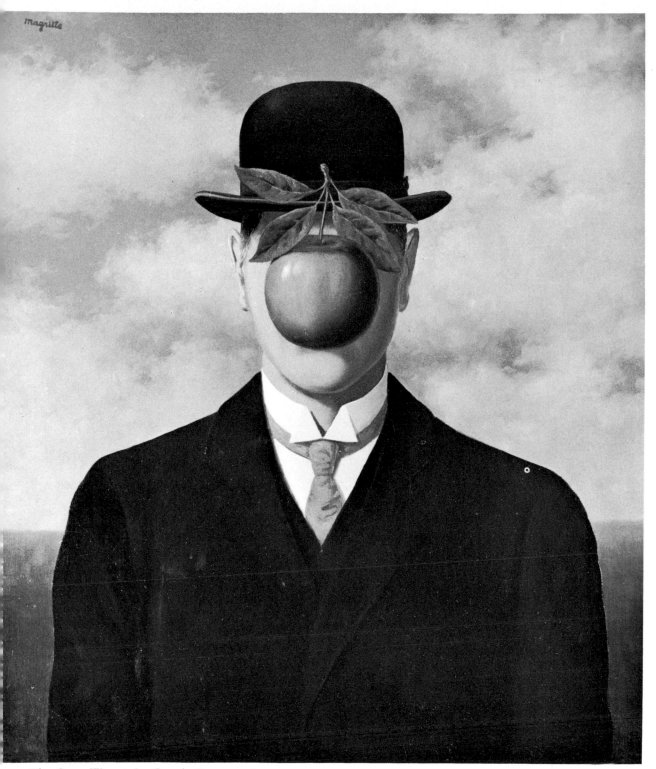

144 The Great War · *La Grande Guerre* 1964

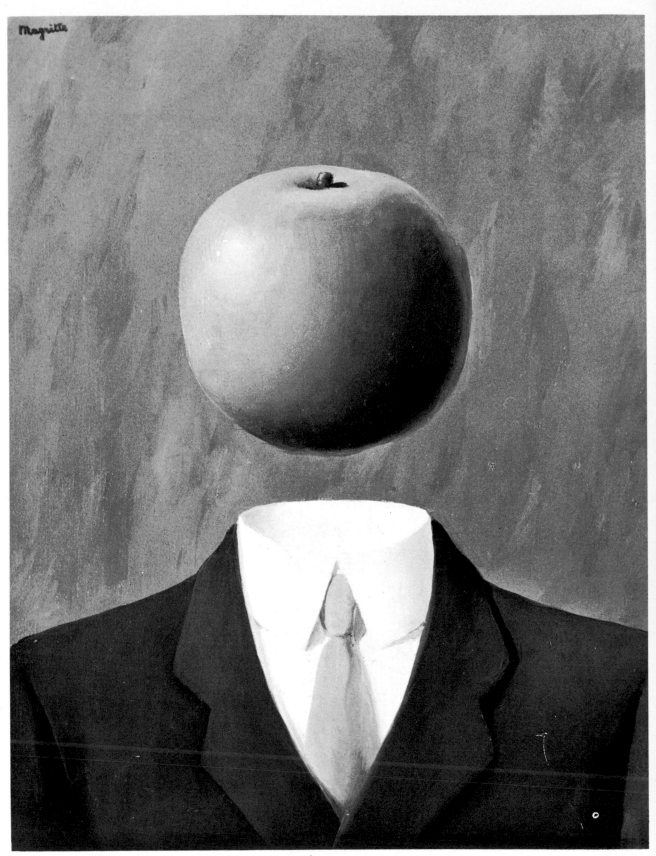

145 The Idea · *L'Idée* 1966

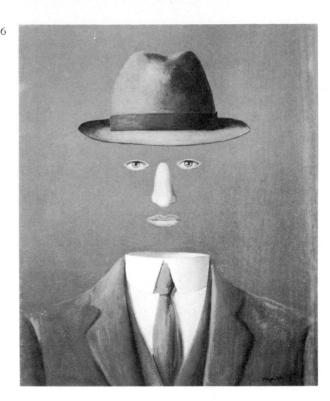

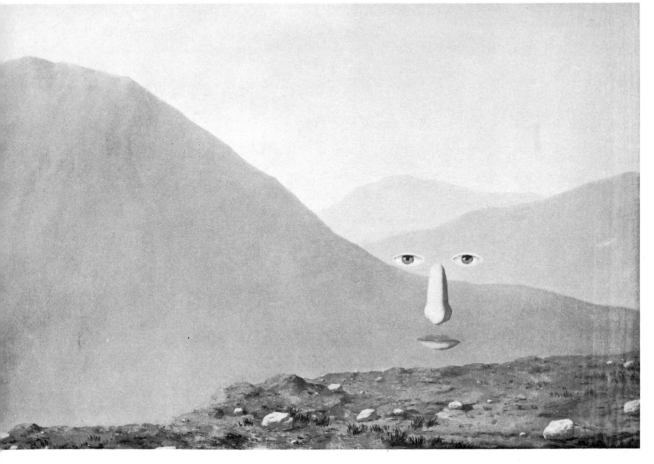

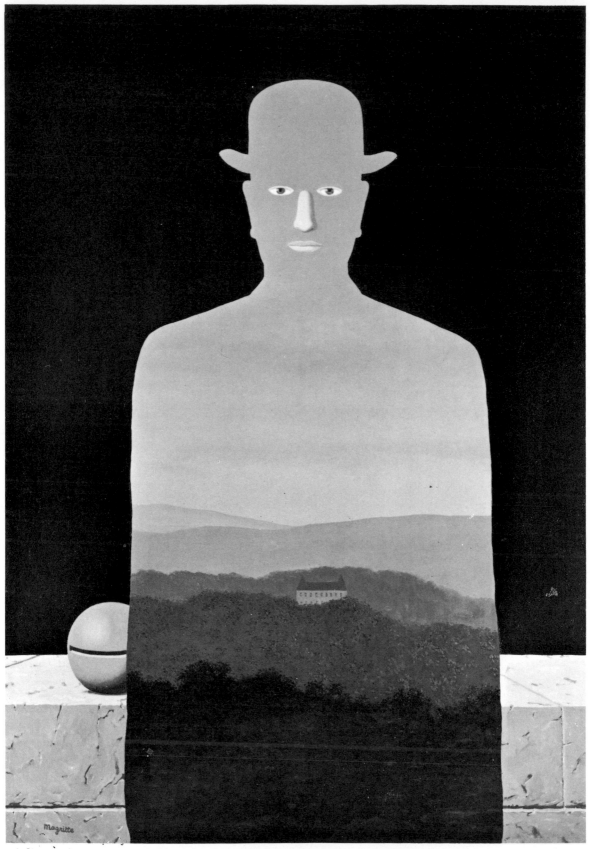

148 The King's Museum · *Le musée du roi* 1966

their location in space, we now know that there is no such thing as absolute rest or absolute motion. Magritte's images show an extraordinary sensitivity to the changes which have occurred in our conception of reality as a result of the shift from Newtonian mechanics to formulations of relativity and quantum theory. In his paintings, events separate in time become simultaneous, and physical laws are defied in a way that questions any dogmatic view of the physical world. For example, the relation of the horse to the trees in *Carte Blanche* suggests certain problems relating to the structural nature of space and time; similarly, the 'floating' rocks and apples suggest problems of position and motion in space.

22

97, 145

For Magritte, physical laws consist of a delimitation of possibilities; they represent an unalterable channel for the course of events which he is constantly challenging. Modern physics has shown that once it is discovered that a law does not hold in circumstances in which it had hitherto always been thought to hold, it is necessary to search out new conditions of applicability as yet unidentified. Facts are not obliged to govern themselves according to our ideas; only our expectations are governed by our ideas.

Magritte casts doubt on the absolute value of laws in the way that Duchamp did, as though it were intolerable to put up with a world established once and for all. As Robert Lebel has pointed out, even gravity for Duchamp was a coincidence or form of politeness, since it is 'by condescension that a weight is heavier when it descends than when it rises'.[18] In Magritte's images of the bowler-hatted man and the apple it is impossible to say whether the apple is rising or descending, or whether it is suspended in space or is in motion. (That an apple is subject to the law of gravity cannot meaningfully be said to occur at a definite moment or to have taken a long or a short time.) As with the rock in *The Battle of the Argonne*, it is impossible to define the apple's position; nor can we determine if it is stable or moving. (The psychologist Piaget has even gone so far as to define equilibrium as a process rather than a state, concluding therefore that any impression we have of comparative stability is due only to the grossness of our senses.) All that we know is that in a given gravitational system, all bodies behave exactly alike. Aristotle thought that heavy bodies fall faster than light ones. Galileo showed that this is not the case when the resistance of the air is eliminated: in a vacuum a feather falls as fast as a lump of lead. Newton related the fall of an apple to the motion of the moon round the earth. Einstein linked time with space, mass with energy,

98

and the path of light past the sun with the flight of a bullet. Magritte
Magritte's images seem to subsume all these ideas at once.

What has become obvious is that the old concepts do not fit nature accurately. The probability function, introduced into physics by quantum theory, does not in itself represent a course of events in the course of time: it merely represents a tendency for events and for our knowledge of them. The so–called 'quantum jump' registers the transition from the 'possible' to the 'actual', since observation selects of all possible events the actual one that has taken place. According to Heisenberg, the probability function introduced something standing between the idea of an event and the actual event – just in the middle between possibility and reality (which perfectly describes many of Magritte's images).

By contrast, classical Newtonian physics had postulated a permanent external world, fixed in its ways and independent of human beings. It had assumed that the world could be described objectively – that is, without reference to ourselves – and that all phenomena could be accounted for in mechanical terms. Scientific laws were always based in a strictly causal or deterministic view of events. But this separation of the world and the self generated an irreconcilable conflict between free will and determinism, which were doomed to remain incompatible so long as man imagined himself as having either complete control over his existence or none at all. Magritte has written:

If one is a determinist, one must believe always that one cause produces the same effect. I am not a determinist, but I don't believe in chance either. It serves as still another 'explanation' of the world. The problem lies precisely in not accepting any explanation of the world, either through chance or determinism. I do not believe that man decides anything, either the future or the present of humanity. I think that we are responsible for the universe, but this does not mean that we decide anything.

The other day someone asked me what the relationship was between my life and my art. I couldn't really think of any, except that life obliges me to do something, so I paint. But I am not concerned with 'pure' poetry nor with 'pure' painting. It is rather pointless to put one's hopes in a dogmatic point of view, since it is the power of enchantment which matters.

As for the power of enchantment, Elizabeth Bowen once wrote: 'Where would Wonderland be without the dogmatic lucidity of the temperamentally unadventurous Alice?'

150 David's 'Madame Récamier'
Madame Récamier de David 1967

149 Perspective: David's 'Madame Récamier'
Perspective: Madame Récamier de David 1951

151-3 Studies for sculpture:
David's 'Madame Récamier' 1967

154 The Therapeutist · *Le thérapeute* 1967

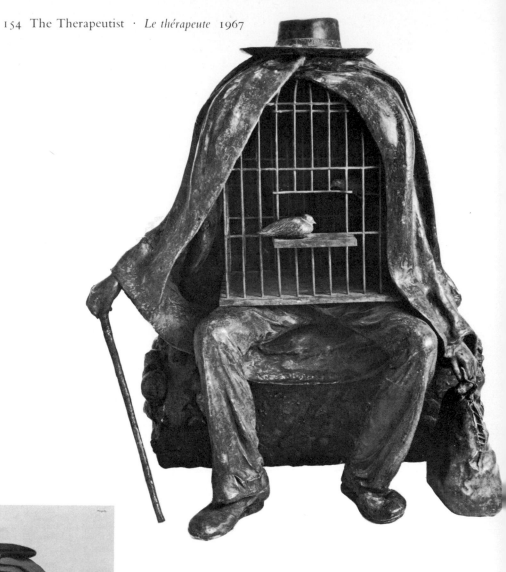

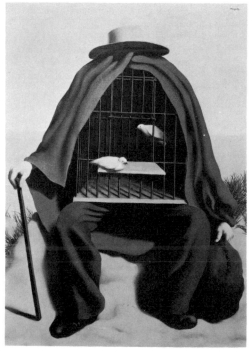

155 The Therapeutist · *Le thérapeute* 1937

156 The Labours of Alexander · *Les travaux d'Alexandre* 1950

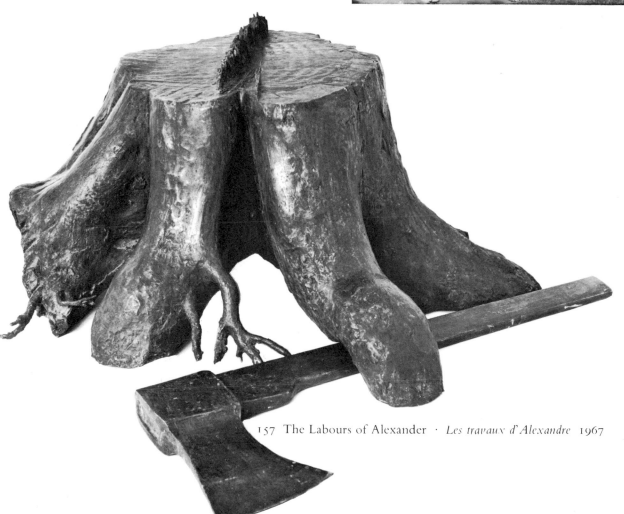

157 The Labours of Alexander · *Les travaux d'Alexandre* 1967

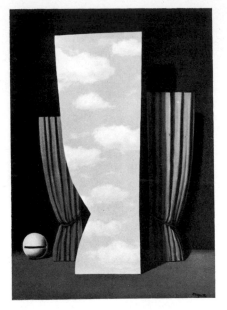

161 The Gioconda · *La Joconde* 1967

158 The Gioconda · *La Joconde* 1960

159 Study for sculpture: The Gioconda 1967

160 Study for painting of curtain: The Gioconda 1967

162-163 Studies for sculpture:
The Natural Graces 1967

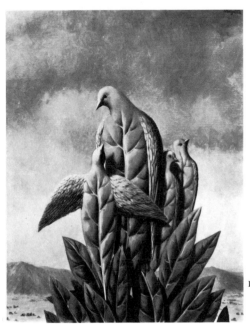

165 The Natural Graces
Les grâces naturelles
1963

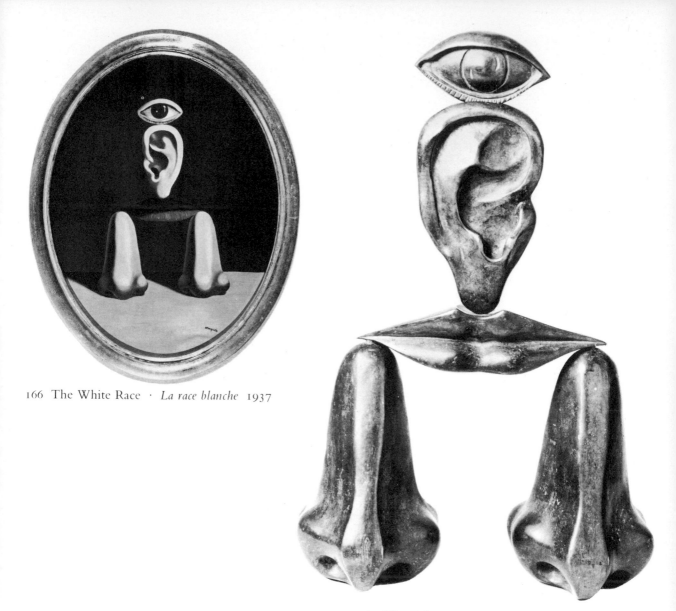

166 The White Race · *La race blanche* 1937

167 The White Race · *La race blanche* 1967

168 Study for sculpture: The White Race 1967

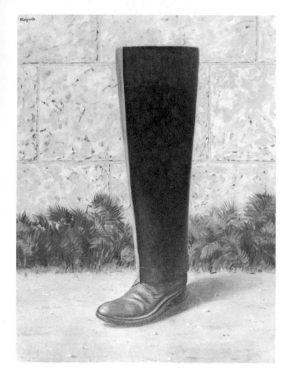

169 The Well of Truth · *Le puits de vérité* 1963

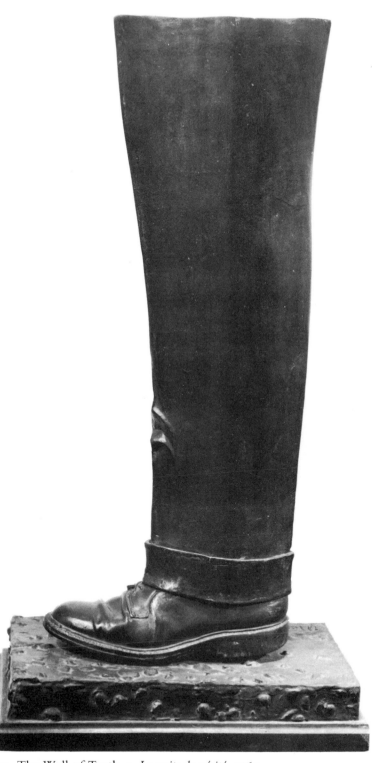

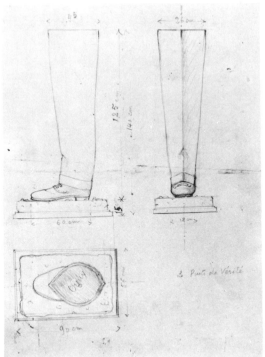

170 Study for sculpture: The Well of Truth
1967

171 The Well of Truth · *Le puits de vérité* 1967

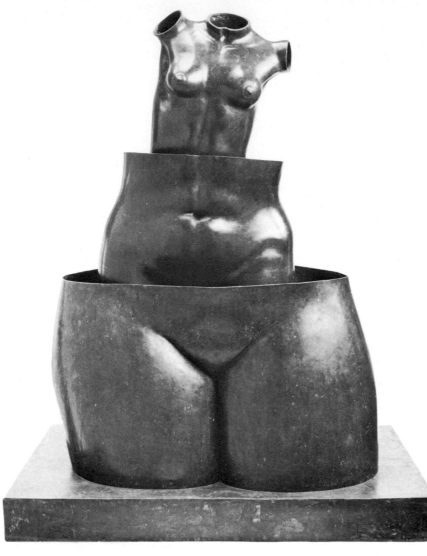

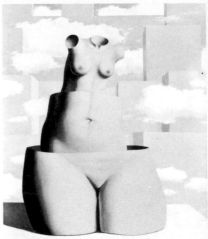

173 Delusions of Grandeur
La folie des grandeurs 1961

172 Delusions of Grandeur
La folie des grandeurs 1967

174-176 Studies for sculpture:
Delusions of Grandeur 1967

Côté

FACE

Sculpture

The idea of making sculptures which would be based on a three-dimensional realization of images from Magritte's paintings was born out of a conversation with his dealer Alexandre Iolas. As a result, in January 1967, Magritte chose the following eight paintings to be transposed into sculptures: *The White Race*; *The Well of Truth*; *The Natural Graces*; *The Labours of Alexander*; *Perspective: David's 'Madame Récamier'*; *Delusions of Grandeur*; *The Gioconda*; *The Therapeutist*. He made working drawings for each one, nearly all of which are reproduced here, deciding the scale and measurements himself, which he seemed to have no difficulty in visualizing or transposing. Full-scale models of each sculpture were initially cast in wax in Verona, at the Gibiesse foundry, before being finally cast in bronze. Each was made in an edition of five; one complete set, representing the Artist's Proof, has gone to his widow.

Unfortunately, Magritte died without ever seeing the sculptures completed. He did see the wax models, however, when he visited the foundry in June 1967, just two months before he died. At that time he made several modifications and adjustments; for example, in *173–177* *Delusions of Grandeur*, he altered the angles of the torso and arranged *158–161* for the arms to be hollowed out. In *The Gioconda*, he had it in mind to paint one of the curtains, and had already made a sketch for the *169–171* stencil of a Magrittian sky with clouds. Although *The Well of* *166–168* *Truth* and *The White Race* are of a size that can still comfortably fit on a table, the other sculptures are much larger and could be *149–153* described as environmental. *David's 'Madame Récamier'*, for example, is a unit consisting of several pieces the size of actual furniture. A couch, lamp and footstool were found which faithfully reproduced those in David's painting of Madame Récamier (1800) in the collection of the Louvre, and these were then cast. The coffin was cast from a specially constructed wooden model which was based on an actual coffin, but with the clasps and ornamental details designed by Magritte. (The theme of the coffin replacing human figures also appeared in a similar paraphrase by Magritte of Manet's *154–155* painting *The Balcony*, which he made in 1949.) *The Therapeutist* was a unique invention of Magritte – an image which appeared in many variations. The sculpture consists of a seated man, whose lower half was first cast in plaster from a man's legs and feet, and whose torso is cast from a birdcage (which had been specially constructed) with birds inside.

Lifeline

I quote here in translation the autobiographical text by Magritte
which was published in the Belgian magazine *L'Invention collective*
No. 2 (April 1940). This was a revised version of a lecture, entitled
'La Ligne de vie', given by Magritte at the Musée des Beaux-Arts in
Antwerp on 20 November, 1938. A still different version was pub-
lished in *Combat* (see Bibliographical Note).

During my childhood I used to play with a little girl in the old
abandoned cemetery of a country town where I spent my holidays.
We used to lift up the iron gates and go down into the underground
vaults. Regaining the light again one day I found, in the middle of
some broken stone columns and heaped-up leaves, a painter who
had come from the capital, and who seemed to me to be performing
magic.

When I began to paint myself, toward 1915, the memory of that
enchanted encounter with painting oriented my efforts in a direction
having little to do with common sense. A singular accident willed
that at that time someone, probably with the intention of playing a
joke, sent me a catalogue with illustrations from an exhibition of
Futurist paintings. It was thanks to that joke that I became familiar
with a new way of painting, and, in a veritable intoxication, I set
about creating animated scenes of stations, festivals, or cities in
which the little girl, associated with my discovery of painting, lived
out an exceptional adventure. Undoubtedly one pure and powerful
sentiment, eroticism, kept me at that time from falling into a more
traditional search for formal perfection. The only thing I wanted
was to provoke an emotional shock.

This painting of pleasure was then replaced by a curious ex-
perience. Believing that it was possible to have the world I loved at
my disposal if ever I succeeded in establishing its essence on canvas,
I undertook to search for its plastic equivalents.

The result was a series of very evocative images, but abstract and
inert, and interesting, in the final analysis, only to the intelligence
of the eye. This experience allowed me to see the real world in the
same abstract manner. Despite the shifting abundance of detail and
nuance in nature, I was able to see a landscape as if it were only a
curtain placed in front of me. I became uncertain of the depth of the
fields, unconvinced of the remoteness of the horizon.

Lifeline In 1925, I decided to break with this passive attitude as a direct result of an intolerable meditation in a popular saloon in Brussels: the mouldings of a door seemed to me to be endowed with a mysterious existence, and for a long time I was in touch with their reality. A feeling bordering upon terror was the point of departure for a willed action upon the real, for a transformation of life.

Finding the same will, moreover, in the works of Karl Marx and Friedrich Engels, but allied to a superior method and doctrine, and making the acquaintance, about the same time, of the Surrealists who were violently demonstrating their loathing of all the bourgeois values, both social and ideological, that have maintained the world in its present ignoble condition, I became certain that I would need to live with danger, so that the world, and life, would correspond more closely to thought and to feeling.

I made paintings where the objects were represented with the appearance they have in reality, in a style sufficiently objective so that the subversive effect, which they would reveal themselves capable of evoking through certain powers, might exist again in the real world from which these objects had been borrowed – by a perfectly natural exchange.

In my paintings I showed objects situated where we never find them. It was the realization of a real, if not actually conscious desire existing in most people.

The cracks and creases we see in our houses and on our faces, I found much more eloquent in the sky. Turned wood table-legs lost the innocent existence usually ascribed to them as soon as they appeared dominating a forest. A woman's body floating above a city acquainted me with some of love's secrets. I found it very instructive to show the Virgin Mary in flattering déshabille. I caused the iron bells hanging from the necks of our admirable horses to sprout like dangerous plants at the edge of an abyss.

The creation of new objects, the transformation of known objects, the change of material for certain objects, the use of words combined with images, the putting to work of ideas offered by friends, the utilization of certain visions from half-sleep or dreams, were other means employed with a view to establishing a contact between consciousness and the external world. The titles of paintings were chosen in such a way as to inspire in the spectator an appropriate mistrust of any mediocre tendency to facile self-assurance.

One night in 1936, I awoke in a room where a cage and the bird sleeping in it had been placed. A magnificent error caused me to see an egg in the cage instead of the bird. I then grasped a new and astonishing poetic secret, because the shock I experienced had been provoked precisely by the affinity of two objects, the cage and the egg, *whereas previously, I used to provoke this shock by bringing together objects that were unrelated*. Ever after that revelation I sought to discover if objects other than the cage could not likewise manifest –

by bringing to light some element peculiar to them and rigorously predetermined – the same evident poetry that the conjunction of the egg and the cage had succeeded in producing. This element to be discovered, this thing among all others obscurely attached to each object, suddenly came to me in the course of my investigations, and I realized that I had always known it beforehand, but that the knowledge of it was as if lost in the recesses of my mind. Since this research could yield only one single exact response for each object, my investigations resembled the pursuit of *the solution to a problem for which I had three data: the object, the thing connected with it in the shadow of my consciousness, and the light wherein that thing would become apparent.*

The problem of the door called for an opening through which one could pass. In *The Unexpected Answer* I showed a closed door in a room. In the door, an irregular opening unmasks the night. *79*

With regard to light, I believed that although it had the power to render objects visible, its existence is manifest only on condition that objects receive it. Without matter, light is invisible. This seemed to me to be made evident in *The Light of Coincidences*, where an ordinary object, a woman's torso, is lit by the flame of a candle. Here it appears that the illuminated object gives life to the light.

The subject of woman yielded *The Rape*. In this painting, a woman's face is made up of the essential features of her body. Breasts have become eyes, the nose is represented by the navel, and the sexual organ replaces the mouth. *87*

The Human Condition was the solution to the problem of the window. I placed in front of a window, seen from inside a room, a painting representing exactly that part of the landscape which was hidden from view by the painting. Therefore, the tree represented in the painting hid from view the real tree situated behind it, outside the room. It existed for the spectator, as it were, simultaneously in his mind, as both inside the room in the painting, and outside in the real landscape. Which is how we see the world: we see it as being outside ourselves even though it is only a mental representation of it that we experience inside ourselves. In the same way, we sometimes situate in the past a thing which is happening in the present. Time and space thus lose that unrefined meaning which is the only one everyday experience takes into account. *61*

A problem to the solution of which I have long applied myself was that of the horse. It was demonstrated to me once again in the course of this research that I knew beforehand in my unconscious the thing that had to be brought to light. The first idea glimpsed was that of the ultimate solution, however vaguely perceived. It was the idea of a horse carrying three shapeless masses, whose significance I did not understand until after a series of multiple steps and experiments. First I painted an object consisting of a jar and a label bearing the image of a horse with the printed inscription: HORSE PRESERVE. Then I thought of a horse whose head was replaced by a hand; the index finger pointed the direction 'Forward'. But I realized that this was merely the equivalent of a unicorn.

I hesitated for a long time over an intriguing effect: in a dark room I placed a horsewoman seated near a table, leaning her head on her hand and looking dreamily at a landscape which was defined by the silhouette of a horse. The lower part of the animal's body and its four feet were the colour of earth, while, from a horizontal line situated at the level of the horsewoman's eyes, the horse's coat was the colour of the sky.

Finally, what put me on the right track was a horseman in the position he assumes while riding a galloping horse; from the sleeve of his arm which was thrust forward emerged the head of a racing charger, and the other arm, behind, held a riding-whip.

Beside the horseman, I placed an American Indian in the same position, and I suddenly divined the meaning of the three shapeless masses that I had placed on the horse at the beginning of my investigation.

23 I knew they were horsemen, and thus I settled on *The Endless Chain*. In an atmosphere of desert land and dark sky, a plunging horse is ridden by a modern horseman, a knight of the dying Middle Ages and a horseman of antiquity.

Nietzsche is of the opinion that, without an overheated sexual system, Raphael would not have painted such a multitude of Madonnas. This deviates singularly from the motivating forces usually attributed to that venerable painter: priestly concerns, ardent Christian piety, aesthetic ideals, search for pure beauty, etc. . . . But this opinion brings us back to a healthier interpretation of pictorial phenomena, and its brutality depends upon the clairvoyant power of thought.

The same freedom of mind could singlehandedly make possible a wholesome restoration in all domains of human activity.

In short, this contradictory and disorderly world of ours hangs more or less together by dint of very roundabout explanations, both complex and ingenious by turns, which appear to justify it and excuse those who thrive wretchedly on it. These explanations do take into account certain experiences.

But it is to be remarked that what is involved is 'ready-made' experience, and that if it does give rise to brilliant analyses, such experience is not itself an outcome of an analysis of its own real conditions.

Future society will develop in the course of life an experience which will be the fruit of a profound analysis whose perspectives are being set forth under our very eyes. And it is owing to a rigorous preliminary analysis that pictorial experience as I understand it may be established from now on.

That pictorial experience which puts the real world on trial, gives me a belief in the infinity of possibilities as yet unknown to life. I know I am not alone in affirming that their conquest is the sole aim and the sole valid reason for the existence of man.

Protais

Magritte's sense of outrage at war is apparent in the brief text which follows, about a French painter of battles and army life. It was published in the review *Temps mêlés* (March 1953).

Protais (Alexandre-Paul). French painter, born in Paris (1815–1890), author of powerful and veracious paintings of army life, *The Battalion in Formation*, *The Two Wounded Men*, *The Morning before the Attack*, *The Evening After the Battle* and various panoramas, etc. (Larousse).

SUPPLEMENT TO THE DICTIONARY
'It is regrettable for the education of the young that war stories are always told by those who survived.'

L[ouis]·S[cutenaire]

Protais shared the common mistake of attributing a civilizing role to the great bloodbaths of history. However, much to the contrary, civilization exists in spite of the wastes of war and the time lost in reparation. No doubt Protais gained certain personal advantages from war, like all those who reinforce, in one way or another, the military myth, without which the life of the nation's killers would be seen for what it is. For the composition of his paintings glorifying gored and gouged flesh, asphyxiation, burial alive, quick death, or other military deeds, Protais had at his disposal enough flattering subjects for a society which took pleasure in its parasitical armies. Since then weapons have been perfected but military exploits remain the same, and except for an outwardly more picturesque science, a Protais of today would not add anything of importance to the Protais of 1850. A society which honours these miseries is the result of a civilization compromised by the existence of military men of every sort and kind: uniformed subordinates as well as their superiors in morning dress. Protais is a witness for the prosecution. As for civilians, idlers or workers: labourers, musicians, shoemakers, glaziers, writers, etc., they are the accomplices of Protais in so far as they admit that military force is a necessary boon or an indispensable evil.

Nat Pinkerton

In addition to the Fantômas series in the cinema, Magritte also followed the thrillers of Fritz Lang, the comedies of Mack Sennett and Charlie Chaplin, and adventure stories by Poe, Bret Harte and Robert Louis Stevenson. He was also an avid fan of the detective novels of Rex Stout, Dashiel Hammett and, in later years, Georges Simenon, creator of Inspector Maigret (a name which resembles his). He also followed the Nick Carter and Nat Pinkerton weeklies, and the following is a version of a day in the life of Nat Pinkerton as written by Magritte. It was published in his periodical in postcard format, *La Carte d'après nature*, No. 4 (April 1953).

The private detective arrives in his office. A visitor is introduced by the detective's lieutenant. As soon as the visitor leaves, the detective gives orders to his lieutenant. The lieutenant puts his gun over his shoulder and goes out. The detective lights a cigar and writes a letter. Towards noon, he goes to a fancy restaurant. After the meal, he takes a walk, and from habit takes a mental photograph of all the people he meets. He notices that his visitor from the morning is sitting on a bench. Passing a bookstore, he buys a book and heads back to his office. Once rid of his coat and cap, he lights a cigar and reads the book he has just bought. The lieutenant arrives and makes his report. Two women are presented by the lieutenant, and as soon as they have stated their case, he takes them away again and returns for further orders from the detective. Toward nightfall, the lieutenant makes an arrest: one of the lady visitors from the afternoon, who was living with an acrobat as his concubine. The acrobat had received the stolen goods as to which the morning's visitor had asked the detective to carry out an investigation. The lieutenant returns to his office, makes his report, draws up a statement of account under the detective's dictation for the visitor and, his day's work over, returns to his boarding-house to eat a meal and go to bed. Before going home, the detective stops to play a game of cards with some friends in a quiet café. He returns home at nine-thirty. His wife and his mother-in-law are waiting for him in the dining-room and together they eat some meat and vegetables. The detective does not speak about his work in front of his family. He busies himself with his wife and mother-in-law, writing a play with suitable roles for both of them, since they are actresses. At bedtime he kisses them and then makes for his private bedroom for a night of restorative sleep.

Disguise of Nat Pinkerton

LES BADAUDS

Composition de Paul Colinet

NAT PINKERTON

Le détective privé arrive à son bureau. Un visiteur est introduit par le lieutenant du détective. Lorsque le visiteur est parti, le détective donne des ordres à son lieutenant. Le lieutenant met une arme en bandoulière et sort du bureau. Le détective allume un cigare et écrit une lettre. Vers midi, il va dans un restaurant pour gourmets. Après son repas, il fait une promenade et, par habitude, photographie mentalement toutes les personnes qu'il rencontre. Il remarque que son visiteur de la matinée est assis sur un banc. En passant chez un libraire, il achète un livre et se dirige ensuite vers son bureau. Après s'être débarrassé de son pardessus, et de sa casquette, il allume un cigare et lit le livre qu'il vient d'acheter. Son lieutenant arrive et lui fait son rapport. Deux femmes sont introduites par le lieutenant et lorsqu'elles ont exposé leur cas, il les reconduit et revient prendre les ordres du détective. Le lieutenant fait une arrestation vers la tombée de la nuit : c'est une des visiteuses de l'après-midi ; elle vivait en concubinage avec un acrobate, receleur du larcin pour lequel le visiteur du matin avait chargé le détective d'une enquête. Le lieutenant revient au bureau, fait son rapport, rédige sous la dictée du détective une note d'honoraires pour le visiteur et, sa journée de travail terminée, se rend à sa pension de famille consommer un repas et se coucher. Le détective, avant de rentrer dans son home, va jouer une partie de piquet avec quelques amateurs dans un café tranquille. Il rentre chez lui vers neuf heures trente. Sa femme et sa belle-mère l'attendent dans la salle à manger et mangent avec lui une pièce de viande garnie de légumes. Le détective ne parle pas en famille de ses travaux. Il s'occupe avec sa femme et sa belle-mère à écrire un drame théâtral dont des rôles conviennent à sa femme et à sa belle-mère qui sont des actrices. Au moment de se coucher, il les embrasse et se dirige vers sa chambre personnelle pour prendre une nuit de sommeil réparateur.

René MAGRITTE.

La Carte d'après nature (*April 1953*)

René Magritte of Yore

The following is the hitherto unpublished French text of Scutenaire's 'The Life and Acts of René Magritte of Yore', with my translation.

LA VIE ET LES ACTES DE RENÉ MAGRITTE D'ANTAN PEINTRE UNIVERSEL ET PARISIEN

1 Unissant Descartes au Mystère primordial et au Tropique le Bloc occidental, René Magritte d'Antan naît d'un Auvergnat et d'une indienne Apuz au Guatémala, à la Chocolata.

2 « Tu seras peintre ! » prédit à l'enfant une envoûtante germano-maya, Canakrol, qui le déniaise dans la grotte initiatique du pueblo. Elle taille des statues maléfiques, dessine des talismans et meurt jeune.

3 René Magritte d'Antan vient à Paris, s'inscrit à l'Ecole de cette ville, dont il devient la coqueluche, et conquiert le marché.

4 « C'est le premier de nos Primitifs » déclare Jean-Baptiste Bernanos. « Il est l'aboutissement extrême de notre modernisme » proclame Jean-Baptiste Gide. « Il va mourir au pied de la croix » écrit Jean-Baptiste Claudel. « Votre gueule ! » rétorque à celui-ci Jean-Baptiste Péret dans une interview à « Le Figaro mercenaire ».

5 Cagoulard, trotskyste, radical et d'union nationale, Magritte d'Antan visite les Baux avec Jean-Baptiste Malraux, qui prononce à cette occasion la plus géniale de ses formules à l'emporte-pièce : « Que beaux sont les Baux ! ».

6 Magritte fait une brève et brutale incursion dans le surréalisme, y subissant l'influence de Dédé Sunbeam, Ulysse Préchacq, Violette Nozières et Maurice Sachs. Il en sort en passant par la sacristie.

7 Au « Jus de Pomone », René Magritte d'Antan provoque en un duel à l'anus une statue de poussière surnommée Léon-Paul Tartre (ou Merdre), animatrice, comme ses noms l'indiquent, de l'Entéritisme.

8 La statue succombe et on la porte en terre dans un des taxis qui stoppèrent à la Marne l'armée de Von Kluck.

9 Flora, tante de Magritte, divorcée du milliardaire Batta-Bottines, est assassinée par les Soviets, ce qui ne retient pas le peintre de s'inscrire à la Guépéou. « Tant qu'à faire . . . » révèle-t-il à Paul Guth au cours d'un entretien célèbre.

10 « Il n'y a qu'une amertume, la nôtre. Mais la nôtre c'est la vôtre et celle du balbuzard fluviatile » écrit Magritte d'Antan à la fin de son poème symphonique sur la Camargue « Tu tuut beu beu zz zz zz zz zz ».

11 Magritte épouse Jean-Marie, vedette fameuse, dont il n'a pas de progéniture (because la pipette).

12 Ses relations avec les fauteurs de grève, nouées aux 5 à 7 de la Concierge de Noailles, le mènent à l'Ile du Diable.

13 Il s'y convertit au catholicisme, puis s'en échappe avec la complicité de Bidegnole, du Vaudou, de la Madone des Clochards, du Comité des Forges, des Prémontrés, de Miss Paris, de la Maffia, de Pierrot-le-Fou, et du Vrai Visage de la France.

14 Membre de l'Institut, lauréat de l'Académie des Arts abstraits et figuratifs réunis, Magritte d'Antan influence à fond Matisse, Van Gogh, Atlan, Bonnat, Renoir et Chabas.

15 Son atelier-salle de vente s'orne d'estamboums ligures, de linges d'accouchée, de birouttes gallo-romaines, d'épis de mais à la Faulkner, de figurines cheyennes et de brouettes saintongeoises.

16 « Il y a souvent eu d'aussi grands imbéciles que les critiques d'aujourd'hui » dit un jour René Magritte d'Antan à son collègue P.c.s.o. « Si, lui répondit l'autre, mais ils n'étaient pas de combat. »

17 Au Concert Colonne, Magritte produit des biffabrenns kabyles et des morcouyes tahitiens, joués sur la harpe par Christian Bérard et sur la viole par Christian Dior. « C'est très *chrétien* » écrit finement l'abbé Bruckberger dans « Franc-Tireur ».

18 Magritte d'Antan décore à la fresque l'arrière-boutique de « Les Temps modernes » de scènes inspirées de « Le Rêve » de Zola. Etourneau Ponty les fait gratter comme trop subversives.

19 Magritte d'Antan fait au pamphlétaire un procès et gagne de gros dommages. A la sortie du tribunal, Brigand Genet lui fait les poches devant les caméras d'Universal, de la Metro-Goldwyn, de Paramount, de Pathé, etc. etc. etc. etc. etc.

20 Aujourd'hui, toujours debout sur le fumier du Lion de Belfort et des Chevaux de Marly, René Magritte d'Antan oppose à la facilité monégasque, à l'intransigeance tartare et à la lourdeur belge la bannière claquante des convenances parisiennes.

THE LIFE AND ACTS OF RENÉ MAGRITTE OF YORE, UNIVERSAL AND PARISIAN PAINTER

1 Joining Descartes[1] to the Primordial Mystery[2] and NATO to the tropics, René Magritte of Yore is born of a man from the Auvergne and a flea-ridden squaw from La Chocolata in Guatemala.

2 'You will be a painter!' predicts a Germanomayan sorceress, Canakrol,[3] as she initiates him into love in the grotto of the pueblo. She carves malignant statues,[4] draws talismans and dies young.

3 René Magritte of Yore comes to Paris, enrolls in the School[5] of that city, where he becomes the rage, and monopolizes the market.[6]

4 'He's our first Primitive,' declares Jean-Baptiste Bernanos. 'He is the outrageous climax of our Modernism,' proclaims Jean-Baptiste Gide. 'He will die at the foot of the Cross,' writes Jean-Baptiste Claudel. 'Shut your trap!' retorts Jean-Baptiste Péret to the latter in an interview with *Le Figaro Mercenaire.*

5 Cagoulard, Trotskyite, and National Unionist,[7] Magritte of Yore visits Les Baux in Provence with Jean-Baptiste Malraux, who pronounces on that occasion his most ingenious dictum, '*Que beaux sont les Baux*!'

6 Magritte makes a brief and brutal inroad into Surrealism, undergoes therein the influence of Dédé Sunbeam, Ulysse Préchacq, Violette Nozières and Maurice Sachs.[8] He makes his exit by means of the sacristy.

7 At 'Pomona's Juice',[9] René Magritte of Yore provokes a duel in the arse with a statue of dust nicknamed Léon-Paul Tartre (or Merdre), animator, as his names indicate, of Enteritism.[10]

8 The statue succumbs and is carried off to the sod in one of the taxis of the Marne which stopped Von Kluck's army.

9 Flora,[11] Magritte's aunt, divorced from the millionaire Bata (of Bata shoes) is assassinated by the Soviets, which does not prevent the painter from enrolling in the KGB.[12] 'What's a little more or less between friends . . .' he reveals to Paul Guth[13] in the course of a celebrated conversation.

10 'The only bitterness is ours. But ours is yours and the fluviatile buzzard's,' writes Magritte of Yore at the end of his symphonic poem on the Camargue 'Tu tuut beu beu zz zz zz zz zz.'[14]

11 Magritte weds Jean-Marie,[15] a famous star; there are no off-spring (*parce que* the wrong organ is played).

12 His relations with the strikemongers, fomented over cocktails at the Concierge de Noailles, lead him to Devil's Island.

13 There he is converted to Catholicism; he then escapes with the complicity of Bidegnole,[16] Voodoo, the Madonna of the Hobos, the Board of Inland Steel, the Premonstratensians, Miss Paris, the Mafia, Pierrot-le-Fou and the True Face of France.

14 Member of the Institute, prizewinner in the Academy of United Abstract and Figurative Art, Magritte has a profound influence on Matisse, Van Gogh, Bonnat, Renoir and Chabas.

15 His studio-saleroom is adorned with big-breasted Ligurian statuettes, delivery-bed linens, Gallo-Roman phalli, corncobs à la Faulkner, Cheyenne figurines and wheelbarrows from Saintonge.[17]

16 'There have often been imbeciles as great as the critics of today,'

says René Magritte of Yore one day to his colleague P.c.s.o.;[18]
'True,' the other answers him, 'but they weren't of our *Times*.'

17 In the Concert Colonne, Magritte produces melodies of Kabylian offal-eaters and Tahitian sheep castrators, played on the harp by Christian Bérard and on the viol by Christian Dior. 'It is very Christian', the Abbé Bruckburger[19] writes, with unusual insight, in *Franc-Tireur*.

18 Magritte of Yore decorates in fresco style the back room of 'Les Temps Modernes' with scenes inspired by *The Dream* of Zola. Etourneau Ponty[20] has them scratched out for being too subversive.

19 Magritte of Yore brings a lawsuit against the pamphleteer and is awarded considerable damages. As he leaves the court, Brigand Genet picks his pocket before the cameras of Universal-International, Metro-Goldwyn-Mayer, Paramount, Pathé News, etc., etc., etc., etc., etc.

20 Today, still upright on the droppings of the Lion de Belfort and the Chevaux de Marly, René Magritte of Yore opposes to Monégasque facility, to Tartar intransigence and Belgian heaviness, the creaking banner of Parisian propriety.

[1] I.e. rationalism.

[2] Unlike the followers of Breton, Magritte was never interested in the Occult.

[3] The name of the woman whom Georgette's father married after the death of her mother. In Walloon, the word means 'curly pubic hair'.

[4] The speciality of Breton, who collected Hopi statuary. Breton was also against the *Vache* paintings.

[5] Ecole de Paris (i.e. Picasso, Chagall, Matisse, etc.).

[6] Magritte had sold nothing at all in his exhibition.

[7] All opposing political views.

[8] Various third-rate Surrealists. Violette Nozières became famous for having murdered her father and mother. Her trial in 1933 was commemorated by the Surrealists in a book of poems and drawings, published by Flamel.

[9] The Café Flore.

[10] Existentialism.

[11] Flora, Magritte's real aunt, had a shoe shop in Soignies, where she sold Bata shoes.

[12] The Soviet Secret Police.

[13] A well-known journalist of the times who interviewed many famous persons but never Magritte.

[14] Reduces literature, especially Lautréamont, to the buzz of a mosquito.

[15] A painter in Paris who liked to dress in women's clothing.

[16] An invented word, made up from *gnole*, which in popular language meant 'alcohol', and from the name of the politician Georges Bidault.

[17] Again, a travesty on the Surrealists' enthusiasm for the primitive, the exotic and the occult.

[18] Picasso.

[19] A Catholic art critic who lived in the Surrealist milieu. It was inconceivable that he should write in *Franc-Tireur*, which was a Communist magazine.

[20] The philosopher Maurice Merleau-Ponty, who was a friend of Sartre's. 'Etourneau' is another play on words. *Merle* means 'blackbird', and *étourneau* means 'starling'.

1 All statements by Magritte are quoted directly from letters and other texts, either published or unpublished, or from my own record of interviews and conversations with the artist. As with his painting, in his writing Magritte would often work and re-work the same idea. At times, his prose is unwieldy and difficult; for the sake of clarity, I have on occasion pieced together relevant statements drawn from different sources to make a composite quote. The major published statements by Magritte are listed in the Bibliographical Note.

2 Paul Nougé, *René Magritte ou les images défendues* (Brussels 1943).

3 Louis Scutenaire, *René Magritte* (Brussels 1947).

4 Comte de Lautréamont (Isidore Ducasse), *Les Chants de Maldoror* (Brussels 1948).

5 Lionel Abel, 'A B & C on Lautréamont', *View*, Series IV, no. 4 (December 1944).

6 Max Ernst, *Au-delà de la peinture* (Paris 1937). *Beyond Painting* (New York 1948).

7 Published in *Distances* (March 1928).

8 *The Introduction to Hegel's Philosophy of Fine Art*, translated by Bernard Bosanquet (London 1886).

9 It is also known as *The Air and the Song*, *The Faithful Image* and *The Deceit of Images*.

10 Robert Morris, 'Notes on Sculpture, Part 4: Beyond Objects', *Artforum* (April 1969).

11 John Cage, 'Jasper Johns: Stories and Ideas', Catalogue of Johns exhibition, Jewish Museum, New York 1964.

12 Ludwig Wittgenstein, *The Blue and Brown Books* (New York and Evanston 1964).

13 Ludwig Wittgenstein, *Philosophical Investigations* (Oxford 1963). Compare with Magritte's comment quoted in the present book: 'It can happen that a subject escapes our attention. A thing which is present can be invisible, hidden by what it shows.' (See p. 12).

14 René Magritte, 'Les Mots et les images'; see Bibliographical Note.

15 Andrew Forge, *Rauschenberg* (New York 1969).

16 George Kubler, *The Shape of Time* (New Haven and London 1962).

17 Jacques van Melkebeke, in *Le Nouveau Journal* (Brussels, 12 January 1944).

18 Robert Lebel, *Marcel Duchamp* (New York 1959).

Bibliographical Note

A bibliography on Magritte compiled by André Blavier has been published in Patrick Waldberg's book, *René Magritte* (see below). It covers the years from 1919 to 1965, when the book appeared, and is fairly complete. Blavier has continued to keep his research up to date. The list below represents a selection of the published texts by Magritte, and about him, upon which I have chiefly drawn in my own text.

Books about Magritte

MARIEN, MARCEL. *Magritte*. Brussels, Les Auteurs associés, 1943.

———. *Les Corrections naturelles*. Brussels, Librairie Sélection, 1947.

NOUGÉ, PAUL. *René Magritte ou les images défendues*. Brussels, Les Auteurs associés, 1943. Reprinted in Paul Nougé, *Histoire de ne pas rire*, Brussels, Les Lèvres nues, 1956.

SCUTENAIRE, LOUIS. *René Magritte*. Brussels, Librairie Sélection, 1947.

———. *Magritte*. 'Monographies de l'art belge' series. Antwerp, De Sikkel, 1948. English translation, Chicago, William and Noma Copley Foundation (1962).

SOBY, JAMES THRALL. *René Magritte*. New York, The Museum of Modern Art, 1965. With bibliography.

WALDBERG, PATRICK. *René Magritte*. Brussels, André de Rache, 1965. With bibliography.

Texts by Magritte

'Les Mots et les images'. *La révolution surréaliste*. vol. 5, no. 12 (15 December 1929). English translation in the exhibition catalogue 'Words vs. Images',Sidney Janis Gallery, New York 1954.

'La Ligne de vie', *Combat*, vol. 3, no. 105 (10 December 1938). See also Appendix II.

'La Pensée et les images'. Catalogue of Magritte exhibition, Palais des Beaux-Arts. Brussels, Editions de la Connaissance, 1954.

'La Ressemblance'. Catalogue of Magritte exhibition, Musée des Beaux-Arts, Liège 1960.

'The Art of Resemblance'. Catalogue of Magritte exhibition, Obelisk Gallery, London 1961.

'Le Rappel à L'ordre'. *Rhétorique*, no. 1 (May 1961).

'Leçon des choses'. Writings and drawings, *Rhétorique*, no. 7 (October 1962).

'Ma conception de l'art de peindre'; 'Déclaration (sur le Pop Art)'. *Rhétorique*, no. 11 (May 1964).

Recent Publications

DYPRÉAU, JEAN. Introduction to catalogue of Magritte exhibition, Museum Boymans-van Beuningen, Rotterdam 1967.

FOUCAULT, MICHEL. 'Ceci n'est pas une pipe'. *Les Cahiers du Chemin* (January 1968).

GABLIK, SUZI. 'A Conversation with René Magritte'. *Studio International*, vol. 173, no. 887 (March 1967).

LEBEL, ROBERT. *Magritte. Peintures.* Paris, Fernand Hazan, 1969.

ROBERTS-JONES, PHILIPPE. 'Les poèmes visibles de René Magritte', *Bulletin des Musées Royaux des Beaux-Arts de Belgique*, vol. 1, no. 2 (1968).

SCHMIED, WIELAND. 'Notizen zu René Magritte'. Catalogue of Magritte exhibition, Kestner-Gesellschaft, Hanover 1969.

SYLVESTER, DAVID. Introduction to catalogue of Magritte exhibition, Tate Gallery, London 1969.

List of Illustrations

Oil on canvas $47\frac{1}{4} \times 31\frac{1}{2}$ (120 × 80)
Photo Moderna Museet,
Stockholm

26 The Difficult Crossing 1926
La traversée difficile
Oil on canvas $31\frac{7}{8} \times 25\frac{1}{2}$ (81 × 65)
R. Vanthournout, Izegem
Photo Paul Bijtebier, Brussels

27 The Difficult Crossing 1963
La traversée difficile
Oil on canvas $31\frac{7}{8} \times 39\frac{3}{8}$ (81 × 100)
Alexandre Iolas, New York, Paris,
Geneva, Milan, Rome, Madrid
Photo Jacqueline Hyde, Paris

28 Elementary Cosmogony 1949
Cosmogonie élémentaire
Oil on canvas $31\frac{7}{8} \times 39\frac{3}{8}$ (81 × 100)
Christophe de Menil Thurman,
New York
Photo F. Wilbur Seiders

29 The Encounter 1929
La rencontre
Oil on canvas 55×39 (140 × 99)
Mr and Mrs Victor H. Beinfield,
New York
Photo O. E. Nelson, New York

30 The Art of Conversation 1961
L'art de la conversation
Oil on canvas $25\frac{1}{4} \times 31\frac{1}{2}$ (64 × 80)
Private collection, Paris
Photo Brompton Studio, London

31 The Annunciation 1929
L'annonciation
Oil on canvas $44\frac{7}{8} \times 57\frac{1}{2}$ (114 × 146)
E. L. T. Mesens, Brussels
Photo Paul Bijtebier, Brussels

32 The Flying Statue 1927
La statue volante
Oil on canvas

33 The Rights of Man 1947
Les droits de l'homme
Oil on canvas $57\frac{1}{2} \times 44\frac{7}{8}$ (146 × 114)
Renato Cardazzo, Milan

34 GIORGIO DE CHIRICO The Two
Sisters 1915
Oil on canvas 26×17 (66 × 43)

35 Midnight Marriage 1926
Le mariage de minuit
Oil on canvas $54\frac{3}{4} \times 41\frac{3}{4}$ (139 × 106)
Musées Royaux des Beaux-Arts de
Belgique, Brussels
Photo Paul Bijtebier, Brussels

36 The Man of the Open Sea 1926
L'homme du large
Oil on canvas $55 \times 41\frac{3}{8}$ (139·5 × 105)
Musées Royaux des Beaux-Arts de
Belgique, Brussels
Photo copyright A. C. L., Brussels

37 GIORGIO DE CHIRICO Song of Love
c. 1913–14
Oil on canvas $28\frac{3}{8} \times 23\frac{1}{2}$ (72 × 59·5)
Private collection, New York
Photo Sunami

38 Dawn at Cayenne 1926
L'aube à Cayenne
Oil on canvas $39\frac{3}{8} \times 28\frac{3}{4}$ (100 × 73)

39 The Threatened Assassin 1926–27
L'assassin menacé
Oil on canvas $59\frac{1}{4} \times 77$ (150·5 × 195·5)
Museum of Modern Art, New
York, Kay Sage Tanguy Fund,
1966
Photo John Webb, London

40 The Backfire 1943
Le retour de flamme
Oil on canvas $25\frac{1}{2} \times 15\frac{3}{4}$ (65 × 40)
Emile Langui, Brussels

41 *Fantômas:* book cover, Paris 1912

42 Still from Louis Feuillade's film
serial *Fantômas*, France 1913–14
Photo British Film Institute

43 The Savage c. 1928
Le barbare
Oil on canvas
Painting destroyed during the
London blitz (photograph shows
the artist, 1938)

44 The Lovers 1928
Les amants
Oil on canvas $21\frac{1}{4} \times 28\frac{3}{4}$ (54 × 73)
J. Vanparys-Maryssel, Brussels

Photo Moderna Museet,
Stockholm

45 Pleasure 1926
Le plaisir
Oil on canvas $29\frac{1}{4} \times 38\frac{1}{2}$ (74·5 × 98)
Gerrit Lansing, New York
Photo Paul Bijtebier, Brussels

46 The Heart of the Matter 1928
L'histoire centrale
Oil on canvas $45\frac{5}{8} \times 31\frac{3}{4}$ (116 × 80·5)
Marcel Mabille, Brussels
Photo John Webb, London

47 Gigantic Days 1928
Les jours gigantesques
Oil on canvas $45\frac{1}{2} \times 31\frac{7}{8}$ (115·5 × 81)
Private collection, Brussels
Photo Paul Bijtebier, Brussels

48 The Voice of Silence 1928
La voix du silence
Oil on canvas $21\frac{1}{2} \times 28\frac{3}{4}$ (54·5 × 73)
Private collection, New York
Photo John Webb, London

49 Man Reading a Newspaper 1927–28
L'homme au journal
Oil on canvas $46 \times 31\frac{1}{2}$ (117 × 80)
Tate Gallery, London
Photo Paul Bijtebier, Brussels

50 A Night's Museum 1927
Le musée d'une nuit
Oil on canvas $19\frac{7}{8} \times 25\frac{3}{8}$ (50·5 × 65)
Marcel Mabille, Brussels
Photo Paul Bijtebier, Brussels

51 The End of Contemplation 1927
La fin des contemplations
Oil on canvas with stud fasteners
$28\frac{3}{4} \times 39\frac{3}{8}$ (73 × 100)
M. and Mme J. Urvater, Brussels
Photo Paul Bijtebier, Brussels

52 Discovery 1927
Découverte
Oil on canvas $25\frac{3}{8} \times 19\frac{3}{4}$ (65 × 50)
Louis Scutenaire, Brussels
Photo I.M.P.F., Ghent

53 A Courtesan's Palace 1928–29
Le palais d'une courtisane
Oil on canvas $21\frac{1}{2} \times 28\frac{3}{4}$ (54·5 × 73)

Private collection
Photo Paul Bijtebier, Brussels

54 The Reckless Sleeper 1927
Le dormeur téméraire
Oil on canvas $45\frac{1}{4} \times 31\frac{1}{4}$ (115 × 80·5)
Tate Gallery, London
Photo Paul Bijtebier, Brussels

55 The Imp of the Perverse 1928
Le démon de la perversité
Oil on canvas $32 \times 45\frac{5}{8}$ (81 × 116)
Musées Royaux des Beaux-Arts de
Belgique, Brussels
Photo copyright A.C.L., Brussels

56 The Salutary Promise 1927
La promesse salutaire
Oil on canvas $21\frac{1}{4} \times 28\frac{3}{4}$ (54 × 73)
Nesuhi Ertegun
Photo O.E. Nelson, New York

57 MAX ERNST The Habit of Leaves
1925
Frottage $19\frac{5}{8} \times 12\frac{3}{4}$ (50 × 32·5)
One of 34 engravings made for
Histoire Naturelle

58 Homesickness 1941
Le mal du pays
Oil on canvas $39\frac{3}{8} \times 31\frac{7}{8}$ (100 × 81)
E.L.T. Mesens, Brussels

59 MAX ERNST Collage from the
'Dragon Court' sequence
published in
Une semaine de bonté 1934

60 MAX ERNST Collage from the 'Lion
of Belfort' sequence
published in
Une semaine de bonté 1934

61 The Human Condition I 1933
La condition humaine I
Oil on canvas $39\frac{3}{8} \times 31\frac{7}{8}$ (100 × 81)
Claude Spaak, Choisel (Seine-et-
Oise)

62 Evening Falls 1964
Le soir qui tombe
Oil on canvas $63\frac{1}{4} \times 44\frac{7}{8}$ (160·5 × 114)
Private collection

63 The Domain of Arnheim 1949
Le domaine d'Arnheim

Oil on canvas $39\frac{1}{8} \times 32$ ($99 \cdot 5 \times 81$)
Mr and Mrs Arthur M. Young,
Philadelphia, Pa.

64 The Domain of Arnheim 1962
Le domaine d'Arnheim
Oil on canvas $57\frac{7}{8} \times 44\frac{7}{8}$ (147×114)
Mme René Magritte, Brussels

65 The Signs of Evening 1926
Les signes du soir
Oil on canvas $29\frac{1}{8} \times 25\frac{1}{2}$ (74×65)
Claude Spaak, Choisel (Seine-et-
Oise)

66 Plagiarism 1960
Le plagiat
Gouache on paper $12\frac{5}{8} \times 10$
($32 \times 25 \cdot 5$)
Harry Torczyner, New York

67 Euclidean Walks 1955
Les promenades d'Euclide
Oil on canvas $64 \times 51\frac{1}{4}$ ($162 \cdot 5 \times 130$)
The Minneapolis Institute of Arts

68 The Waterfall 1961
La cascade
Oil on canvas $32 \times 29\frac{1}{2}$ (81×75)
Alexandre Iolas, New York, Paris,
Geneva, Milan, Rome, Madrid

69 The Fair Captive 1947
La belle captive
Oil on canvas $21\frac{1}{8} \times 26\frac{1}{4}$
($55 \cdot 5 \times 66 \cdot 5$)
Mr and Mrs Brooks Jackson, New
York

70 The Flood 1931
L'inondation
Oil on canvas $28\frac{3}{4} \times 21\frac{1}{4}$ ($73 \times 54 \cdot 5$)
Credit Communal de Belgique

71 Threatening Weather 1928
Le temps menaçant
Oil on canvas $21\frac{1}{4} \times 28\frac{3}{4}$ (54×73)
Sir Roland Penrose, London
Photo John Webb, London

72 The Ladder of Fire I 1933
L'echelle du feu
Oil on canvas $21\frac{1}{4} \times 28\frac{3}{4}$ (54×73)
Photo Wallace Heaton, London

73 Magritte arranging a still-life, still
from Luc de Heusch's film *La
Leçon des choses ou Magritte*, Brussels
1960

74 The Alarm Clock 1957
Le réveil-matin
Oil on canvas $21\frac{1}{2} \times 24\frac{1}{2}$ ($54 \cdot 5 \times 62$)
Harry Torczyner, New York

75 Common Sense 1945-46
Le bon sens
Oil on canvas $18\frac{7}{8} \times 30\frac{3}{4}$ (48×78)
Mme Jean Krebs, Brussels
Photo Paul Bijtebier, Brussels

76 The Sweet Truth 1966
L'aimable verité
Oil on canvas $35 \times 51\frac{1}{8}$ (89×130)
Private collection

77 The Field-Glass 1963
La lunette d'approche
Oil on canvas $69 \times 45\frac{1}{4}$ (175×115)
Loan Collection, Institute for the
arts, Rice University, Houston,
Tex.
Photo F. Wilbur Seiders

78 MARCEL DUCHAMP Fresh Widow
1920
Miniature French window, wood
frame and eight panes of glass
covered with leather $30\frac{1}{2} \times 17\frac{5}{8}$
($77 \cdot 5 \times 45$)
The Museum of Modern Art, New
York, Katherine S. Dreier Bequest

79 The Unexpected Answer 1933
La réponse imprévue
Oil on canvas $32\frac{3}{8} \times 21\frac{1}{8}$ ($82 \times 53 \cdot 5$)
Musées Royaux des Beaux-Arts de
Belgique, Brussels
Photo Oliver Baker Associates,
New York

80 Amorous Perspective 1935
La perspective amoureuse
Oil on canvas $45\frac{3}{4} \times 31\frac{7}{8}$ (116×81)
Mme Yvonne Giron, Brussels

81 ROBERT RAUSCHENBERG The Bed 1955
Combine painting 74×31 ($188 \times$
$78 \cdot 5$)

Mr and Mrs Leo Castelli,
New York
Photo Rudolph Burckhardt

82 JASPER JOHNS Flag '54 1954
Encaustic and collage on canvas
42 × 60 (106·5 × 152)
Philip Johnson, New Canaan,
Conn.
Photo Rudolph Burckhardt

83 FRANK STELLA Jill 1959
Enamel on canvas 90 × 78
(228·5 × 198)
Albright-Knox Art Gallery,
Buffalo, N.Y.
Photo Rudolph Burckhardt

84 JASPER JOHNS Painted Bronze 1964
Painted bronze $5\frac{1}{2} \times 8 \times 4\frac{1}{2}$
($14 \times 20\cdot5 \times 11\cdot5$)
Jasper Johns, New York
Photo Rudolph Burckhardt

85 State of Grace 1959
L'état de grâce
Oil on canvas $19\frac{3}{4} \times 24$ (50 × 61)
William N. Copley, New York

86 Homage to Alphonse Allais 1964
Hommage à Alphonse Allais
Gouache $13\frac{3}{4} \times 21\frac{1}{4}$ (35 × 54)
Mr and Mrs Brooks Jackson, New
York
Photo Jacqueline Hyde, Paris

87 The Rape 1945
Le viol
Oil on canvas $25\frac{5}{8} \times 21\frac{1}{4}$ (65 × 54)
Mme René Magritte, Brussels

88 Natural Knowledge c. 1938
La connaissance naturelle
Oil on canvas $29\frac{1}{2} \times 19\frac{3}{4}$ (75 × 50)

89 The Red Model 1935
Le modèle rouge
Oil on canvas $28\frac{3}{8} \times 19\frac{1}{8}$ (72 × 48·5)
Moderna Museet, Stockholm

90 The Seducer 1950
Le séducteur
Oil on canvas $19\frac{1}{8} \times 23$ (48·5 × 58·5)
Mr and Mrs Paul Mellon

91 The Empire of Lights 1954
L'empire des lumières
Oil on canvas $57\frac{1}{2} \times 44\frac{7}{8}$ (146 × 114)
Musées Royaux des Beaux-Arts de
Belgique, Brussels
Photo copyright A.C.L., Brussels

92 Hegel's Holiday 1958
Les vacances de Hegel
Oil on canvas $18\frac{1}{8} \times 11\frac{3}{4}$ (46 × 30)
William N. Copley, New York

93 A Little of the Bandits' Soul 1960
Un peu de l'âme des bandits
Oil on canvas $25\frac{1}{2} \times 19\frac{3}{4}$ (65 × 50)
Private collection, Paris

94 Collective Invention 1935
L'invention collective
Oil on canvas $28\frac{7}{8} \times 45\frac{5}{8}$ (73·5 × 116)
E. L. T. Mesens, Brussels

95 The Natural Graces 1963
Les grâces naturelles
Oil on canvas $21\frac{5}{8} \times 18\frac{1}{8}$ (55 × 46)
Pierre Scheidweiler, Brussels

96 The Explanation 1952
L'explication
Oil on canvas $18\frac{1}{4} \times 13\frac{3}{4}$ (46·5 × 35)
Mr and Mrs Harry W. Glasgall,
New York

97 The Glass Key 1959
La clef de verre
Oil on canvas $51\frac{1}{4} \times 63\frac{7}{8}$ (129·5 ×
162)
Private collection

98 The Battle of the Argonne 1959
La bataille de l'Argonne
Oil on canvas $19\frac{5}{8} \times 24$ (50 × 61)
Private collection, New York

99 Heartstring 1955
La corde sensible
Oil on canvas $44\frac{1}{8} \times 57\frac{1}{8}$ (112 × 145)
Private collection, Brussels
Photo Paul Bijtebier, Brussels

100 The Song of the Storm 1937
Le chant de l'orage
Oil on canvas $25 \times 21\frac{1}{4}$ (63·5 × 54)
Private collection
Photo F. Wilbur Seiders

101 The Origin of Language 1963
L'origine du langage
Gouache $13\frac{1}{2} \times 10\frac{1}{4}$ (34 × 26)
Ronald Gurney, London

102 The Flavour of Tears 1948
Le saveur des larmes
Oil on canvas $23\frac{1}{2} \times 19\frac{3}{4}$ (59·5 × 50)
Musées Royaux des Beaux-Arts de
Belgique, Brussels

103 The Lost Steps 1950
Les pas perdus
Oil on canvas $19\frac{3}{4} \times 25\frac{5}{8}$ (50 × 60)

104 The Art of Conversation 1950
L'art de la conversation
Oil on canvas $25\frac{5}{8} \times 31\frac{1}{2}$ (65 × 80)
Mme H. Robiliart, Brussels
Photo Paul Bijtebier, Brussels

105 Remembrance of a Journey III 1951
Souvenir de voyage III
Oil on canvas $33 \times 25\frac{1}{2}$ (84 × 65)
Private collection

106 The Haunted Castle 1950
Le château hanté
Oil on canvas 15×18 (38 × 46)
Dr Bernhard Sprengel, Hanover

107 Remembrance of a Journey 1955
Souvenir de voyage
Oil on canvas $63\frac{7}{8} \times 51\frac{1}{4}$ (162 × 130)
Museum of Modern Art, New
York, Gift of Dominique and John
de Menil

108 The Proper Meaning IV 1928-9
Le sens propre IV
Oil on canvas $28\frac{3}{4} \times 21\frac{1}{4}$ (73 × 54)
Robert Rauschenberg, New York
Photo Oliver Baker Associates,
courtesy Sidney Janis Gallery

109 The Use of Words I 1928-9
L'usage de la parole I
Oil on canvas $21\frac{1}{2} \times 28\frac{1}{2}$ (54·5 × 72·5)
William N. Copley, New York
Photo Geoffrey Clements, New
York

110 The Two Mysteries 1966
Les deux mystères
Oil on canvas $25\frac{5}{8} \times 31\frac{1}{2}$ (65 × 80)
Private collection, London

111 The Air and the Song 1964
L'air et la chanson
Gouache $13\frac{3}{4} \times 21\frac{1}{4}$ (35 × 54)
Hanover Gallery, London

112 The Shadows 1966
Les ombres
Oil on canvas $25\frac{5}{8} \times 31\frac{7}{8}$ (65 × 81)
Mr and Mrs Norton S. Walbridge,
La Jolla, Calif.
Photo Paul Bijtebier, Brussels

113 The Key of Dreams 1930
La clef des songes
Oil on canvas $14\frac{1}{2} \times 22$ (37 × 56)
Sidney Janis Gallery, New York
Photo Geoffrey Clements, New
York

114 The Key of Dreams 1936
La clef des songes
Oil on canvas $16\frac{1}{4} \times 10\frac{3}{4}$ (41·5 × 27·5)
Jasper Johns, New York
Photo Rudolph Burckhardt

115 The Fright Stopper 1966
Le bouchon d'épouvante
Oil on canvas $11\frac{3}{4} \times 15\frac{3}{4}$ (30 × 40)
Alexandre Iolas, New York, Paris,
Geneva, Milan, Rome, Madrid

116 Guessing Game 1966
Le jeu de mourre
Oil on canvas $11\frac{3}{4} \times 15\frac{3}{4}$ (30 × 40)
Private collection, London

117 The Palace of Curtains III 1928-29
Le palais des rideaux III
Oil on canvas $32 \times 45\frac{7}{8}$ (81 × 116·5)
Sidney and Harriet Janis collection,
gift to the Museum of Modern Art,
New York.
Photo Oliver Baker Associates,
New York

118 The Blue Body 1928
Le corps bleu
Oil on canvas $28\frac{3}{4} \times 21\frac{5}{8}$ (73 × 55)
Private collection, London

119 The Duo 1928
Le duo
Oil on canvas 28¼ × 23⅝ (73 × 60)
E. L. T. Mesens, Brussels

120 The Use of Words II 1928–29
L'usage de la parole II
Oil on canvas 21¼ × 28¾ (54 × 73)
E. L. T. Mesens, Brussels
Photo Paul Bijtebier, Brussels

121 The Phantom Landscape 1928–29
Le paysage fantôme
Oil on canvas 21¼ × 28¾ (54 × 73)
Private collection

122 Figure Walking towards the Horizon 1928–29
Personnage marchant vers l'horizon
Oil on canvas 31⅞ × 45⅝ (81 × 116)
Mlle Betty Barman, Brussels
Photo Paul Bijtebier, Brussels

123 The Imprudent One 1927
L'imprudent
Oil on canvas 39⅜ × 28⅞ (100 × 73·5)
Harry G. Sundheim, Jnr., Chicago, Ill.

124 The Harvest 1943
La moisson
Oil on canvas 23¼ × 31½ (59 × 80)
Louis Scutenaire, Brussels
Photo John Webb, London

125 The Forbidden Universe 1943
L'univers interdit
Oil on canvas 31⅞ × 25⅝ (81 × 65)
Fernand C. Graindorge, Liège

126 Lyricism 1947
Le lyrisme
Oil on canvas 19¾ × 25⅝ (50 × 65)
Louis Scutenaire, Brussels

127 The Treatise on Sensations 1944
Le traité des sensations
Oil on canvas 25⅝ × 31½ (65 × 80)

128 Lola de Valence 1948
Oil on canvas 39⅜ × 23⅝ (100 × 60)
Louis Scutenaire, Brussels

129 The Pebble 1948
Le galet
Oil on canvas 39⅜ × 31⅞ (100 × 81)
Mme René Magritte, Brussels

130 The Suspect 1948
Le suspect
Oil on canvas 25 × 21 (63 × 53)
Harry Torczyner, New York
Photo Malcolm Varon, New York

131 The Rainbow 1948
L'arc-en-ciel
Gouache and gold paint 18½ × 13 (47 × 33)
Photo Paul Bijtebier, Brussels

132 The Magician 1952
Le sorcier
Oil on canvas 13¾ × 18⅛ (35 × 46)
J. Vanparys-Maryssel, Brussels

133 René Magritte, 1965
Photo Duane Michals, New York

134 Familiar Objects 1927–28
Les objets familiers
Oil on canvas 31⅞ × 45⅝ (81 × 116)
E. L. T. Mesens, Brussels
Photo Paul Bijtebier, Brussels

135 The Road to Damascus 1966
Le chemin de Damas
Oil on canvas 19¾ × 28¾ (50 × 73)
Mme G. Marci-Monet, Geneva

136 Double portrait of the artist, 1965
Photo Duane Michals, New York

137 The Spirit of Adventure 1960
L'esprit d'aventure
Oil on canvas 21¾ × 18 (55 × 46)
Private collection, New York
Photo Paul Bijtebier, Brussels

138 Infinite Gratitude 1963
La reconnaissance infinie
Oil on canvas 31⅞ × 39⅜ (81 × 100)
Private collection

139 The Pilgrim 1966
Le pèlerin
Oil on canvas 31⅞ × 25⅝ (81 × 65)
Alexandre Iolas, New York, Paris, Geneva, Milan, Rome, Madrid

140 The Masterpiece or the Mysteries
of the Horizon 1955
Le chef d'œuvre ou Les mystères de
l'horizon
Oil on canvas $19\frac{1}{2} \times 25\frac{1}{2}$ ($49 \cdot 5 \times 65$)
L. Arnold Weissberger, New York

141 The Pleasure Principle 1937
Le principe du plaisir
Oil on canvas $28\frac{3}{4} \times 21\frac{1}{4}$ (73×55)
Edward James Foundation,
Chichester, Sussex

142 The Ready-made Bouquet 1957
Le bouquet tout fait
Oil on canvas $65\frac{5}{8} \times 50\frac{5}{8}$ ($166 \cdot 5 \times$
$128 \cdot 5$)
Mr and Mrs Barnet Hodes,
Chicago, Ill.

143 The Postcard 1960
La carte postale
Oil on canvas $27\frac{1}{2} \times 19\frac{3}{4}$ (70×50)
Mrs Lionel Fraser, London

144 The Great War 1964
La Grande Guerre
Oil on canvas $25\frac{1}{2} \times 21\frac{1}{4}$ (65×54)
Private collection, Paris
Photo Jacqueline Hyde, Paris

145 The Idea 1966
L'Idée
Oil on canvas $13 \times 16\frac{1}{8}$ (33×41)
Alexandre Iolas, New York, Paris,
Geneva, Milan, Rome, Madrid

146 The Landscape of Baucis 1966
Le paysage de Baucis
Oil on canvas $21\frac{5}{8} \times 17\frac{3}{4}$ (55×45)
Private collection
Photo Paul Bijtebier, Brussels

147 Every Day 1966
Tous les jours
Oil on canvas $19\frac{3}{4} \times 28\frac{3}{4}$ (50×73)
Nesuhi Ertegun
Photo Jacqueline Hyde, Paris

148 The King's Museum 1966
Le musée du roi
Oil on canvas $51\frac{1}{4} \times 35$ (130×89)
Alexandre Iolas, New York, Paris,
Geneva, Milan, Rome, Madrid

149 Perspective: David's 'Madame
Récamier' 1951
Perspective: Madame Récamier de
David
Oil on canvas $23\frac{1}{2} \times 31\frac{1}{2}$ (60×80)
Private collection, Washington,
D.C.
Photo Brompton Studio, London

150 David's 'Madame Récamier' 1967
Madame Récamier de David
Bronze h. $47\frac{1}{4}$ (120)
Photo courtesy Hanover Gallery,
London

151–
153 Three studies for sculpture: David's
'Madame Récamier' 1967
Pencil and ballpoint on paper
$8\frac{1}{4} \times 8\frac{1}{4}$ (21×21); $10\frac{3}{4} \times 8\frac{1}{4}$ ($27 \cdot 5 \times$
21); $10\frac{1}{4} \times 8$ ($26 \times 20 \cdot 5$)
Photo courtesy Hanover Gallery,
London

154 The Therapeutist 1967
Le thérapeute
Bronze h. 63 (160)
Photo courtesy Hanover Gallery,
London

155 The Therapeutist 1937
Le thérapeute
Oil on canvas $36\frac{1}{4} \times 25\frac{1}{2}$ (92×65)
M and Mme J.-B. Urvater,
Brussels
Photo Paul Bijtebier, Brussels

156 The Labours of Alexander 1950
Les travaux d'Alexandre
Oil on canvas 23×19 ($58 \cdot 5 \times 48$)
Mr and Mrs Brooks Jackson, New
York

157 The Labours of Alexander 1967
Les travaux d'Alexandre
Bronze h. $23\frac{5}{8}$ (60)
Photo courtesy Hanover Gallery,
London

158 The Gioconda 1960
La Joconde
Oil on canvas $27\frac{1}{2} \times 20$ (70×51)
Alexandre Iolas, New York, Paris,
Geneva, Milan, Rome, Madrid
Photo Jacqueline Hyde, Paris

LINE DRAWINGS IN THE TEXT
Page

45–46 Illustrations for *Les Chants de Mal-doror*
Published Brussels 1948

65 Lion with flowers 1962
Lion fleuri
Pencil on paper 6 × 4 (15 × 10)
Byron Gallery, New York
Photo O. E. Nelson, New York

103 Drawing from *Leçon des Choses*
Ink on paper
M and Mme F. Deknop, Brussels
Reproduced in *Rhétorique*, no. 7
(October 1962)

105 Four drawings for *The State of Grace*
Pencil on paper
Suzi Gablik, London

107 *Persian Letters* and its Genesis 1960
Les Lettres Persanes et sa genèse
Nine sheets of studies for the
painting eventually called *A Little
of the Bandits' Soul* (pl. 93)
Ballpoint on paper
Harry Torczyner, New York

121 Letter with drawings 1958
Ballpoint on paper
Suzi Gablik, London

126 Seated figure
Drawing from *Leçon de Choses*
Ink on paper
M and Mme F. Deknop, Brussels
Reproduced in *Rhétorique*, no. 7
(October 1962)

128 Drawing 1964
Pencil and ink 9 × 12 (23 × 30·5)
Alexandre Iolas, New York, Paris,
Geneva, Milan, Rome, Madrid
Photo Jacqueline Hyde, Paris

137 Cross-section of a pipe
Drawing from letter to Paul Colinet
Ink on paper
Mme René Magritte, Brussels

138– Words vs. Images 1929
140 Les mots et les images
Illustrations for article in *La
Révolution surréaliste*
(see Bibliographical Note)

141 Drawing 1964
Grey-green Conté crayon on paper
9 × 12 (23 × 30·5)
Photo courtesy Alexandre Iolas
Gallery, New York

144 Drawing from *Leçon des Choses*
Ink on paper
M and Mme F. Deknop, Brussels
Reproduced in *Rhétorique*, no. 7
(October 1962)

155 Fifteen drawings 1967
Ballpoint on paper
Harry Torczyner, New York
Photo Malcolm Varon, New York

169 Drawing 1964
Pencil and ink on paper 9 × 12
(23 × 30·5)
Alexandre Iolas, New York, Paris,
Geneva, Milan, Rome, Madrid
Photo Jacqueline Hyde, Paris

186 Protais 1953
Illustration for article in *Temps
mêlés*

187 Disguise of Nat Pinkerton
Drawing from letter to Paul
Colinet
Ballpoint on paper
Mme René Magritte, Brussels

Index